Conversations
WITH
Ellie

A humorous book for dog lovers and those interested in education, politics, spirituality and everything else under the sun!

"What better view to take on the challenges of life than through the eyes of artistry and creature. Worrell and Ellie take the reader on a ride through the questions humans have been asking throughout history, but never quite like this."
— *JUDY SKEEN, Professor of Theology, Belmont University, Nashville, Tennessee*

"Ellie May Lucille Worrell is the dark woman in Bill Worrell's life. She is both confidante and playmate, supporter and defender. Mostly, she is the incredible subject of this newest book by one of America's best artists."
— *GRETCHEN M. BATAILLE, President, GMB Consulting Group*

"I got a message from Worrell a few years back. He told me that he had a new girlfriend, 'she was the love of his life.' Ellie was her name."
— *RONNIE DUNN, Nashville Recording Artist/Songwriter*

"Bill Worrell reflects on life and love, using his own life as an artist and his love for his dog, Ellie May, as the lens for seeing everything. The Worrell world is revealed through these conversations with his dog, God spelled backwards. And we get to laugh and cry along with him."
— *KATHLEEN HUDSON: Professor of English at Schreiner University and Executive Director of the Texas Music Heritage Foundation*

"Dogs look back at us, and we see ourselves – a living mirror – but it's the best in us – always smiling – it's the mirror we always want to look into ... love me some Ellie!"
Kix Brooks, *Nashville recording artist, songwriter, American Country Countdown radio host*

"Heaven goes by favor; if it went by merit, you would stay out and your dog would go in."
— *MARK TWAIN*

The World
ACCORDING TO *Ellie May*
Lucille Worrell

" *Lemme ask you, Worrell, just who's got who on this leash?"*

"I gotta tell you something, Worrell. One year of bliss beats the heck out of a lifetime of misery. Even one day does! Humans should think about that."

"I got to thinking, Worrell, weird is so normal now that nothing is weird anymore."

"Always remember, Worrell, some people have gratitude. Some have unending gratitude. Some have neither."

"Hey Worrell, why are all you humans always telling other humans to add vices? "

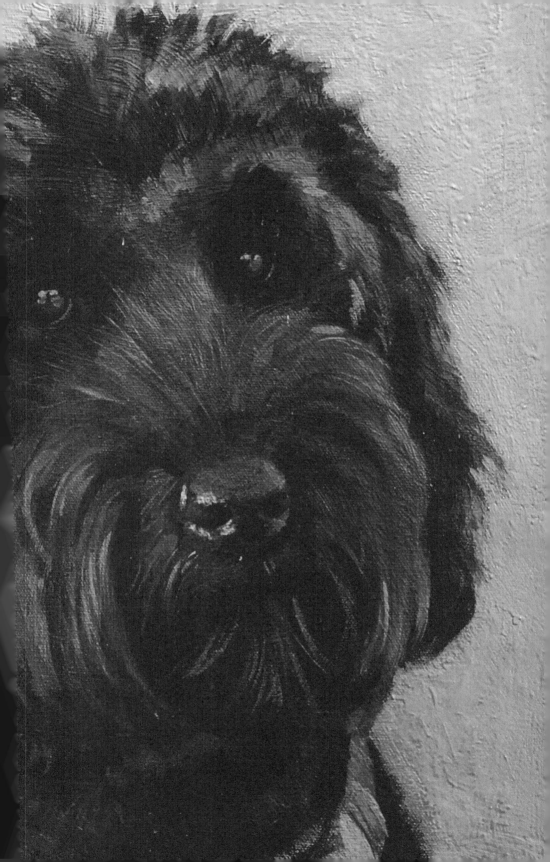

OTHER BOOKS BY BILL WORRELL:

Places of Mystery, Power and Energy –
A Nonfictional Anthology (2013)

Colorado City, Texas (1977) A Photographic Essay

Voices From the Caves – The Shamans Speak
(First printing 1996, Second printing 1998)

Journeys Through the Winds of Time (2000)

FORTHCOMING:

Anthology – A Collection of Worrell's Thoughts, Songs,
Poems and Writings

Outside the Lines – A Journey Through the World of Art

El Coyote del Llano – A Collection of Coyote Stories

Eye of a Needle – A Treatise on Possessions
and Looking Back

Worrell

Conversations

WITH *Ellie*

A humorous book for
dog lovers and those
interested in education,
politics, spirituality and
everything else under
the sun!

by Bill Worrell
& Ellie May
Lucille Worrell

IRIE
BOOKS

Conversations with Ellie is published by
Irie Books, Bokeelia, Florida.

Cover painting and photo on page 160 by Jim Eppler.
Note: At age 19 Jim Eppler met Worrell, taking watercolor lessons from
him and later some sculpture lessons. Eppler became a leading artist in
the Southwest and beyond. *Visit jimeppler.com.*

Photos of Worrell and Ellie (inside dust jacket and end biography)
by Wallace Bosse.

All other photographs and artwork in this book by Bill Worrell.

Cover and interior design: ital art by Mariah Fox
Body text set to Adobe Caslon Pro.
Headings: Trade Gothic, Wrexham Script.

For information regarding gallery affiliations
and other inquiries, please contact

BillWorrell.com
8111 Lower Willow Creek Road
Mason, Texas 76856

ISBN 13: 9781627553872
First Edition

10 9 8 7 6 5 4 3 2 1

In Gratitude

his book is dedicated to every soul on this planet who has ever been in love with a pet.

To Ellie's parents, Prince and Josey, and to Sawndra, who brought Ellie to New Art and gifted her to me, and to my wonderful sister, B.J., who is a catalyst in most all that I do.

To my many patrons, collectors, gallery owners, and friends who have believed in me (or at least have believed there is some value in my art and writings). Naming these would add far too many pages to this volume.

To my various enemies and/or adversaries, few though they may hopefully be, and to the various teachers and administrators who have caused me grief. Without them I would likely have stagnated in some milieu of complacency in the ever-growing quagmire of organized academia.

To those wonderful teachers who inspired me to new heights: those such as Miss Miller, Dick Cheatham, Wilfred Higgins, Dr. Robert

Calvert, Dr. Ray Stephens, Don Scaggs, Richard Davis, Ray Goff, Rod Parkinson, John Queen, and too many others to name.

– Bill Worrell

Friends & Angels are Always Beside you watching Over you

Contents

Acknowledgments

mong the great social hazards is the one of making acknowledgments. People expect something personal, and perhaps rightfully so. It just does not do to say, "I want to thank everyone who has ever lived on Planet Earth."

With trepidation I engage in this hazard. I want to first of all thank my co-writer, Ellie May Lucille Worrell, without whom this book would not have come into existence. I would like to thank my daughter Sawndra. She gifted Ellie to me. (This is a redundancy, I know. In fact, I myself might be a redundancy: a tautological nimiety, and also a pleonastic and a repetitious one. There will surely be others in this book, too.) I would like to thank my owner, manager, and sister B.J. Worrell. Without her I would be lost: not necessarily simply spiritually lost, but just lost in every manner possible.

My brother, Dr. John M. Worrell, Jr. has always inspired me and I thank him for that, as I do my son Bill, Jr. and my other daughter, Lareda Young.

I thank all my collectors. They made my other books, *Voices From the Caves – the Shamans Speak, Journeys Through the Winds of Time,*

and *Places of Mystery, Power, & Energy* wonderfully successful, and by purchasing my bronzes and paintings they have kept me off the streets and out of the universities; and I thank God I am in neither of those places! There are too many thousands of you to name. Just know that it is people such as you that bring forth most of the creativity on this globe. God knows how much all artists need you!

Except for those I have failed to mention, gratitude is expressed to Ronnie, Jeanine, Haley, Kix, Barbara, Molly, Eric, Ron Worrell, Jay & Mary Adams, Sam Baker, Robert Howard and Connie Cole, Walt, Tina & Luke Wilkins, Bob Titley, Spider Johnson, Ross LewAllen, Mariah Fox, Gerry & Lorry Hausman, and the Little Old Ladies of the Attic of Odessa, Texas, thank you. Thank you James Busby, for creating my big break in Santa Fe. Thank you Meta Hunt and Bob and Betty Monteith for helping to make New Art a reality. Thank you Perry Donop, Ted & Suzanne Stewart, Gail Ainsworth Houston, Ross Newell, David Merritt, Dr. Charles Henry Lane, D. C., Hollis and Nell Gainey, Ron Dorchester & the late Linda Yell, Frank Howell, Sandstone Cellars, Ron & Karen Whitmore, Katie Hummingbird, Joan Seagraves, Marilee Davis, Wallace & Susan Bosse, Marty, Diane, Rambo & Caesar Herman, Franny Jackson, Mark Clark, Dr. Kathy O'Conner, Karen Kolstead, Marlene, Kathy, Larry Gomes, Jennifer Howell & Brazos Fine Arts, Kim Roseman & LeeRoy, Deb, Armando, E, and N. Hernandez, Wyman & Sylinda Meinzer, Kim McCollum and Scott Mele, Jessi Colter, the late Nikki Mitchell, the guy that pulled me out of the ditch, the Monastery of Christ in the Desert, Donna Dodson, Jim & Beckie Eppler, Alex Betts, Elayne Patton, my many other friends, and my hopefully few enemies, Odessa College, Houston Baptist University, Texas Tech University, the University of North Texas, Colorado High School, and Mrs. Coffee. Thank you for allowing me to play triangle in your kindergarten band. I thank all of you for the joys, the battles, the struggles, and the inspiration.

I think I need not even begin to attempt to thank Great Spirit, for surely The Creator knows my love and how grateful I am. I thank my Master Teacher, Jesus of Nazareth, the man who was murdered 2,000 years ago and who still keeps trying to teach me about spirituality and integrity and about how rich life can be if we simply "go for it."

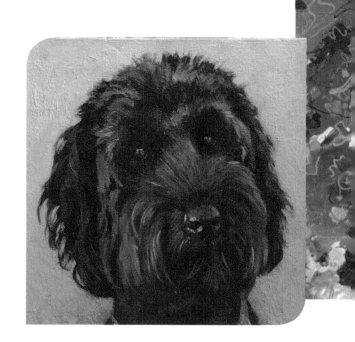

Preface

he is a Leo. At least that is what whoever devised the astrological or zodiac charts state. I would not label her that. I would call her a *Leoness:* not a lioness, but a Leoness. She is one of seven sisters and therefore she could be aptly named Pleiades, which is what I briefly thought about naming her. She came into this world on July 25, 2006. She is the most wonderful canine lady I have ever known. I love her and I tell her that several times a day – and many times each night.

I pondered for a while about her name. I thought of various ones and then it came to me what was proper. Mother's name was Elizabeth. She was descended from the Lucys of England. Barons they were. At least that is how the story goes. The Lucys owned a castle somewhere in Britain, along with vast grounds. Legend is that Shakespeare poached a deer on Lucy's land and Lucy had him prosecuted. William's way of obtaining revenge was to write, "If Lucy be lawsy then lousy be Lucy." Now, I cannot find that reference in Shakespeare's works but my grandmother told me the story and I trust her more than I trust some dark and dusty concordance. Besides, maybe

Shakespeare wrote it and it was not published: like with my stacks and stacks and stacks of manuscripts and journals.

Daddy's middle name was Mays. He really did not cotton to that too much. That name sounds a bit feminine, but it is often a surname. Daddy did not allow his dislike of his middle name to bother him so much as to not endow my brother with the name of John Mays Worrell, Jr. (If you Google Dr. John M. Worrell you will understand why I had an inferiority complex most of my younger, middle child life! He is two years my senior.) All these things considered, combined, and distilled is how the best doggie in the United States of America and to the Republic For Which It Stands came to be named Ellie May Lucille Worrell. And she does not bitch, she does not nag, she does not order me to sweep the floors, make the bed, wash the dishes, or take out the trash. She does not ask me where we are going or when we are coming back, and, unlike some people I have known, she is always happy to see me!

This is my second doggie marriage. There was almost *Amuhrilluh*, but like many girlfriends in my life, it was not an enduring relationship. One winter day she was dropped off at my studio by some deer hunters. They found her at their pickup with an injured paw, brought her here and left her. They used the excuse that they had to get back to Austin. I took her to Dr. Rosberg, who gave her proper medical treatment (she was spayed two times) and we tried unsuccessfully to find her owners. Since she was a bit yellow I was going to name her Amarilla, but I quickly realized that everyone was going to call her Amuhrilluh, anyway, so that is what I named her. She just would not stay home. She loved going to the neighbors and terrorizing their thirteen or more cats. These neighbors, the Bosses, were in the process of constructing a house, thus there were a lot of workers around. These workers loved to tune in Tejano music stations and play them on several radios simultaneously, and at full volume. I suppose Amuhrilluh loved mariachi music too, for each morning when the sound was cranked up she would sojourn over to the Bosses and stay there most of the day, enjoying both the music and the chasing of the cats. I eventually entrusted her care to the Rheinshelds, who took her to live in Big Spring, Texas. I still grieve for the owners who lost her, whoever they might be.

My brother and I, and later our sister, B.J., had a dog when we were very young. He was a cocker spaniel that we named Lucky. He lived to be quite an old man, and most of his days were spent stalking Poochlin, a fox terrier that lived with the Bradley family next door. After Lucky passed, I was dogless for a long time and then acquired B.B.D., which stood for Becky Bird Dog. She was an English pointer. She was a good companion and we highly respected each other, but it was not what I would call a marriage. It was more of a bond sealed by a mutual love for hunting quail out on the Cuthbert and Iatan Flats. (Iatan is not misspelled. The I was actually a cursive S, but the railroad commissioner misread the construction foreman's report and Satan Flats, a name quite descriptive, became Iatan Flats.)

My first doggie true marriage was with my best friend, an Irish Setter named Cadmium Red. Cadmium could do almost anything except to execute the calculus or use a computer. She considered both to be absolutely useless, and of course, she considered the slide rule to be an archaic instrument, much like the abacus. This breed is not well known for being able to do such tasks but she could execute basic mathematics and perform modern dance with a high degree of proficiency.

I lost Cadmium in a marital divorce. I was legally betrothed to a woman with whom there was basically one thing in common: we both loved her: not the dog, but her, my then wife! I was more married to this wonderful Irish Setter doggie than I was to the woman who lived with us – at least lived with us part time. When we split, she got the dog. I mourned for years and I think Cadmium did too. After a twenty-nine year hiatus, another canine came into my life. This was, and is, Ellie May Lucille Worrell.

Much as the cricket is to Carlos Collodi's wooden puppet, so is Ellie to me. She keeps my nose much shorter than it otherwise might be as she constantly reminds me of the truth and asks me poignant questions, such as her puppyish query, "Hey, Worrell, why do people lie?"

Sawndra gifted Ellie to me in November of 2006. I have learned more since then about unconditional love than I learned in all the prior years of my life. She is the best gift of my life. Ellie and I have a wonderful existence here on the Llano River in the Hill Country of Texas, at our second home in Santa Fe, New Mexico, and at our third

home, a Ford Expedition. We ride the Mule together, hike together, and travel together. We play Frisbee, stick, and rock together, go to the Llano River in front of the house and play in the beautiful crystal water together. We share thoughts and have conversations throughout much of the day. We have conversations in the early morning hours and throughout the nights. During these exchanges she keeps me on *track*. This book is about these conversations.

A NEW DAWN

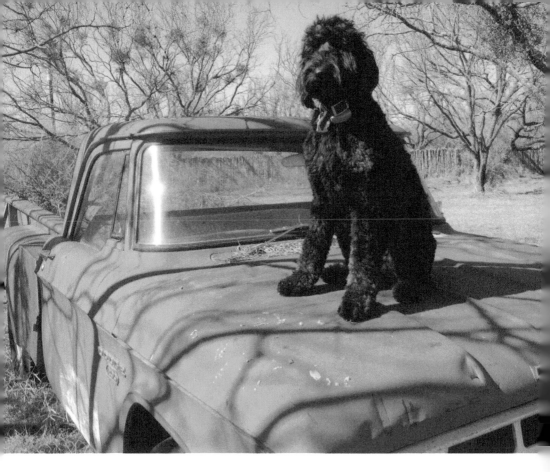

ELLIE MAY ON THE 1968 DODGE PICKUP

A Perspective on Loyalty

"*Ellie May! Where* have you been? I've been worried sick about you! Didn't you hear me calling you?"

"Yeah, Worrell, I heard you. I'm sorry, but there were some deer over there that really needed chasing. Real bad, man! Good grief those things can run! They went way over in the north pasture, but I dang sure got rid of them. Aren't you glad? Then I heard you calling and had started back when a big ol' rabbit jumped up. He ran right in a pile of brush and I tried for thirty minutes to get him out."

"But didn't you hear me calling you?"

"Yeah, I wanted to come, but you know how it is."

"No I don't know how it is! How is it?"

"Well, put yourself in my place. Think about if some really good-looking hottie was kinda hitting on you, rubbing around on your arm, saying pretty words, and smelling sweeter than a bouquet of flowers. Think about that going on and me telling you I wanted to play with the squeaky toy, or have you throw the Air Dog or Flippy Flopper for me. Would you just walk off from that babe and start playing squeaky toy with me? Think about it. I couldn't any more leave that rabbit than you could leave that beautiful woman. In fact, I am still thinking about that rabbit."

And in an instant she was off. Off again!

ELLIE WITH HER AIR DOG TOY

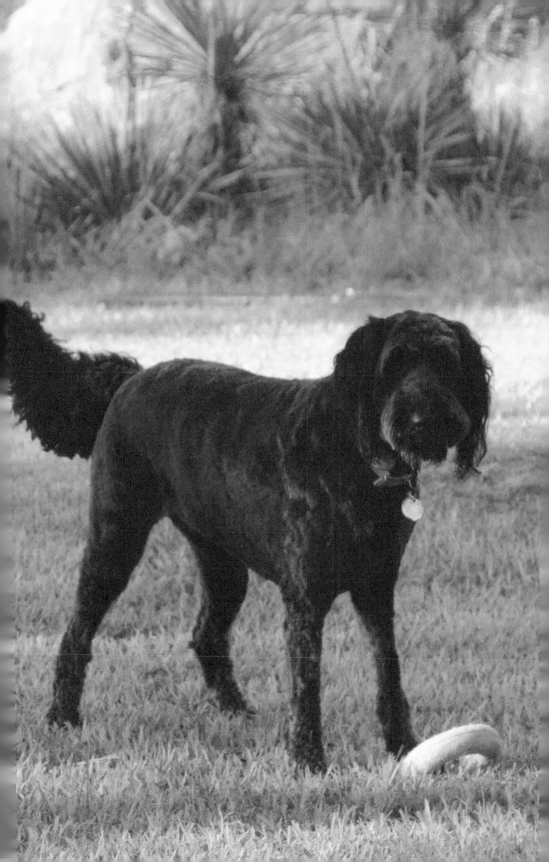

II.
It's all a Matter
of Taste

"*Ellie May Lucille,* what are you doing, Baby?"

"That ought to be obvious, Worrell, I'm chewing on this dead snake. Haven't you ever done that before?"

"NO!"

"Well, you ought to try it sometime. They're really good, especially after they've been dead for two or three days. They are kind of scaly though. A dried rabbit's a lot better, except the hair gets in your mouth. Kinda like feathers do off dead birds."

"O.K. Gimme the snake, Ellie!"

"No!"

"ELLIE!!!"

"No!"

And she wagged her tail, grabbed that several day old deceased snake and ran off a ways. When I walked up to her, she ran off some more, taking the snake with her.

"You're something else, Ellie. Think I'll just stick with beer and pretzels."

"Crunching pretzels makes a similar noise to chewing a dead, dry snake," she said. "I can understand why you like them."

ON A STALK

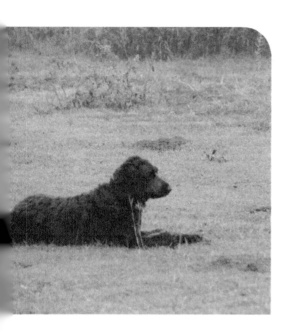

III.

Gopher
Mining

I *was in my studio doing something.* I don't remember just what. I frequently look out the big, double glass doors toward the Llano River, which is the border of my front yard. I usually spot some species of wildlife when I look outside. Sometimes there are deer, sometimes armadillos, and sometimes rabbits. Sometimes I see ospreys and bald eagles. Last spring I saw a mountain lion. It was a big cat, and so dark it was almost black. It was slowly and nonchalantly strolling across the campground.

But this time when I looked outside I saw Ellie May Lucille Worrell. She was having a ball. Her ears were flapping. She had a smile on her face and her front paws were going 101 miles an hour. Only she was not running. She was digging. She could have been digging clear to China from all the dirt that was flying.

"Good grief Ellie! What are you doing, Baby Dog?"

"I'm trying to get this dadgum old gopher out of here! Boy, do they smell funny! It's incredibly enticing. Probably something like beer smells to you."

"But Ellie, you're digging up the yard. You're making holes."

"Well, I think this gopher is more important than some old yard. Besides, the gopher's the one that made the holes in the first place."

"I can't argue with that, Ellie Baby, but your holes are a lot bigger and deeper."

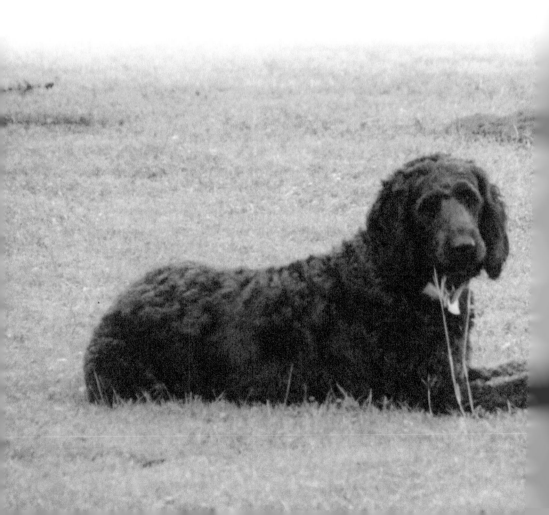

"They may be bigger, but they're not deeper," she replied, as she kept digging away. "And besides, if I don't get this gopher you're gonna have ten dozen more holes in your wonderful yard."

"I guess you're right, Ellie May. You just go on and get that ol' gopher."

A few hours later as I viewed the lunar landscape I realized we could make money out of this. We'll just open it up to spelunkers for two bucks a head. Ellie was still digging, of course, determined to catch that gopher. I have not seen her catch a one yet, but she is the epitome of determination.

ELLIE MAY ON GOPHER DUTY

IV.
Physical Limitations

One warm spring morning, the Llano River was as still as a sheet of glass, except for the rapids singing their unceasing lullaby. Flowers were blooming brightly. Hummingbirds were so busy chasing each other away from the feeders that none of them could get a drink. Cowbirds were seeking other birds' nests so they could peck holes in the rightful owners' eggs, kick them out and onto the ground, and then lay their own eggs in the invaded nest. This is one of the cleverest of all welfare systems yet devised. Here is how it is implemented. Cowbirds invade a nest, destroy the existing eggs, then lay their own eggs. The cowbird's eggs hatch. Then cardinals, mockingbirds, and various other species, depending upon which one the cowbirds have invaded, assume the tasks of raising cowbird chicks. It is quite a scheme.

The cowbirds disavow all parental responsibility and the other birds never consider obtaining DNA tests to check on the offsprings' legitimacy. The alien's eggs hatch, the chicks grow up, learn to fly, leave the adopted parents' nest, mate, and the cycle is

HOLE AND YARD DIGGER

FUTILE ATTEMPTS AND WISTFUL THINKING

repeated. It resembles some social patterns in the 21st century United States. An armadillo was busy digging up the yard in search of grubs and worms, a few deer were browsing on whatever was browsable down in the campground, and tree rats were scurrying about. That is what we oftentimes call squirrels: tree rats.

Sweet Ellie May Lucille walked up, gave me a wet lick and said, "Worrell, I need to ask you a question."

"O.K., Baby Dog, what?"

"Why didn't God make me able to climb trees?"

"Shoot, Ellie, I don't know. Maybe you can but you have not tried hard enough, or maybe you have not had enough faith to enable you to do it. Maybe God was afraid you'd fall and get hurt. Why do you ask?"

14

"Because I'd sure like to get hold of some of those birds up there, that's why! They drive me crazy the way they are always flitting, flapping, pecking, and chirping like a bunch of squeaky toys. They sound so delicious and chewable!"

"I tell you what, Ellie, you're a lot better off precisely the way you are. Just think how it would be if you could climb trees. Just think what could happen if you were twenty feet up, about to latch onto a bird, and then it flew. You're so used to being on the ground that you might forget you are up in a tree. You could make a lunge for that bird and then … twenty feet down is a long way."

"Well, then God should have made me able to fly, too!"

I realized then that Ellie's logic is non-refutable, and I got to thinking, God should have made me able to fly too, just the way I did in my childhood dreams. It was so wonderful, flying was.

ROSS AS ANDERSON COOPER
AND CASSIE CLIMBING A TREE

SOMETIMES WORRELL IS SO BORING!

V.
Basic
Theology

O *ut here in Mason County,* Texas life is wonderful. This county is the Gem of the Hill Country. There are streams and springs and prodigious live oak trees. There are picturesque escarpments of limestone. There are enormous mounds of granite, and herein are found some of the finest specimens of blue topaz in the world. There are ancient campsites where prehistoric people dwelled over three thousand years in the past, and in more rare incidences, over 10,000 years in the past. In Mason County both Folsom and Clovis type points have been found. These points were crafted some six to eight thousand years before the Egyptian pyramids were erected. I have a flint projectile point picked up near my driveway that an archaeologist estimated was between 5,300 and 5,800 years in antiquity.

I purchased my first piece of property in Mason County in

the winter of 1979. I acquired more about 1995, and more in 2005 and 2006. I was teaching at Odessa College when I made the first purchase. Odessa is 255 miles to the northwest by paved roadways. We used to call that town "Odessalation," and with every chance I could create I burned up the highways to get to New Art, as we named it, because this place seemed like Heaven and Odessa seemed like Hell. Odessa would not have been so bad had it not been for the administrators of the college where I was teaching. Most of them had risen to their highest levels of incompetence, demonstrating the accuracy of the Peter Principle and without any doubt whatsoever, authenticating it. Please understand that this is not stated in bitterness. In fact, it is stated with humor: vast amounts of retrospective humor! This was the opinion of almost one hundred percent of the faculty of that college, too, along with most of the inept staff, at least those staff members who did not kiss certain delicate parts of the administrators' anatomy.

In 1982 I took a leave of absence from that "institution of higher learning" and accepted a doctoral fellowship at the University of North Texas. From there I went to Houston Baptist University where I was professor of art. This latter mentioned institution was kind enough to give me an unsalaried one-year leave of absence so I could determine if I could "make it" as a sculptor and painter. This allowed me to live on the Llano River and create art: to do nothing but create: sculpt, paint, write music, pick a guitar, play the piano, and write both serious things and trivial things. Since then I have been here full time, other than to visit various places and travel to shows and exhibitions.

I write a lot of trivial things. Sometimes they are entered in my journals, and sometimes they are written on plain, white envelopes. Now and then I might just grab the closest thing handy and pen something on it, like a piece of cardboard I discovered a few days ago. I am certain that someone of national or international disgrace was the inspiration, but I really do not remember. There was no date noted but what I had written was as follows:

GARDEN OF THORNS –
MOONRISE

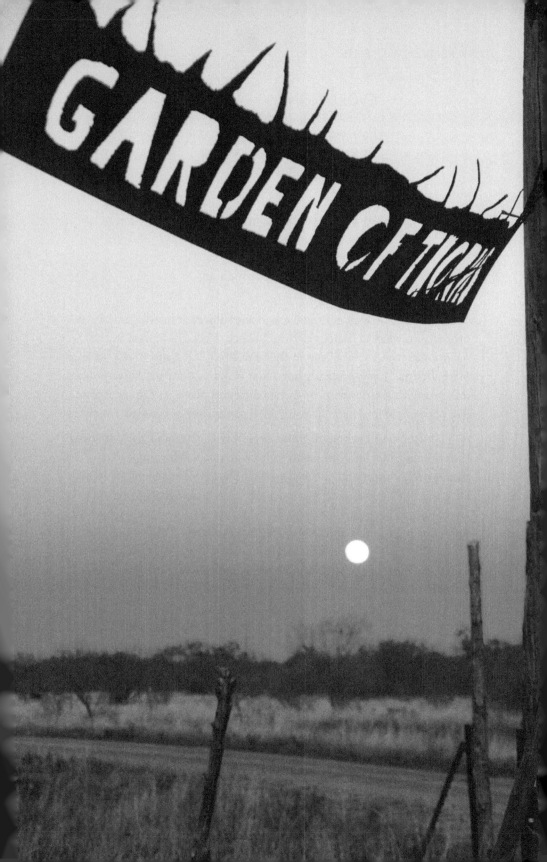

EVOLUTION

Preacher says its folly
Says there ain't no such a thing
Something in his eyes
Makes a bell start to ring

By his simian demeanor
I come to understand
He's a perfect example
That monkeys came from man

Well, anyway, getting back to the subject at hand, I am also a
property steward in Santa Fe, New Mexico. I bought a place in that
quaint and wonderful village in the year 2000 A.D., and thus I became
bi-residential. I was probably born that way, too, for I have always been
infected with the desire to be in two different places at the same time.
My peripatetic impulses have subsided somewhat in more recent times.

Looking back upon those days of B.E. (Before Ellie), life back
then seems a bit drab compared to how it is now. Mornings are so
wonderfully bright and cheerful when Ellie May Lucille jumps in bed
with me and begins nuzzling under my arms and hands, giving me
sweet doggie kisses and stroking me with her big, black paws. As Ellie
gives me unconditional love, the feathered marvels flitting about outside
chirp and tweet and whistle, almost demanding that I feed them, which,
of course, I do. In the spring there are swarms of hummingbirds eagerly
imbibing my offerings. There are a lot of creatures to care for: deer to
feed, other birds to feed, the kitties, Milagra, Midnight, and That Other
Black Cat to feed, and of course there is Ellie and there is myself to
feed. Sometimes there are numerous guests to feed. In addition to all of
these creatures, there was another. This was Katrina. Recently Katrina
became AWOL, and the two above mentioned refugees from the Bosse
residence decided to avert the competition at their other numerous
feline habitat and came to live with Milagra. There is another Bosse
refugee that is a tabby. He is named Buddy, and he is as standoffish
as is That Other Black Cat. The United Kingdom And Independent,
Sovereign Nation Of New Art, as I fondly call it, is actually a welfare

state. Sometimes this makes me wonder what I am coming to!

So one morning I was having coffee and oatmeal and Ellie was having some Blue Buffalo. She looked at me and asked, "Hey Worrell, do you believe in God?"

"I do, Ellie. Why do you ask?"

"It's just something I have been wondering about," she replied. "So who is God, anyway, and where does God live? Is God a boy or a girl? Is God a doggie or a human?"

"Well, Ellie, people have been wondering that since man came down from the trees. At least they have been wondering about some of those questions."

"What trees? Live oaks? Pecans? Cottonwoods? What do you mean? I really like mesquite trees, even though some ranchers cuss them."

"Well, Baby Dog, there is a theory that human beings descended from primates, sort of like how you descended from wolves, only humans descended over a much longer period of time. You doggies evolved over a period of about 10,000 years, or so some say. It has taken humans millions of years, if, in fact, we have evolved at all, and if we have it is questionable as to whether the evolution has been positive or regressive. Some people disagree with all such notions, and there are some that believe monkeys are a much higher order than humans and were descended from man."

"That's funny!"

"Not really, Ellie. People have fought wars and killed each other arguing about this. 'The Church,' which is supposed to teach about love and forgiveness, has burned people at the stake because its subjects argued about this. Even right now people are fighting because they think they know who God really is, and because they think that God wants them to kill everybody who does not believe exactly as they believe. Some think that God is actually ordering them to kill their fellow beings. This is very similar to the God that one reads about in the Old Testament of the Bible. Let me tell you, Ellie, that God was a mean bastard, and a son of a bitch!

"How could He be a son of a bitch or a bastard if He was the only thing existing in the beginning?"

"Touché! Ellie, but you know what I mean."

"Anyway, Ellie, the ancient Hebrews thought God lived in a box. They called it 'The Arc of the Covenant.' The box was not very large, you know. A man named Bezalel constructed it. It supposedly was 45 inches long, 27 inches wide, and 27 inches high. I personally think it was a rather small deity that could be contained in such small quarters. There are some people who think God lives in a city in the Middle East named Mecca. Some think God lives in Heaven, and they think Heaven is somewhere up in the sky. Some think that since in what they conceive as 'the beginning,' in other words the cosmogony, there was nothing except God, and then God made everything; thus everything that exists is God. They believe trees, rocks, flowers, rivers, the sky, life, and everything is God. They believe all is God. Some refer to this philosophy as pantheism."

"Really?" queried Ellie. "It sounds like something I might like to chase. Is it really furry?"

"No, Ellie, it is not an animal. It is a philosophy. And yes, really, some actually subscribe to it, only I am not saying this is how it really is; I am saying this is how they think it is. Jesus said the Kingdom of God is within us. That is what I believe. The ancient Greeks had so many gods you cannot count them all, from Apollo to Zeus, A to Z, so to speak. Some of the Greek humans married other human beings and some married gods and goddesses, or so the many legends go. Some had children, and some of these offspring went up into the sky and became constellations. At least this is what they claimed they believed. The idea of God, gods, and goddesses is an idea that has always confused humans. To deal with this confusion people have found ways and means to cope with it. The main coping mechanism has been the invention of what they term faith."

Ellie perked up her long, black ears and wrinkled her forehead, then asked, "Faith? What does she have to do with it? I thought she was a country music singer!"

"Well, Ellie Baby, she is, but the word I am referring to is

another faith. That faith is sometimes the subjugator of reason. It is the subjugator of reason by reason, which is absurd and a bit insane, if you ask me."

"Why would anyone want to do that: to subjugate reason, or let reason subjugate reason?"

"Because of fear, Ellie, because of fear. Fear. It is a strange paradox. There are some people who fear truth because they think it might destroy what they believe, so faith was invented and given a paramount position over reason. When people do that, what is really happening is that truth and science and reason subjugate faith. The irony is, their minds do not realize what is happening.

"The spiritual gurus, the prophets and priests and preachers have almost always used the notion of faith as a means of controlling their subjects. Some religious tenets and canon seem absurd and ridiculous to laity. I mean, just think, Ellie, Baby Doggie, about how ridiculous some of them are! Thus the priests, preachers, prophets, and the like explain them, or attempt to explain them by citing the notion of faith, admonishing the followers that if they simply had enough faith these things would not be issues for them. Through the centuries this has been their ecclesiastical copout.

"The ancient Hebrews created a God in their own image, then avowed that God created man in His own image. The God they created was wrathful, jealous, filled with vengeance and hate, and he was destructive beyond some mortals' comprehensions. They created him this way because that is the way they themselves were. They gave him a name. It was Yahweh. Sometimes they called him Jehovah. If doggies could read I would direct you to some pages in the Bible. There you would read and learn what that Old Testament God was really like. It would make you want to hide under the bed like you do during a thunder and lightning storm! In fact, it's worse than a thunder and lightning storm, and a lot more frightening than lightning!

Ellie shuddered and said, "I hate thunder and lightning!"

"I know you do Ellie, but it is a necessary thing. It puts nitrogen into the soil and really greens the plants up. But anyway, as I was saying, some have met God, the Supreme Architect of the Universe, the Great

Spirit, and have thus comprehended love and beauty. Those who have had such an experience have never since been at war with God, and we know true inner peace."

"Wow! All that makes me glad I am a dog and not a human."

"Yea, you're lucky, you lucky dog. And remember, dog is God spelled backwards."

Later Ellie May and I were strolling around the yard, playing stick and Frisbee when we happened to look up at the hummingbird feeders. Hummingbirds were everywhere! There were dozens and dozens of them, and the way they were behaving prompted me to say to Ellie: "They are so like humans, the animals. They need each other, the animals. They depend upon each other, the animals. They fight each other, the animals. They bluff each other. They claim territories and then attempt to drive all others away and to keep them away." I went on as Ellie stared at me. "They are so God-like, the humans. They assume omnipotence, the humans. They declare their kingdoms, the humans do. They make their wills very manifest. They establish laws and decide punishments. They declare rewards for those who obey and for those who live in accordance with their wills, and mete out horrible punishments for those who do not. They are jealous and demanding and declare their supremacy. They judge almost constantly and they attempt to govern, govern, govern. Always, they attempt to govern and to rule: to be *supreme* rulers, too!" Ellie kept staring at me as if she only half-believed what I was saying.

"When you think about this it makes God seem so human, at least it makes the god that man has created seem human. Perhaps that is because man has almost always attempted to create God in man's own image. Animals? Humans? God? Is there a difference? Do things equal to the same thing equal each other?" Are the pantheists right?"

"This is getting a little bit above me, Worrell, and I am not too fond of being compared to humans, either!"

"I know, Ellie, but this stuff bothers me. I really hate to trouble you with it but I can't help wondering about a lot of these things. Was matter God's raw material or did God create that too? It seems simple enough to consider that the universe has always existed. Should it not

be equally simple to believe that God has always been?" And which is which, or are they both the same, God and matter?"

Then Ellie asked me, "Are you asking me these things or are you attempting to explain them to yourself by asking me these questions? Or are you just thinking out loud in attempts to answer your own questions? Like I just told you, you are getting a bit over my head. You are six feet tall, Worrell. I am a lot closer to the ground than you are."

"I am just attempting to answer your question, Ellie, and out loud stuff is always thinking too, unless it is coming from the mouths of politicians or educational administrators."

I continued by asking a rhetorical question. "Is what we know about God what we have gained from personal experience, or are the things we assume we know about God those things that have percolated through the prophets, elders, teachers, preachers, shamans, gurus, parents and ancestors?

"Sometimes when I am sculpting I imagine the fun and humor the Creator experienced when He put together the phyla: especially phylum Chordata. Then, having completed a sculpture, I muse about why God has so often been so harshly disapproving of man, the being He created. I also muse about why man has been so disapproving of both God and man: the god he created, the children he brought forth, and the officials he has elected."

Ellie looked up from the floor where she was comfortably sprawled out, rolled her big dark eyes upward and asked me, "What in the ever-loving hell is phylum Chordata? Pardon my language, Worrell, but do you have to use all those big words? And I should have equal say-so in this book, too. Why do you write God with a capital G and other times with a lower case g, and do that with the pronoun, too. Sometimes it is He and other times it is he. Why?"

I realized that she was correct in her observation: she is a lot closer to the ground than I am, and I suddenly wished that I could sprawl out like she does. "Aw, Ellie, Baby, that's what you are. That is what I am too. We both belong to phylum Chordata and subphyla Vertebrata. And beyond that we are mammals in that classification. That's also what all those gophers and deer and rabbits you chase are.

Anyway, sometimes when I am painting I view the different bird feeders I have filled with a rich blend of maize, cracked corn, and black, oiled sunflower seeds. I view those and the containers of sugar-water I have filled for the hummingbirds. The behavior of birds mimics so much the behavior of humans that I am astounded. I am also a bit amused. There is an overflowing abundance of seeds and sugar-water, literally, and an almost endless supply to back it up. Even so, the dominant ones of these fine, feathered marvels are so busy chasing the weaker ones – the beta group, or the less aggressive away that it seems they all would die of starvation. The aggressive ones cannot feed because they are too busy bullying the beta ones and the beta ones cannot feed because the bullies are constantly chasing them away. They are so much like people! They fight over abundance. Somehow they survive and keep me busy replenishing their staples and maintaining the welfare program at New Art. Perhaps aggression and flight is their work ethic. Perhaps those two things are what makes them feel worthy of the harvest and are the things that make life worthwhile for them.

"I just don't worry about it, Worrell, and I don't think it serves you well for you to worry about it either, and you still didn't answer my question about upper and lower cases."

Ellie is always right. It probably doesn't serve me well. I did explain to her that God and He refer to The Creator, and that god and he refer to mythical creations of human beings.

"I was working in my studio one day, Ellie, and I thought I overheard one hummingbird ask another, "Do you believe in Worrell?" The other replied, "There is no Worrell!"

"Surely there is!?"

"No, there isn't!"

"There is. I know there is. I have seen him. I saw him walking down by the Llano River one day. He looked at me, and he smiled, too."

"Don't give me that!"

"Really, I have."

"I don't believe you."

"If there is no Worrell then from where comes all those

seeds those guys over there are munching on, all that food the cats are consuming, the corn the deer are eating, and all this sugar-water we drink?"

After asking this question the hummingbird stopped flapping its wings and lit on the feeder. The other hummingbird did the same and casually stated, "It just happens!"

"What do you expect from a bird brain?" Ellie asked.

"I tell you, Ellie May, I was bewildered! I started laughing and went back to painting, then I resumed my ponderings and my musing, thinking, *how human can birds get?*

"I tell you what, Baby Dog, I would submit that if someone does not believe in God, he could just as easily also not believe in matter, or even in existence, for that matter. It occurs to me that if I can conceive that matter has always existed, I can conceive that God has always existed. If I do

WELFARE RECIPIENTS

not believe that matter has always existed, then it would seem to me that I might not exist. But I seem to be aware that I do, so by this awareness I am acknowledging creation. I cannot see that disbelieving makes more sense than believing. I cannot see that believing makes more sense than disbelieving – except that – I am! *Cogito ergo sum!* Since I am, it is my choice. I believe! My belief is not necessarily in the god so many have told me about. My belief is in God. My belief is in the kind, loving, guiding Spirit I met a few years back."

"LIKE I SAID, YOU SURE
KNOW HOW TO DIGRESS."

VI.
Ellie Asks
About Deism

Ellie came over to me and wedged herself between my legs. She loves to do this. I love it when she does, too. She just rubs and rubs and rubs herself on the inside of my knees and shins, and wags and wags and wags her long, beautiful, black tail. "That's pretty interesting stuff you told me about God," she said. I have wondered sometimes if maybe God made whatever He made and then just went on to do something else: maybe He just went somewhere else. You know, kinda like you do when you attempt to multi-task so much, Worrell, like when you attempt to water the flowers, water and mow the lawn, and work out while you are trying to create art, write songs, and cook a pot of beans all at the same time, that and talking on the telephone while you are trying to do all those things. Maybe it is a bit like your tilling the soil, planting your garden, and then running off to Santa Fe and the Rocky

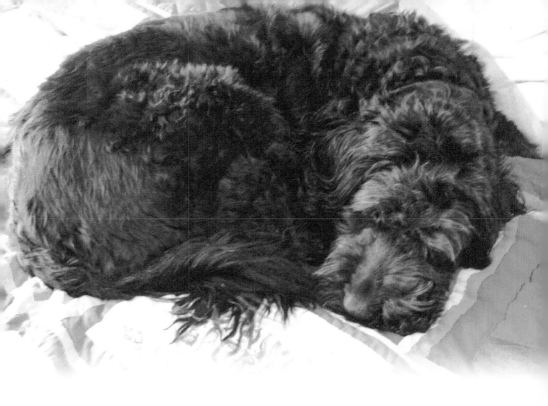

HER ROYAL BLACKNESS

Mountains for a month. When you come back to New Art all you have is a jungle of weeds with a puny tomato plant or two somewhere in the forest of weeds you call a garden. It doesn't even resemble a garden. You know, maybe God just decided to leave the world alone and see what would happen if He just let it go. Maybe He did this and it got all grown up with weeds and thorns and stickers and misery, where He doesn't even recognize it any more, and it's gotten to the point where it needs a good mowing and cleaning. This could certainly account for all the misery I see you watching on TV."

"Well those are pretty incredible statements, Ellie May, Baby Dog. You are certainly not the first to wonder this. Those who believe this to be the case are referred to as deists. They believe God is perfect, that He created the earth, the things on the earth, then the animals, and finally, man. They think that then He just left it all alone, that He has nothing at all to do with what He created and has no need to be worshiped, praised, adored, or even thanked for the creation. The so-called Fundamentalists argue against this. Back in the eighteenth century, that era referred to as 'The Age of Reason,' Benjamin Franklin

wrote a paper in attempts to refute the concept of deism. As he wrote it he became more and more convinced that the deists were correct, and then he became one himself."

"So what do you think, Worrell?"

"Well, Ellie, let me put it this way. I do not consider myself a deist, but I have certainly considered the question. When you ask me if I believe in deism I might best answer your question by just telling you to look at the garden that you mentioned. Look at my lawn. Look at my stacks and stacks and stacks of manuscripts and journals. Look at the 500 or more songs in my computer and the half-dozen books on the hard drive. Look at the papers, writings, and books in drawers and in the file cabinets, stored there before I obtained a computer. Look at the hundreds of cassette recordings and the stacks of CD recordings I labored over. Look at my inventions. Look at my abandoned relationships. Look at the thousands of photographs that for whatever reasons I took, and that have now been twenty-five years and even fifty years in file drawers. For that matter, look down the road of all my many good intentions. I have created a lot of things that I have simply left alone and abandoned.

"Look at the thousands of things I have made and written and now just seem to leave alone. I am not certain that I have abandoned them because I wistfully think that someday I will get back to them, like *The Snake Story Book,* the book named *Windmills,* and my long ago abandoned humorous book on evolution. In my heart I know that I will never get back to them because I am so busy creating new projects. I have left piles and piles of cold, rusting dreams, just walked away from them. So on the deism thing I can only speak an answer for myself, and I cannot answer for anyone else, certainly not for God. There is certainly nothing I know of that indicated God is as neglectful of projects as I am. I certainly hope He is not, and I pray that deism is not a fact. Wouldn't that be ironic, praying to a deistic God if deism is a fact?

"It seems that religion has always spawned fear. Always it seems the prophets and gurus (mostly and most likely self-appointed) have generated fear in the minds of the masses. This fear has been the underlying cause of many wars. In ancient times they were more local and not so pandemic as they are in modern times. The New World

had not been discovered. Civilizations were compacted into relatively smaller spaces, giving people greater opportunities to engage in more localized territorial conflicts. Of course, there were not as many people then as there are now and they did not have the high-powered weapons we have today. Mostly they just clubbed and bludgeoned each other to death until they invented swords, spears, and later, bows and arrows. Eventually they invented and developed firearms and weapons of mass destruction.

"Back in those ancient days there were more localized territorial wars: wars between adjoining states or countries. Those wars were fought because of greed for territory and greed for resources. Some might have been fought over women: over male lust for sexual pleasure. Wars were also fought because of religion, and they are still fought for these reasons. More and more modern means of transportation and more effective weaponry caused wars to spread across continents until in this age there are ongoing global religious wars and energy wars. Those conflicts are exacerbated by newspapers, radio, and television, plus the Internet, of course. Religion burned so-called witches at the stake in Europe and in early Colonial America. Religion ignited the Crusades, as they were called. Cross campaigns, or, wars for the cross. More irony, as much irony as the cry, "fight for peace." Religion created Black Friday. I am speaking of Friday, October 13, 1307, not the Friday when Wall Street crashed, and not the Friday after Thanksgiving Day. Black Friday was the day King Philip IV of France and Pope Clement V conspired to assassinate hundreds of the members of the Knights Templar. The king did it for money and prestige. Pope Clement participated because he regarded the Templars as heretics. Religion crucified Jesus. Ironically, religion crucified Jesus because he practiced spirituality rather than religion and religious tradition.

"Consider the life of Jesus and His teachings and you will know spirituality. Consider the life of Mohammed and his philosophy and you will know religion, along with hatred, and intolerance. Consider Buddhism and you will know spirituality. Consider what is mislabeled as Fundamental Christianity and again you will know religion, intolerance, hatred of sin, an infestation of guilt, and a sense of self worthlessness. This is because many of the so-called Fundamentalists are not fundamental at all. They are completely modern. They just

give lip service to fundamentalism. Some have electric lights and air conditioners in their church houses but no musical instruments. They say musical instruments are not in the New Testament, so they do not use them. I do not know where in the New Testament they found the lights and air conditioners – or the hymn books, the indoor plumbing, the pews, radio and TV broadcast devises, or even the church buildings. Such illogical reasoning reeks with religion and seems void of spirituality. Consider the *modus operandi* of almost every so-called preacher of notoriety and you can see religion in action.

"Religion is of laws and regulations, and a 'Thou Shalt Not' philosophy. Spirituality is of love, compassion, and benevolent action: a philosophy of what beings *should* do rather than what they *should not* do.

"This is how it seems to me, Ellie. Religion blasphemes the spiritual teachings of Jesus, or at least it tends to do so, while spirituality echoes what Jesus was teaching. This is true for other spiritual leaders' teachings also, and it is a fact that wars are yet generated by both leaders' religion and for the love of power, territory, and nowadays, oil."

Ellie May went over to the couch, curled up, and showed me the whites of her beautiful doggie eyes. "I am *so* glad I am a dog," she said. "I'm just gonna close my eyes and think about some rabbits and deer for a while. Boy! You sure know how to digress, Worrell!"

⸺

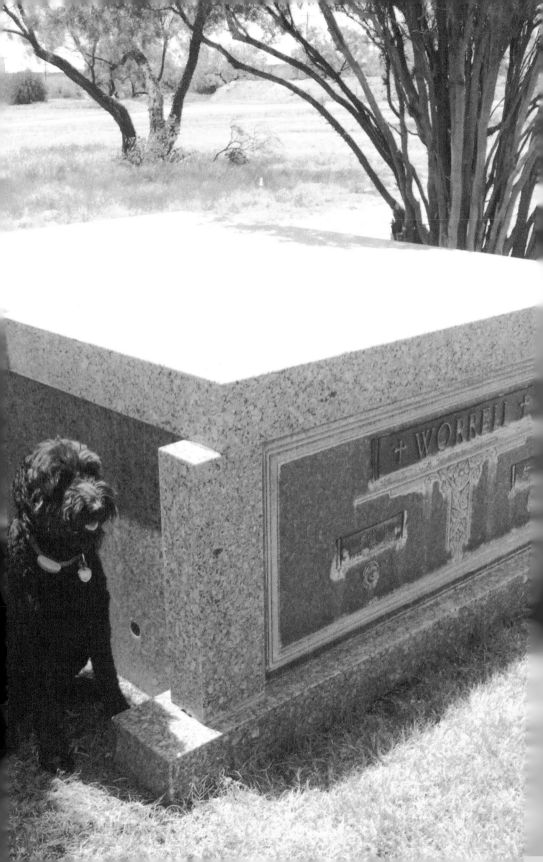

VII.
The God
I Know

E *llie did not intend* to offend me by telling me how much I digress. It is true, I do. I just can't help it. There are so many thoughts to share. This truth may embarrass me at times but it never offends me. Digression is just a part of my nature. I have no desire to be drastically laconic and I have no desire to be so stuffy that I seldom or never laugh. I actually laugh a lot. I even laugh at my own idiosyncrasies. Sometimes I even laugh at my gross stupidity. Sometimes the latter angers me. Sometimes I feel overwhelmed and inundated by both.

As Ellie curled up on the bed and slept I drifted off into reverie,

recalling my days as professor of art at Houston Baptist University, and remembering one particular day when I was there alone in the pottery/sculpture lab. I was busy creating art. I was wedging a big hunk of clay.

I remember the day and the experience so well. As long as I have consciousness I will never forget it. It was the day I was "saved," as some call it. It was the day I was "born again," as I term it. It was such a vivid and exhilarating happening that I recorded it by inscribing it on a slab of clay. This I carefully placed upon a shelf and allowed to dry for many days. Likely I dried it for a month or longer, being careful to let all of the free water leave that slab of clay so that it would not explode from escaping vapors as I fired it in a kiln, ever so slowly. That was in March of 1985. I successfully fired the piece and it has been hanging on my wall in Medium Cotton since that time. (Medium Cotton was the first structure erected at New Art. That was in 1983.) More precisely, the day I created the clay slab was March 5, 1985 at 1:26 p.m. I am referring to the day I met God, a Spirit quite different from what various personalities had tried to tell me about. As stated, I have also referred to it as the day I was born again. A minister friend admonished me not to use that phrase. I think he considered the term "born again" as low-classed: as what used to be referred to as "Holy Rollerish*," and resembling practices or statements attributed to *glossolalia* groups, and what he considered to be somewhat "uncultured" fundamentalists. I still refer to it as "born again," because it was a rebirth. It was a spiritual rebirth. Additionally I consider his judgments out of line with scripture, even though I do not take every Bible scripture literally. And speaking of that, I think there is a lot of evidence that very few others do, either.

* *"Holy Rollers" is a politically inappropriate term used by denominations that considered themselves to be above sublime spiritual ecstasy, and far too sophisticated to enter into spiritual trances and rolling on the floor, speaking in unknown tongues.*

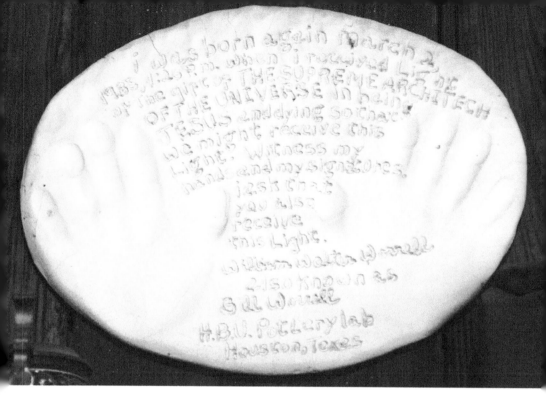

THE CLAY SLAB

I considered the HBU pottery/sculpture lab to have been an unusual place for a man to meet his Maker because of the particular location, and because it is unlikely that one might meet God in any of most religious or denominational spaces. Most of these remind me of a scene from a movie named "Sounder." In this movie Taj Mahal laughingly told another black person not to worry or feel bad about being evicted from a white church. He said that God had been trying to get into that church for many years without success. I had a similar attitude about certain areas of that university campus: that place where I was professor of art. I was a beer-drinker and a two-stepper on a Southern Baptist university campus! Even so the administration treated me with both respect and admiration. At least most of them did. In the two or three incidences when students filed grievances against me the administration treated all of us in a fair and impartial manner. I likewise attempted to be fair to the complaining students. I was willing to change my opinion and at the same time I was determined to hold to my integrity. I did not lose one of those contests. Perhaps no one lost

because we all had things to learn and thus something to gain.

My six years at that place were filled with a lot of experiences: a lot, and all sorts of them. There were meaningful experiences and some that were not, if an experience can be without meaning. Meeting some wonderful and hopefully life-long friends was among the meaningful ones. Faculty meetings were at least a hundred other experiences! More on that later: much more. One of the most humorous of all those happenings at Houston Baptist University involved a conversation I had with Dr. Riley, the chairman of the Christianity Department.

Back in those times Dr. Bill Hinton was the president of HBU. He was a very keen businessman. He was responsible for the founding of that university and in the process the institution acquired vast amounts of acreage just off one of Houston's interstate highways. This was in the Sharpstown area and property there became worth about $100 a square foot on the then Houston real estate market. There are 43,560 square feet in an acre. Several acres were sold to the Howard Johnson Motel Corporation, and one of its chain facilities was erected upon this tract of land. In the sales contract the lending institution for the Johnson chain inserted a short but very significant clause. It stated that in the event that particular Howard Johnson Motel folded the university would assume responsibility for operating the establishment. If HBU failed to do this then the property would be repossessed and owned by the lending institution. Now remember 43,560 times $100, times many. Ah, but the old handwriting was on the wall for that particular Howard Johnson facility; and it did fold. Since HBU did not want to lose $4,356,000 times however many acres were involved it assumed operation of the establishment.

So Dr. Riley and I were drinking coffee one morning in the Student Center, talking about golf, about academics, and about Christianity. "Riley, let me ask you a question." And I asked him how it was that Houston Baptist University was operating a bar, and especially operating a bar on the HBU campus. Keep in mind that clubs and bars are almost a standard part of many hotel and motel chains. I was being a sly devil's advocate. At least I thought I was being sly. Maybe I was just being a devil more than I was being the devil's advocate.

"You don't understand, he replied," and then he related

information about the loan contract and how the university would otherwise lose that property. He was referring to the equation above: (43,560) x ($100) x (many).

"Wait a minute, Riley, let me ask you a question ..." and I asked the same question again. He gave me the same answer. I told him that it reminded me of the man who propositioned a woman to go to bed with him for $10,000. She said she would. Then he asked her if she would do it for $100. She replied, "What do you think I am?" To that he responded, "We have already established that. We are just arguing about the price."

I had the best job an art teacher could ever have, teaching at Houston Baptist University. I just did not care to abide in Houston. In the six years I taught there I probably did not spend more than twelve weekends in that city. I remember spending only one weekend on campus when I was not required to be there by some collegiate function, such as a faculty art show, a student art show, or commencement exercises. That was the weekend when I created the clay slab. Most of my classes met in the sculpture/pottery barn, as it was called. It was adjacent to the maintenance department and far over on the west end of the campus. It was remote and it was rather isolated. It was actually a part of the maintenance building. There was usually not much going on in the maintenance part of the maintenance building, which was something that could be observed over most of the campus.

Unlike every other male teacher on this campus I did not wear fine clothes. Most other professors wore suits, or at least wore starched and pressed shirts and neckties. I wore jeans, boots, and often times a tank top. These were usually covered with dried clay, giving my attire an appearance a bit like that of someone having dry skin. The clay that I regularly got over most of my attire would dry, shrink, turn into flakes, and fall off.

They were actually very clean, my clothes. They just appeared to be dirty. Clay is quite clean and quite wonderful. Why else would God have constructed man from this substance, from the dust of the earth?

Jenny Billings was one of my favorite art students. She was bright, cute, and the daughter of Dr. Ed Billings, athletic director at HBU. The pottery barn was distantly separated from the administration

building and the general classroom areas, and was located behind
the gymnasiums. I made frequent trips daily across campus by foot.
I purchased a pedometer so I could determine just how far a week I
walked as I engaged in my daily activities at the school. My campus
treks averaged 27 miles every three and one-half days. Frequently I
would pass Dr. Billings as I rounded the PE Building and we would
always exchange greetings. When Jenny introduced me to him at the
student art show – and I was then in what most would regard as "regular
clothes" – he was shocked to learn I was a faculty member. He thought
I was a member of the maintenance crew because I usually looked a bit
grungy and the maintenance personnel and I dressed in similar fashions.

It is hard for some to imagine the conservatism of various
individuals who might happen to have been brought up in the Southern
Baptist tradition. In a class I was teaching labeled "Creativity" I read a
passage from J.D. Salinger's famous book, *The Catcher in the Rye*. It was
the part where Salinger wrote about cars and horses.

"Take most people. They're nuts about cars. Not me. I'd rather
have a goddamn horse. A horse is at least human, for Christ's sake."

Thus I was summoned into the office of Dr. Donald Looser,
the vice president. This was because some student reported to someone
in the administration that I was using profanity in class. Looser was
obliged to call me in, and he was also a bit embarrassed for doing so.
Don Looser was a fine vice president, and we were casual friends. I sat
before him, clay on my arms, clay on my boots, clay on my jeans, and
clay on my shirt. He smiled at me and said, "Bill – *ahem, ahem* – you
are an – uh, you are an *earthy* person. A university like this can't have
too many earthy people." We both laughed and then I explained the
situation to him and that was that. He shook his head and chuckled as
he remembered Salinger's words.

Suddenly the trespassing alarm went off! I was startled out of
my reverie. It was Ellie's barking alarm. She was having a conniption
of some sorts. Then I heard voices and the banging of a canoe on the
rocks. I grabbed a cup of steaming Ohori's coffee and headed for the
River. Two men were wading the rapids and hopping around on the
granite rocks. A canoe was beached nearby. It was obvious the men were
making an assessment of the rapids and how to negotiate them. I was

torn between watching their odyssey and running back to the house
to get my video camera so I could record what I was certain would be
a humorous event. I have seen many a comical happening executed by
people in canoes and kayaks as they attempted to run the rapids in front
of my studio. This turned out to be nothing spectacular because they
were more astute than some. When I saw them line the craft down the
south bank in water barely deep enough for it to float, I just walked back
to the house to resume my reverie. I flashed back to the days when I
left Odessa, when I was wondering if I had made a proper decision in
leaving there and going to Houston.

When I signed my contract with HBU it was agreed I would
not have night classes and would have no classes on Fridays. The
administration changed the day off to Mondays and that suited me
just as well. This allowed me to travel back to New Art and spend long
weekends.

One of the university deans, Dr. Jerry Ford, wanted to learn to
draw so that he could write and illustrate children's books, so he signed
up for my drawing class. He was a cheerful and dedicated student, and
he performed well. In fact, he had so much fun in my drawing class
that he decided every student that entered HBU should take a class
under me. There was only one way for this to be negotiated, and that
was to have me teach a required class for all entering students. Dr.
Ford scheduled me to teach a team-taught core class. I was outraged.
The class not only met at night, but on Monday nights, which would
absolutely mess up my long weekends. It was not an art class and I had
been hired to teach art, not "Violence in American Society!" (That was
the title of that particular quarter's core class.) At the first session I told
the 200 or so students in the auditorium where we assembled that I was
just like them, which meant that I was there due to legislation. They
were required to take that course and I was required to teach it. I told
them I did not want to spend Monday nights in that auditorium any
more than they did, but since my participation had been mandated I was
determined to make the most of it, make it as pleasurable as possible,
and to try to create a good experience for everyone, despite the situation
and the subject.

Alas, one of the vice president's daughter-in-laws was in the

class. This particular vice president was very red necked and pious, and was the business manager for the university. His sweet little daughter-in-law told him I said I did not want to be in that class. She misquoted me because I had stated that I did not want to *teach* that class and be in that space on Monday evenings. Although she misquoted me she nevertheless unwittingly spoke the truth, because I did not want to be in it, either. Alas, I was summoned to the office of vice president Dr. Troy Womack. There I was, in jeans, tank top, and boots, all of which were covered with clay. I squared off with the bigot. I told him in no uncertain terms that he had no reference to the context or the situation in that classroom. I knew for certain that even then, he would not have gotten it. I stated that I was attempting to establish rapport with the students (and I did) and thus had them "eating out of my hand," so to speak. I furthermore told him that he was transgressing upon my academic freedom. He stated that he did not know what that meant.

"I don't know anything about teaching," he said, "But I don't think you should have said it." What a laconic statement that was! What someone considers to be insubordination usually has repercussions. The following day an order was issued. I was not to wear tank tops on the HBU campus. Additionally (and parenthetically) he was correct when he made that profoundly accurate statement. Very truly he did *not* know anything about teaching!

That was sometime about 1988, the year our mother was dying. I was distressed. I was scared. I was grieving. I drove almost every weekend to either Big Spring, Texas or to Midland, Texas to see her. This was an 800 to 900 mile round trip and made the Monday night core classes more difficult and even more of an annoyance. Jim Busby, chairman of the art department, covered for me on some occasions. To their credit, and for which they have my undying gratitude, the higher ups in the administrative chain also cut me great amounts of slack.

Mother was dying, and both Mother and Daddy always had a fear of death. They had a fear of interment. Neither of them could stand the thought of forever being buried in the cold, dark ground. It was due to this, along with the semi-annual trips to the old folk members of our family in Dallas and Waxahachie, and the constant admonition, "This may be the very last time," that I also came to have such a fear

and dread of death. I despised death and all of the sociological customs that surround and go along with it. Impending death was everywhere. When I was a child it came from Mother, warning us that Daddy might die if we were not responsible children. It came from Daddy, warning us that Mother might die if we were not industrious and helpful around the house. Our aunts and uncles were elderly, thus there were frequent discussions and vacillations about driving to East Texas to visit them because, as they so often stated, it might be the "very last time."

Death was all around us. One night Granddad (as we referred to Mother's old step-bastard father) died. One day the neighbor's dog killed Peeper, our pet duck. Another time Uncle Floyd, my dad's first cousin died. One of my best friend's dad died one night while we were camping at the lake, after we had stolen a load of watermelons. Guilt! Guilt! *Post hoc, ergo propter hoc!* Another of my best friend's dad died. Later that year the friend died. A few weeks later his grandmother died. It did not take too much longer until the town died. These deaths nearly always coincided with my failure to pray the night before for those who died. The town was Colorado City, Texas. The nose of the chamber of commerce grew long, and even longer when it claimed the municipality had over 5,000 citizens. C. City is not the most desiccated burg in Texas, but it is desiccated beyond the belief of some who were residents during its "golden days."

I wonder if death might be harder in a small town than in a large city. Cities have distractions and entertainment. Small towns have clusters of churches, too many preachers, and not so many distractions, although the ecclesiastical entities often provide rich and humorous entertainment.

Life in a small town is a lot different, I think, than life in some large city. Everyone seems to know something about everybody's business. Preachers preach, teachers teach, and practically everyone gossips. Death might come harder in small towns than in large cities, and although it might just seem to be the case, death appears to be accompanied by more austere customs in small towns than in large cities. As I was recently pondering this I penned these lyrics:

I WISH THAT DYING WEREN'T
SO DAMN MUCH TROUBLE

I wish that dying weren't so damn much trouble
Just lay me down, close my eyes, let me go to sleep
Let me dream sweet dreams of forever and forever
Where there is no trouble and everything is peace

When people die there's so damned much trouble
With things they've left behind and those they've left to mourn
Why can't it just be simple without any hassle?
And we return to how it was before we were born?

Dying sure is lots of trouble
Usually racked with pain
Mostly filled with sorrow
And never fully been explained

Some regard it as a blessing
Some regard it as a curse
For me I often wonder if
It's just another kind of birth

I wish that dying wouldn't trouble anyone
With all the money and arrangements just to bury my bones
With no pain with no sadness for anybody
Just lay me down, close my eyes, and let me go at my home

I wish that dying weren't so damn much trouble
Just lay me down, close my eyes, go to sleep
Let me dream sweet dreams of forever and forever
Where there is no trouble and everything is peace

Dying seems so much harder
On those left behind
While the dead rest in peace
The living are left with tormented minds

They ought to make it easy
On everyone concerned
Devise a simple way

Unto the dust to return

I wish that dying weren't so much damn much trouble
Just lay me down close my eyes and go to sleep
Dying is so much trouble for everyone else
While the dying one simply drifts into eternal keep

Some people are sad
Some people are glad
While some people cry
And some people mourn and weep

Put my guitar in my hand
And a mouth harp or two
One mouth harp in b flat
And an e that bends the blues

I will make my way to glory
Join the angels and their band
Watch what's going on below
From God's Eternal, Promised Land

Mother's death came while I was professor of art at Houston Baptist University. She died on a Sunday evening. As was my custom, I was at my New Art place on the Llano River and was not scheduled to be back to teach the core class until the following Monday evening.

It was March 20, 1988. I had just spoken with my brother's wife and it seemed Mother was doing as well as could be expected. Shortly afterward I received a call from a family friend advising me to get to Stanton, Texas promptly. (My brother was a physician at the Stanton hospital.) "You had better leave now," she told me. I left my New Art Studio in haste about 6:30 p.m. and drove as fast as I dared. In those days the speed limit was 55 miles per hour, thanks to Richard Milhous Nixon. I was not worried about patrolmen. It was the white-tailed deer that worried me. If a driver hits a deer and is driving a van, as I was, such a happening can leave him stranded. If one is driving a car that collides with a deer the event can leave the driver dead, and in this part of the country the deer are incredibly numerous. I hit four of them in a five-year period. That last hit did leave me stranded, and of all times, I

did not need or want that now!

It is 210 miles to Stanton, Texas from my Llano River home. I was there by 10:30 p.m. I was juiced up on caffeine and had the butterflies pretty bad as I entered that small town hospital. I should have stopped and called from Brady. That would have made it a lot easier on everybody else because Mother had died shortly after I left New Art, and they could have taken her back to Sweetwater without waiting three and one half hours on my arrival. Calling me while I was en route was not an option for them because there were few, if any cellular telephones in those days.

It is a bit of a long loop from New Art to Stanton to Sweetwater. It was black, cold, lonely, and the drive was full of questioning, wondering, and dread. It was that type of troubled ride. It was a haunted ride. Mother had died, and thus ended the earthly and mortal life of a remarkable lady. She was truly a lady, and she was also a knockout beauty. Her physical appearance would rival any movie starlet who ever has been, and part of her beauty was her total and innocent unawareness of it.

She was born in Ysleta, Texas and was on her own by age 13, likely due to her dislike of her stepfather (the one I referred to earlier

as the "bastard stepfather"). That is pretty young for a girl. That is pretty young for anyone to be on his or her own, except for peoples in prehistoric times. She was kind and loving and caring and a financial genius. That lady could quadruple investments within five years – without engaging in anything dishonest or even questionable. She was just so keen and sharp. She is daily strength for me now.

As mentioned, Mother had a fear of death, and of being buried. So did Daddy. "*Sheol,*" the

ancient Jews called the grave. It was the place of darkness. When Daddy died on April 4, 1977 we interred his body in a temporary vault. I do not intend to be crude, but it was a sort of corpse apartment house, and had something like a 25 to 35 corpse occupancy capacity. It was not insulated, and that worried Mother sorely because she could not bear to think of Daddy's body decomposing, something that West Texas summer heat would accelerate. This multi-corpse crypt was above ground and also multi level. This created another fear for Mother, and that was the possibility of a tornado demolishing the corpse apartment house and scattering Daddy's remains to the four corners of the earth. So a few months and $12,500 later there arrived at the Trinity Cemetery, just south of Big Spring, Texas on Highway 87, a multi-ton, rose granite crypt that was quarried in the Hill Country at either Marble Falls or Llano, Texas.

The crypt was set in place with a crane and it then awaited the casket containing Daddy's body. It was "the transfer," as Mother called it, and she fretted and fretted about when we would execute it. She also fretted and fretted about how hot the desert around Big Spring, Texas could get in the summers and wanted the vault insulated so that Daddy's body would not deteriorate in the heat that locals create legends and lore about.

As you might imagine, insulating a crypt in today's world is unheard of. If you do not believe so just try looking in the yellow pages for "crypt insulators." I still remember the inflection in the man's voice at Odessa Insulation Company when I made the call.

"A what?"

"A crypt," I said, very simply and casually, just as if that would

be a quite common inquiry.

No, he had no experience.

I was left to my own ingenuity. You do realize, don't you, that I had to measure the casket and measure the crypt before I could order the pieces of polyurethane? Well, I did measure them and I did order the polyurethane. When I picked it up at Odessa Insulation Mr. What's His Name had a strange look upon his countenance: a sort of smile with a wrinkled brow.

No, he did not know what the best thing was that would stick polyurethane to the walls and ceiling of a granite crypt. You do realize, don't you, that we needed an adhesive compound, a sticker-oner that would last until Armageddon? One that would last until the Resurrection. I was again left to my own resources and acquired some brand of black goo that claimed to be permanent, although it made no reference to the "last days," to Armageddon, the Second Coming, or to the Resurrection.

Sometime just before Christmas of 1988, Dick Richardson, my sister's then husband and I insulated the crypt. It was a double crypt and we insulated the top and both sides of it, for it was a "his and hers" crypt. It was almost dark and so hellaciously cold that our numb fingers would not work the zippers on our jeans. We almost drowned because a job like that job takes more than just a couple of beers.

It was something! It was a very messy job, the smearing of that until Armageddon black goo on those sheets of urethane. We were lying on our backs using our hands and feet to hold and press that insulation on the ceiling of the vault – and doing so in that dim and darkening Texas blue norther. Lying on my back those relatively few minutes inside that vault gave me a completely new perspective on the length of eternity.

Then, within a day or two it was as warm as spring. That's the way it is in West Texas. It was a beautiful day and we made the "transfer." The family was there for the event. My sister later expressed to me her apprehensions. She had mental images about the casket being dropped and Daddy's remains spilling out on the ground before us, which, of course, did not happen.

They say that truth is stranger than fiction, and it was hard for

me to imagine, months later, as I drove down Highway 153 at 4:08 p.m., on Tuesday, September 19, 1989, headed for my sister's house near Sweetwater, Texas and penning this account as I so drove, that any writer of fiction could conjure up any novelette stranger than, or even equally as strange as what I have just written.

Ah, but the story is not over! On March 23, 1988, at the First Methodist Church of Sweetwater, Texas, the pastor read the obituary that my sister had written. It was our Mother's obituary. My aunt, until her death at age 101, and my cousin (still to this day, I think) had hurt feelings because they were not mentioned as survivors. (Just more of death being so damned much trouble!) After the church services were over we caravanned to the Trinity Cemetery south of Big Spring. Both the church and the cemetery services were beautiful, if such events can be beautiful, but wouldn't you know, there is always a hitch of some sort. Nearly always, there is some hitch.

Mother's side of the vault was not open. We had a casket to place in it and the door was not open. It was locked! It had not been opened since the "transfer" in 1977. This was a slight oversight on the part of the cemetery operator, you might say, and he made attempts to shoo the congregation away because he was embarrassed by his poor performance of not having the crypt ready and also at not having the key to the crypt. He wanted us to all leave and just entrust Mother's interment to him, or more likely to his crew.

No way! I was not leaving until that casket was at rest in the crypt and the crypt door was once again locked. But since the cemetery operator had forgotten the key he had to leave and go back seven miles to Big Spring to get it, and once he was there he had difficulty finding it. When he at last did return he had difficulty unlocking the lock that had not been used for over ten years. That one-time-used lock was set in a slab of granite that was the door of the crypt.

After he finally did get the lock open the door creaked like the "Inner Sanctum," and when he opened it there were cobwebs everywhere. Naturally there were spiders, too. Spiders were everywhere. It was like some Halloween set! I cannot describe the cemetery operator's embarrassment. What he wanted most of all was to get us all out of there, and with his first attempts to shoo us away, I faced the

congregation and said: "Folks, the door is locked and we have to get the key. It will be a while. Leave if you wish, but I am staying. I am staying until my Mother is in this tomb and the door is locked."

I probably do not have to tell you how much the cemetery operator did not enjoy that, but it sure relaxed the crowd. I also probably do not have to tell you that it still isn't the end of the story. The black, gooey, until the Last Days, Armageddon, the Second Coming, and the Resurrection insulations-sticker-upper did not last until Armageddon! It did not last until the Second Coming or until the Resurrection Day! So once again, only this time in the presence of a crowd of fifty or more people, there I was, crawling into a crypt to stick up insulation – just another experience in the length of eternity. This time I was sticking it up with no stickum-upper, either. Crumbly urethane dust fell into my eyes and all over what was the closest thing to a suit that I owned! I got it pushed up, crawled out of the crypt, and the pallbearers bought forth the casket. However, there are all manners of little elements related to physics that apply to placing a casket in a rose granite crypt, especially an insulated crypt, one that was not cut and designed to accommodate the extra dimensions of insulation. There are factors like leverage, and factors like two items of matter occupying the same space at the same time. The pallbearers cannot walk inside a crypt like this crypt because it is less than four feet in height, so the casket has to be pushed into the chamber from the outside and not carried in. It would not go into the chamber! It lacked a few, bare inches because insulation was occupying the space where the casket needed to be. The cemetery operator wanted to pull out the insulation. I would not allow it. He was getting increasingly nervous and made more attempts to shoo away the crowd.

Now, it was not only the research in crypt insulation, the bizarre odyssey itself, that cold, howling December Texas blue norther, and all those things that came to my mind. What mostly came to my mind was Mother's wish, and of course the thought of her body being slammed around inside that casket. Mother had a certain way of frowning when something was not pleasing her and I could visualize her unhappy countenance inside the casket. She would not be frowning at me, but she would certainly be frowning at the incompetence of the cemetery operator and probably thinking, "Oh, for goodness sake!" The cemetery operator! What a jerk he was. When his attempts to shoo us away again

did not work he again suggested that we remove the insulation. He just did not know how adamant Mother was about that insulation, and it was not he that had gone to the numbing cold trouble to install it on that miserable and bitter long ago winter day.

So for the third time he again attempted to shoo us off. I informed him that the insulation would remain and that it would be intact when Mother's casket was safely inside the crypt. The pallbearers pulled the casket out, and then shoved it in again with more force, two times, three times. It is amazing under such circumstances how loud a thud can be. Out again, in again, out again, in again. *Thud! Thud! Thud!* Each thud grew louder than the previous thud.

The crowd was a bit stunned as I addressed those attendees again. "You'all don't worry. We're having a bit of difficulty. Look at it this way: not everyone gets the opportunity to be buried three times on the same day. Leave if you wish but I am staying until this casket is locked in this vault."

As I recall, not one person left. The casket was taken the rest of the way out, I crawled in again and adjusted the polyurethane and finally – finally – Mother's body was placed at rest beside Daddy in that double, rose granite, insulated crypt.

Now, if any of you readers ever have need to insulate a crypt feel free to call Ellie or me. I think we might have some ideas that will save you a considerable bit of hassle.

Mother and Daddy were sweethearts until the day Daddy died. She never got over his death. They lie side by side in their eternal field of dreams, and I know that if the dead can move and exchange thoughts then Daddy reached over to her side and gently placed her hand in his, saying, "I love you, Sweetheart."

"That's a nice story," said Ellie.

"Yes, Ellie, it is, and it is a true story, too."

As I proofed this on November 24, 2013 – a quarter of a century after the event, I was crying.

VIII.
The Birth of the Shaman Bronzes

Ellie sleeps a lot. She loves to sleep under the Expedition. This worries me considerably because I do not want to start an engine and back up if she is under a vehicle. I take great care to be aware of where she is when I start up. Also, she has developed a reflex to respond quickly to the sounds of the engines starting. She can be fast asleep in the studio and when I start one of the vehicles she quickly runs out and wags her beautiful tail, telling me, "Hey, Worrell, let's hurry up and go!" She absolutely does not want me to leave her and drive away, and she really enjoys riding shotgun.

I have an obsessive compulsion for activity. I am seldom bored and I seem to always need to be doing something constructive. I need to be creating something. I checked on Ellie's whereabouts, played a bit of Air Dog with her, went into the studio, and then began working some

wax. As I did so my reveries continued.

I had a sculpture student named Vicki. She just couldn't seem to come up with any ideas for making a wax pattern. She would just stare at the material, and while doing so she seemed to be paralyzed, as if she were in some state of catatonia. "Look," I told her one day, taking the wax from her frozen hands, "just start mashing on it, like this! Something will happen!" And I began mashing, twisting, and shaping that soft, beautiful, wonderful, responsive substance with my hands.

Something did happen! What happened was a shaman! In my hands and before my very eyes, as I demonstrated to Vicki, the wax was transformed into my first sculpted shaman. I was in orbit. I have always learned more from my students than I have from anyone else, and I have learned more from them than they could ever have learned from me. After hundreds of bronze shamans later I wonder what happened to Vicki. Like many of the countless numbers of students I taught, Vicki will likely not ever know the contribution she made to me, and to my art career. One day pretty little Vicki was just suddenly gone. I have not seen her or heard from her since. But the shaman was magic. Since my float trip down the Lower Pecos River I had been painting images of cave art for several years, and I had given lots of thought to sculpting forms inspired by them, but until that day I had just not gotten around to it. Then, suddenly, there was one. There was a three-dimensional object made of wax inspired by prehistoric images painted upon the rock walls of the Lower Pecos River. This wax form would soon become bronze. After it did there were more and more and more of them. I worked on these images almost constantly. It was a very involved process. I sculpted them in wax, invested them, burned the wax out of the investments, melted bronze, poured the bronze into the burned-out investment molds, broke the bronze out from the investments, chased them, applied chemicals to create desired patinas, mounted them on stones, and collected them. I had quite a large collection when I got my big break in the magical and quaint village of Santa Fe, New Mexico, "The Land of Enchantment."

FOR THOSE WHO DO NOT BELIEVE IN EVOLUTION, TAKE A LOOK AT A MORE RECENT BRONZE SHAMAN. (*MIRACLES*, 39.5" ABOVE STONE)

I worked hard. I spent sixteen to eighteen hours a day in that lab that we all called the pottery barn. Then one night, a few miles away, while I was sleeping at my apartment, someone burglarized my VW van. I discovered it the following morning and called the Houston police. An investigator came and took fingerprints. His name was Sergeant Smith. He was polite and thorough. In a kind and polite way he informed me of the chances of apprehending the thieves by showing me a printout of Houston car thefts. It was three legal-sized sheets of paper in small font, with three columns to the page. He informed me that the printout was for just the past seven days. I concluded there must be a thousand cars a week burglarized or stolen in Houston. I knew my goodies were gone. I changed my residence. I was burglarized again. This time the invader – or the invaders came into my abode while I was sleeping. The thieves, or the thief, took everything except my driver's license, which was considerably left lying upon the floor. They got my camera case, my camera, lenses, and a loaded, stainless steel 357 Ruger magnum revolver. They even got the film out of my freezer. I got out of the apartment and stayed with Jim Busby for the next two or three weeks, until school was out for the summer.

Three months later fall came and it was time to go back to Houston and to the pottery barn to begin classes. With a bit of my usual sadness at departing from New Art I left the Llano River and drove to the forth-largest city in the United States. I had no place to live. I looked at apartments and viewed the predators viewing me, just waiting until I moved in so they could burglarize me yet another time. This sounds as if I was paranoid, I know, but seeing so large a host of sleazy-looking and thuggish-looking men sitting around smoking and drinking in midday gave me cause for great caution. I was so uneasy that I drove back to the pottery/sculpture lab, worked for a while, and then spread my bedroll out in my Chevy van, out in the secluded courtyard behind the facility. There I slept. I did the same thing the following night. I did the same thing again and again, night after night. I went apartment hunting a few times, but every time I went looking I found myself going back to the parking space behind the pottery lab and sleeping in the Chevy van. It was a very secluded environment, and the campus had security guards that roamed and patrolled the property both day and night, so I felt safe and comfortable there. When the first blue norther

blew in I went inside and slept on the floor of the lab. I kept thinking I would find an apartment, but I just couldn't get around to breaking the momentum I had established, and I couldn't seem to abate the fears of once again engaging in the probability of being burglarized.

There was another factor. That was firing pottery. This is another of the many involved ceramics processes, especially when doing stoneware reduction firings. Some of these firings reach temperatures of 2,386 degrees Fahrenheit, and to execute these tasks I would oftentimes have to awaken three times during the night and drive to the university to check the cones. Cones are temperature indicators set inside the kiln and are viewed through peepholes. They are pieces of clay formulated to melt at precise temperatures. These bend when certain temperatures are reached inside the kiln. They indicate degrees of heat and thus make it known when it is time to perform certain tasks, such as reducing the amount of oxygen inside the kiln chamber in order to bring out rich colors in the clay bodies. Reduction firing also brings out the non-oxidized colors of elements in the glazes that have been applied to those clay bodies. If the kiln is not shut down at the appropriate time the over-fired result can be a heap of lava. Sleeping at the lab made executing these tasks much more convenient. I could set the alarm, get up, check and reduce the kiln, go back to bed – or floor, as it was – re-set the alarm, and continue the firings until it was time to turn the burners off and close all the dampers. Then I could really get some rest.

When I was sleeping in my van I would awaken about dawn, go to the security officers, get them to open the gymnastics gym for me, work out, shower, then walk over to the chancellor's office and drink coffee with colleges. After an hour or so of fraternizing I would return to the lab and sculpt until it was time to teach classes. I would resume sculpting when the students left and I would usually sculpt until after midnight. When the season's first blue norther whistled in I would drag a piece of 4-foot by 8-foot by 2-inch Styrofoam onto the center of the workroom, throw my bedroll on it, tune KILT in on the jam box, and go to sleep. This became a *modus operandi* for me and I began to wonder if I could do it for an entire school year. That was a nightly wonder for me until the end of the spring quarter, when I could return to New Art for the summer. I did it! I slept on the floor of the pottery/sculpture lab for an entire school year. Not only that, I did it for two years following, until

I took my leave of absence. For three years I slept on the floor of the pottery/sculpture lab! Never in my life had I gotten so much work done. It paid off big time, too, when I got my wonderful break in Santa Fe, thanks to James Busby – and after a few weeks I did get a piece of foam rubber to place on top of the Styrofoam block. After I resigned from HBU and came to New Art to live I created several sculptures from that block of foam. Those bronze editions of fifty are now scattered across the earth, resting upon the tables and desks of various collectors.

Classes were over for me about 3:00 p.m. on Fridays, the time when I would saddle up and drive to New Art, 265 miles to the northwest. There were times when I would stop in Austin and spend the entire weekend there, not driving the 100 remaining miles to New Art, but those times were not often. Jim Busby, the art department chairman once told me I was crazy. He said this because I was spending 40 hours a month in my vehicle. I acknowledged to him that I was crazy but the driving had nothing to do with that. "You live in Katy. It takes you one hour to drive to the university. Then you drive back in the evenings. That is two hours diving and you drive it five days each week: sometimes six or seven. Almost every day your wife has some "honey-do" for you and you drive back to Katy, do whatever chores you do to appease her, or deliver whatever it is she needs, and then you drive back to the school. That is four hours driving in one day! Even when you do not make the extra trips home you are driving 40 hours a month and you are looking at exhaust pipes, car bumpers, asphalt, signs scripted in Vietnamese, bricks, buildings, Houston smog, and general urban clutter. You are listening to horns honking and sirens wailing and all the other general messes of the city. I look at trees and fields of flowers and hills and creeks during my forty hours. I write stories and songs, and I think about the art I am going to create. I think you are the one who is crazy!"

During those years of the 1980s I would return on Tuesdays in time for my 1:20 p.m. class. It was over at 3:40 and then I would begin sculpting. I would usually take a supper break at sundown. An hour or so later I was back in the lab working. I was investing waxes in a plaster/sand mixture. That is to say I would encase the waxes in a mixture of sand, plaster of Paris and water. When the mixture set up, or hardened, I would place the investments in a kiln and burn the wax out. These investment molds were very heavy. Some would weigh 150 pounds or

more. The burnout would require 24 to 48 hours. After the burnout I would set them out in the courtyard and fill the hollow spaces left by the burned out wax with molten bronze. In this process the wax is gone. It is oxidized away. That is how the term, "lost wax casting" came to be. After the bronze cooled I would break away the plaster and clean the castings, using a hacksaw to cut away the sprues and feeders. This is a greatly abbreviated description of the process, called chasing, and I assure you that it was long and hard work. It was very hard, and in the Houston humidity and oftentimes under the dim courtyard lamps with a million mosquitoes buzzing around, it was grueling.

One Tuesday I left New Art about 5:30 a.m. and drove to Houston. I taught my class and afterward began working. By 2:00 a.m. on Wednesday morning I had three waxes invested and was placing them into the kiln. One was so heavy I thought there would be no way I could lift it into the oven. It probably weighed close to 200 pounds and I feared it would break the kiln shelf. But I did it, and after managing to do so I began talking with myself. "I am 53 years old! I can't keep doing this! I have got to find some help!" Then I ignited the burners on the kiln, went into the pottery lab, and fell into deep sleep upon the floor.

The following day I looked in the Yellow Pages for foundries. Therein I found a listing for Deep In The Heart Art Foundry at Bastrop, Texas. My custom was to pass through Bastrop two times a week: en route to New Art and then back to Houston. I called and made an appointment with Steven Logan, the foundry owner. A week or so later I brought him five small waxes. They were fat little shaman waxes with cores inside. Thanks to an idea inspired by John Queen, my sculpture teacher at Texas Tech University, I had developed a system of constructing cores and sculpting wax around them. For this I was using soft firebricks, often referred to as insulating firebricks. The bricks are not actually soft. The material is as hard as dense firebricks, but the firebrick clay is mixed with sawdust before the bricks are fired. This produces countless voids that become insulators. It also enabled me to crumble away desired parts of the bricks. Cores are refractory materials inside wax patterns that displace molten metal and enable one to cast bronzes hollow. Queen had planted the seed for building around plaster/ sand cores and I developed it further by using the bricks. I would saw these bricks into trapezoidal prisms, then take course rasps and file them

into the shapes I wanted. Ferrier rasps worked very well for this. I then dipped them into a pot of molten wax, let the wax cool, and then dipped them again. I repeated this process until I had a shell of wax around the brick core that was about an eighth to three-sixteenths of an inch thick. Then, with more wax I would sculpt arms, legs, heads, and whatever else I desired on this basic form. When a wax or clay sculpture is completed it is called a pattern. I would push a few small nails through the wax shell into the firebrick core, allowing the nails to stick out about a half an inch beyond the surface of the pattern and then stick a small bead of wax beside each nail. When the pattern was then encased in a mass of plaster/sand and the wax burned out, these pins would suspend the core inside the hollow cavity of the investment. This prevented the core from falling against the walls of the cavity or floating up and occluding the flowing bronze as it was filling the mold. By this means the bronze could be cast around the core, which was not removed. The core was benign and would cause no metal disease such as heavy oxidation or corrosion. I then removed the nails. This left small nail holes, and I hammered the small beads of bronze into the holes. It was simple and it worked beautifully.

When I described my method to Steve Logan he did not believe me. Most modern foundries now use a ceramic shell to invest waxes. This replaces the old plaster/sand method. A plaster investment that would weigh one hundred pounds can be replaced by a silica shell investment that might weigh ten or twelve pounds. The burnout requires a few minutes compared to twenty or more hours for the former. All I had wanted Steve to do was attach sprues to the patterns (Sprues are wax rods attached to a wax funnel through which the wax burns and flows out of the investment and the molten bronze flows into the resulting cavity), coat the patterns with ceramic shell, burn them out, and pour bronze into them. I would do the entire cleanup. The pieces were already cored, so he did not have to be involved with that process or any rubber mold making processes that would enable the pieces to be reproduced. Steve quoted a price of $125 per piece. These were unique items: one-of-a-kinds that were selling in Santa Fe for $285. The gallery took forty percent and I got sixty percent.

Elementary mathematics would prove there was little profit in my resulting forty-six dollars, plus I had to pay for shipping to the

galleries. I argued with Steve. He argued with me. We argued back
and forth. It was a friendly and jovial arguing. I finally told him to cast
the pieces and charge me based upon his experience and not what he
was presuming his experience would be. "Just cast them. I will pay you
whatever you ask. Treat me fairly and I will give you a lot of business."
Two weeks later I picked them up and he billed me $33.50 each. That
was some twenty-five years ago. We have given Deep In The Heart Art
Foundry millions of dollars of business, and have also brought to them
the business of many renowned sculptors. It was just a simple deal with
no written contract. We sealed it with nothing but a handshake. Both
of us kept our word. It was the best business deal I have ever made and
probably the best the foundry ever made, because I have brought them
such clients as Gene & Rebecca Tobey (Gene died in 1996), Josh Tobey,
Jim Eppler, Mark Harris, Warren Cullar, Jim Busby, Star York, Bob
Titley, and other successful bronze artists. The world would work quite
wonderfully if all people performed in this manner and would simply
keep their agreements.

The business deal with Steve at Deep in the Heart Art Foundry
was a major breakthrough. It enabled me to work in a much more
creative fashion because I could leave the technicalities of casting to
professional foundry personnel. I did not have to worry about fitting a
wax pattern into a particular space in order to invest it. I did not have to
worry about getting a massive investment into the kiln for a burnout. I
did not have to worry about casting pieces in separate investments and
then welding them back together and chastening them. The foundry can
do that process in a heartbeat with a heliarc welder. I could do it in an
hour or two with an ox/acetylene torch. I could also then create a piece
six feet or more tall – and I did. In fact, many of such size were sculpted
and cast, the largest being one named "The Maker of Peace." It is almost
twenty feet tall and stands over Seminole Canyon State Historic Park,
just above the Fate Bell Shelter.

Many are the stories I could tell about the bronze shamans
I have sculpted. In Boulder, Colorado at a one-man show, a woman
approached me and asked, "If that shaman could talk, what would he be
saying?"

For a moment I contemplated her question, then with complete

SHAMAN OF THE RIO GRANDE (77")

integrity I replied, "I am not sure, probably –" and then I began chanting a few phrases in an unknown tongue. This seemed to satisfy her.

It might have been at that show that the owner of the gallery balked at displaying a six-foot or seven-foot wall-hanging bronze shaman. It was a cruciform, of sorts. I told her I had driven some 1,100 miles to bring the piece to the gallery, and asked her why she did not want to display it.

She stuttered. "Well, uhm, ah, it is very Christ-like," she replied, "And we have many Jewish clients. We do not want to offend them."

I was bewildered. For one thing, I have at least a few Jewish genes and it did not begin to offend me. For another thing, I thought she was outlandishly prejudiced. Additionally, I had gone to a lot of trouble to create the piece and then transport it to Boulder, Colorado from New Art, Texas. After a bit of argument she agreed to hang it for a

short time and see what happened. The following week it was purchased and placed in the entranceway to a very prestigious home in Boulder. A Jewish couple purchased it.

Back in my pedagogical and professorial days, as can be imagined, I had all sorts of students. There were seven-foot basketball players who were only quasi-literate. I am not joking about that! There was a six-foot-seven inch tall basketball player who left a senior seminar course proposal on my office door. It read, *"I, Larry Holland, propose to do my senior seminar in plaster."* This was an arranged course and had no scheduled classroom sessions. There were students with learning disabilities who had IQs of less that 75. (And some of these were wonderful and beautiful people!) There were students with green teeth and the worst halitosis I have ever known. There were emotionally disturbed students. There were students that would cut class at the drop of a hat to go skiing in the Rockies and never say a word about why they missed class. Then, when they were truly sick they would come up to me and asked to be excused, coughing and sneezing flu viruses all over my person. They did this to prove that they were actually ill. They were! And then I was!

There were energetic, enthusiastic, and creative students. There were those with energy and enthusiasm who had very little creativity. There were students who loved me. There were those who hated me. There were students I loved and those I had difficulty being around. There were students who became teachers. There were students who became artists. There were students who now and then cross my path in these days, bringing joyful reunions. In all of my total teaching years – twelve at Odessa College, one as a doctoral fellow at UNT, and six at Houston Baptist University, I did, as previously mentioned, learn far more from all of them than any one of them ever learned from me. As Galileo Galilei said, "You can't teach anyone anything. You can only help someone learn it for himself."

This concept was fundamental with Dr. R.L. Moore, professor of mathematics at the University of Texas at Austin. Through my brother, who was one of his students, I learned this principle. I learned to regard my job as teacher to be defined as that of helping students discover problems. The student's job was to discover problems, and then

to solve those problems. My job was to assist with this process, and the more I could stay out of it the better it was for the student. Some students could not and cannot grasp this concept. Neither can some administrators, and therein lay the seeds for great contentions, a lot of strife, the loss of academic freedom, and a large gap for lobbyists and special interest groups to seep through. This was not so for me at HBU. The administrators gave me complete liberty to teach as I wanted to teach.

It has always been difficult for me to tell a story without digressing, just as Ellie has pointed out, and I do realize that I have been doing this during these pages. These side-stories serve a purpose. One purpose, and this is only one of the purposes, is to describe the climate at the place where I met God. Back in kindergarten I wondered who God was. By the time I was in high school I thought I had met God. While first in College I almost became an atheist due to a Methodist pastor in Ft. Collins, Colorado and I realized I did not have the foggiest idea who God was/is. Later, in Lubbock, Texas I thought for certain I had really met God. There, at Texas Tech, I was a varsity letterman on the fencing team. We fenced with sabers, epees, and foils. We drank. We told jokes. We chased women. We chased them but did not catch them. Drugs were unknown to us but we did most of the crazy things that rah-rah hormone-saturated college boys do.

After some two years as a member of the fencing team I began running with the wrong crowd. That was over at the Baptist Student Union. There I became absolutely certain I had met God. I got "saved." I "surrendered to the ministry," as it was termed. I quit the fencing team and all those horrible, sinful, Hell-bound practices of playing cards, telling dirty jokes, drinking beer, and chasing women. I became a licensed Southern Baptist Minister and later an ordained one. I became a Southern Baptist Church pastor. I was a pastor for four years, and that four years gave me even one more definition of how long eternity is. This was just prior to, and after being graduated from Texas Tech. This, too, almost made an atheist of me! In fact, after I left the ministry I professed to be one for a while. I did not make a very good atheist so I became what some call an agnostic. I was trying to be a decent agnostic when, as I had thought at other times, I finally, really and truly, absolutely for certain, positively and for real, met God. As cited

elsewhere in these reveries this was on March 5, 1985 at the pottery lab at Houston Baptist University. It was 1:26 p.m. I believe I did meet God.

Our parents had taught us to believe in God, whatever that ambiguity might mean. That was back in the 1930s and 1940s, when almost all of the American population believed in God Almighty of the Holy Bible, or claimed to do so. If it did not, it did not condemn those who did, and special interest groups (or *dis*interested groups) did not try to enact legislation to halt and desist people from letting the world know that they were believers. Since those days there has been an increasing evolution of disbelief in this country. (That is amusing, that the disbelievers of evolution are proving evolution by their evolving behavior.) It has woven its threads into the heart and core of American politics, creating a wider gap than previously existed between Democrats and Republicans. Not only has it widened this separation; it has created a division within the Democratic Party, and perhaps within the bodies of both major parties. It is worth considering that this division led to the second election of George W. Bush as president. This was because there are many believers within the Democratic Party that voted for the outspoken "Christian candidate." His opponent, John Kerry, was trying to walk a narrow and sharp fence that divides the very far-left members of his party from more moderate or the right wing members of his party. It was a task that any candidate would have found hard to accomplish, if not an impossible one. His mission was further complicated by the fact that he is Roman Catholic, which is, or claims to be, Christian. But Kerry is a paradox within his own religious body. Many Democrats are in opposition to some of the tenets of the Roman Catholic Church: *per se* the birth control issue, the abortion issue, and the divorce issue. Kerry is a divorced and re-married man and leaned in the direction of what is called pro choice. Some view this as hypocritical and contrary to the scriptures, and many could not understand his position on abortion or marital divorce, especially since he is a Roman Catholic. Thus many of the disillusioned members of the Democratic Party simply (or with great consternation) voted for George W. Bush.

It is interesting that in 2008, as this manuscript was first being written, religion was once more a major issue in the forthcoming elections. Both Democratic candidates were espousing a very strong

belief in God and a firm Christian faith. It was much like a soap opera and had many elements of the same grim humor. But by the time this book finds its way into print, most of this will have been forgotten: not by all, but by many.

The glaring paradoxes of the Bush Belief System, as it might be labeled, resulted in producing the most divided America since the days of Abraham Lincoln and the Civil War. This was after he quickly inherited a situation where the nation became more united than it had been since the time of World War II and the days of F.D.R. He then engaged our nation in another war. Many run in fear and try to hide from a god who would order us into Iraq to perform as we have performed, even though there is a great resemblance with this "mandate" to some of the Old Testament episodes (Just read the Old Testament and you will see for yourself). And so it seems that we were and are becoming a nation of believers and non-believers, or a nation of believers vs. non-believers. Separation of church and state is becoming a very heavy matter. The Republican Party of Texas allegedly voted to "Dispel the myth of separation of church and state." The governor of Texas staged prayer meetings in football stadiums, even though Jesus instructed His disciples not to engage in such activities (Matthew 6: 5-7). Every citizen has good cause to be frightened about this: both the believers and the non-believers. The perpetrators of such a platform are testimonies to the fact that evolution exists. They are in evolution's processes. They are creating it; at least they are creating it in American politics.

In 2011 the governor of Texas was making a strong and unsuccessful bid for the executive office at the White House. As he so did he was in blatant violation of that New Testament scripture. Of course, the governor is not the only person who violates this caveat. Practically every so-called Christian church in the world violates it. What a paradox it is, people violating the teachings of Jesus in the name of Christianity – in more ways than cited herein, too.

Ellie Doggie can read my mind. She is telepathic. She looked at me with a bored countenance and asked, "You're not thinking about all that political garbage stuff again are you, Worrell? Good grief! Why don't you do something constructive? Wanna go play Frisbee?"

"In a minute, Baby Dog. Give me just a minute." And I continued remembering and thinking about how things do change. Change is the nature of the universe and all of its constituents. The universe is fluid and so is the earth contained within. On and above this planet the winds do blow. The streams do flow. The seas do give up their waters. These waters fall upon the land, trickle down countless tributaries, flow into the great rivers, and return again to the oceans and to the seas. There is a constant flux of life. There is such an abundance of life that at any given moment, at any given second, at any given nanosecond there is no definable number or quantity of vertebrates, invertebrates, or microorganisms. There is constant, unceasing change with everything, even with human thought. The millions of books and writings scattered around the globe and that are now in process testify to this. Trying to establish how many units of life there are is like trying to measure how much light there is in the universe.

Change is ongoing in the individual's consciousness and in the consciousness of a society. If written history, or a portion thereof is accurate, most of America's founding patriots were believers in Deity. Most believed in the God of the Bible's Old Testament and in the Christ of that book's New Testament, or they so claimed to believe. Not only was such their persuasion, they also founded American jurisprudence upon laws and principles found in biblical writings. Nonetheless the plants, seeds, and rhizomes of atheism existed in those days too. They always have, but since 1776 they seem to have propagated logarithmically in America. They entered the lymphatic system of United States politics and have grown like kudzu grows in the South. With the advent of the ACLU, Madelyn Murray O'Hare, and others, atheism became, if not fashionable, a once private concept that people were at last willing to openly admit.

Moreover, atheism seemed to become reasonable when contrasted to or with some of the obvious contradictions found within the tenets and covenants of some organized religions, including various factions (generally labeled denominations) of Christianity. This has led to various statements of grim humor, such as:

"Lord! Save me from your followers!"

"Nuke the gay baby whales for Jesus."

"Born O.K. the first time!"

"Fight for peace!"

"Who would Jesus bomb?"

As stated, the humor is grim. With that grim humor there are amazing paradoxes, a prime example being Adolf Hitler's supposed belief in God! Imagine him praying for Divine support in his Nazi conquests while Americans are upon their knees praying for God's help in defeating Hitler! Imagine more grim humor when God answers all concerned by replying, "You boys work this one out among yourselves and leave me out of it!" (Talk about deism!) The post war evidence seems to be, however, that God did not take such a position!

There are amazing and glaring paradoxes. Two football teams, two basketball teams, boxers, fencers, sprinters, and on and on each pray to God to win. What is God supposed to do, let every contest end in a tie? That would certainly establish a new genre of competition! And if God takes sides in these contests winners might be decided not by which or who or what is the better or best athlete or athletes, or team, but actually decided by God in accordance with who can pray the best, who can pray in the most effective manner. Forget physical training. And remember, they must pray properly, alone and in their closets! Blame the quarterback if he does not pray effectively!

What a chaotic similarity exists presently. Radical Islam considers Americans to be infidels and is bent upon killing us. Christians are at war with this ideology. Both of these belief systems go back to the (same) God of Abraham, Isaac, and Jacob, or so it is claimed. Who is this God supposed to assist? If the answer is "the most dedicated" then the free world is in grave danger! If you doubt this consider how many Christian martyrs there are compared to Islamic ones! It seems so strange that both religions stem from the same source, yet both their major prophets were at opposite ends. Mohammed was a warlord. Jesus was a peace lord. With Christianity there is forgiveness. With Islam there is no forgiveness. Here are two factions, each attempting to serve God, and while so doing they are each killing the other, or attempting to, along with killing innocent bystanders. It is *koyaanisqatsi!* It inspired yet another short-short story, as follows.

A SHORT-SHORT STORY ON MONOTHEISM
(YAHWEH & ALLAH MEET)

He was surveying His creation, Yahweh was. It was not just a matter of chance that He encountered Allah as they both sat beside the limpid pool of Siloam.

"You look so familiar," One exclaimed. Have We met somewhere in the past?"

"Perhaps We have, either in the past, the future, or with certainty in the ever-abiding present."

"Are You here to be cleansed?" One asked.

"Oh! Myself no! I have been forever clean and pure. Are You here for cleansing?"

"Oh! Myself no, either! Like You, I have forever been pure and clean."

"Well, that makes two of Us."

"I Am not clear on that. It might be only One of Us."

While They were thus conversing Their many followers were at different places, congregated and engaging in prayers and meditations directed unto the two of Them. Yahweh and Allah could not hear them, and in fact, They did not even know them, as is most often the case with stars and celebrities. The followers of such often conjure up various imagined relationships: fantasies, if you will, and they often claim to know Godanalities they actually do not know.

They pondered this for a while and One said, "It is just another method they have of taking My Name in vain!"

So beside the limped Pool of Siloam Allah asked Yahweh: "Tell Me, have You been circumcised?"

"I have not been, but I Am. How about You?"

"The same for Me."

"I don't know why I put that foreskin on Adam. I did not like it at all after I finished him. I Am a bit regretful of the facial hairs, too, and the nose hairs have turned out to be a tormenting thing: an unintended curse. In addition to that, Eve had great resentment about the hair I put in her armpits and on her legs. But somebody always pays a price for the success of someone else. Just think of the money that has been made from this by the razor and cosmetics companies."

"Do You eat pork?"

"Me in heaven no! Do You?"

"Never!"

"Swine are an example of a good idea gone wrong. I only created them to keep trash and garbage contained, and to help the vultures keep up with decaying animals, much as I did by making catfish and shellfish and placing them in the rivers, streams, and seas. It never occurred to Me that anyone would want to eat such unclean things, especially with such a plentiful supply of crickets and locusts readily available for the table."

They conversed for a small portion of the eon, and then looked into the pool. In the water They saw the reflection – and realized Yahweh had been talking with Himself. So had Allah!

Ahhhhhh! I drifted out of my long reverie. Ellie yawned, stirred, and came down from the couch. I yawned too, and walked out into the yard to look at the River and to play Air Dog with her. How absolutely beautiful and peaceful it is here at New Art. How far away from war … yet how so very close!

MUTUAL COEXISTENCE
IS POSSIBLE

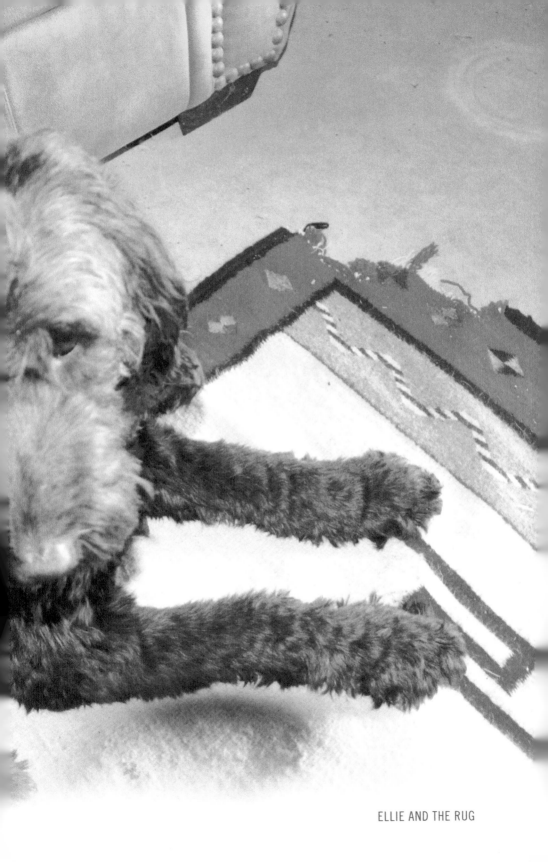

ELLIE AND THE RUG

IX.
The Letter
from Ellie

t had been another beautiful, wonderful, joyful day here at New Art. I planted trees and flowers, cleaned up a bit around the new guesthouse, and then drank clean, pure water and some really good cold beer. It grew darker. Sunset came on, then dusk. In the past I used to work about sixteen hours a day. I processed each bonze, applying patinas and polishing certain areas. I gathered and drilled every stone for mounting the bronzes, and packaged and shipped every piece. In addition I created and processed jewelry, put two books into print and stored five more in the computer. I also produced a few dozen paintings each year.

I no longer work that hard, but I still work and I still enjoy it. My manager-sister-owner, B.J. has taken tons of pressure off me, and nowadays when darkness falls I go to bed and read. Sometimes I watch

the human comedies portrayed on CNN, FOX, and NBC. These usually put me to sleep within a few brief minutes.

So off to sleep I dozed one evening very recently, and began dreaming.

> I went to bed last night
> Ellie May Lucille and me
> Drifted off to sleep
> And I dreamed a doggie dream
>
> I dreamed she wrote me a letter
> In her own sweet doggie way
> And I will likely cry
> Relating what she had to say
>
> *It read:*
> I think back on my puppy hood
> When I first came to live with you
> I was feisty I was frisky
> Full of licks and puppy chews
>
> My energy was boundless
> I was a bit mischievous too
> Back in my puppy hood
> When I came to live with you
>
> You taught me how to play stick
> Catch and bring it back to you
> You taught me to play tag
> And how to swim the River too
>
> You never once abused me
> No matter what I would do
> Unconditional love
> That is what I taught you
>
> I am so glad we live together
> In this wonderful home
> I had rather have you
> Than a truckload of bones

Remember that big Zapotec rug
Your sister gave to you?
That was the most delicious thing
I think I ever chewed

And all those toys and Frisbees
I ate them one by one
And you never fussed at me
Cause you knew I was having fun

I am so glad we live together
We make a perfect pair
Life is one pure pleasure
With you there's not a care

I am so glad we live together
In this wonderful home
I had rather have you
Than have a truck load full of bones

Yes I had rather have you
Than a truck load of bones

OUR TEXAS STUDIO

X.
A Letter
to Ellie

I sent a copy of Ellie May's letter to my friends Connie Cole and Robert Howard. Connie said that since Ellie had written me such a sweet letter I should write one to her in return. I did, and this is the letter:

Dear Ellie May Lucille,
I got your lovely doggie letter
So sweet it made me cry
Guess no two souls ever got along
As good and you and I

I thought I knew most everything
I thought I was so wise

I've learned more from you in one year
Than in all the rest of my life

I learned that a wagging tail
Means more than money in the bank
And for your nightly doggie snuggles
I daily offer thanks

I learned what really doesn't matter
I learned what really does
I learned the sweetest thing of all
Is your sweet doggie love

I love you Ellie May
I love you in my life
If I could marry a doggie
You would surely be my wife

I love you Ellie May
We are a perfect pair
You taught me how to love
You taught me how to care

I love you Ellie May
You are my best friend
I love to toss the Frisbee
You bring it back again

You don't boss me around
You never fuss, you never whine
You're the best doggie in the world
I am grateful that you are mine

You jump high as the sky
You are my main delight
I love you Ellie May
I'm grateful you are in my life

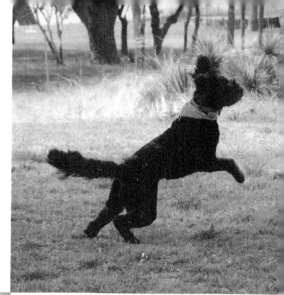

ELLIE AS A BALLERINA

MINNOW CHASING

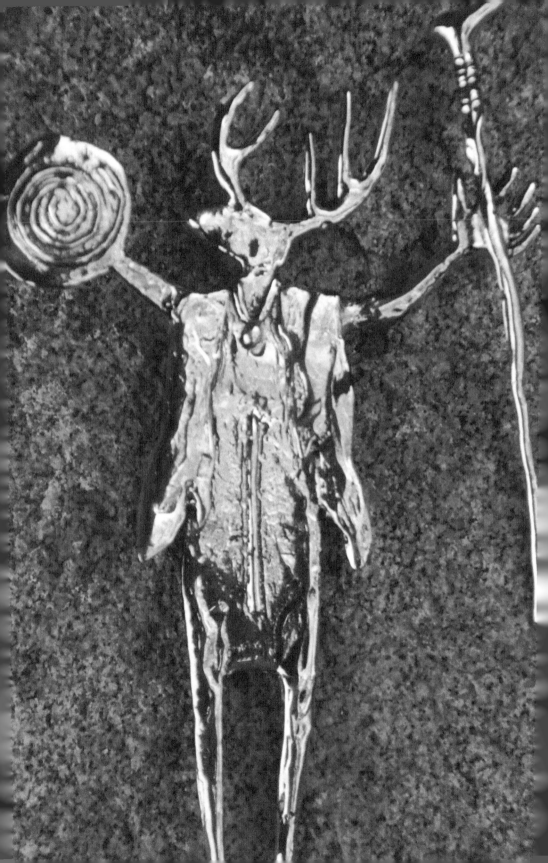

XI.
Phobias

here are all sorts of phobias among Homo sapiens. There is the fear of heights, the fear of falling, the fear of flying, the fear of water, the fear of ambush, the fear of spiders, and on and on and on the fears go. There are some who have the fear of relationships. Back at Texas Tech in the old days when students were required to live in dormitories there was, among many of them, the fear of dorm food. One of the confusing phobias, that is, confusing to me, is the fear of dogs. I can understand someone being afraid of a vicious, barking, growling, canine with fangs barred, but not of some gentle, loving, sweet doggie like Ellie May.

I have a friend who has a very pronounced phobia about dogs. He is not afraid of being attacked by dogs. He is afraid of their germs, their smells, their dander, and what to him is their uncleanliness. I admit that there are some obnoxious canines, just as there are obnoxious humans. I smelled a woman in a grocery store in Mason, Texas who

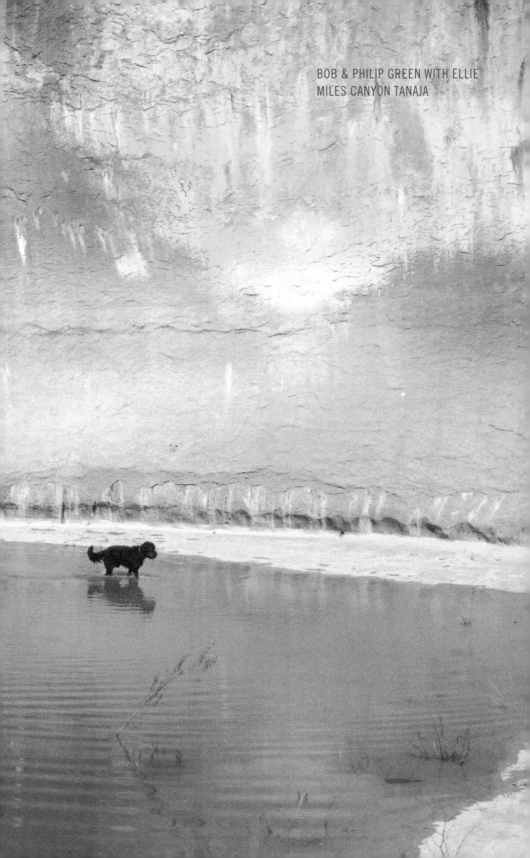

BOB & PHILIP GREEN WITH ELLIE
MILES CANYON TANAJA

literally had me retching with the dry heaves. I had never smelled a human being with an odor like that! I ran out the door and into the parking lot where I heaved and heaved and heaved. Dry heaves. Never have I smelled a dog with an odor that obnoxious, yet they will not allow dogs in that store while they allow such humans in.

Now it is understandable that any doggie can have a bad odor now and then, just as people can. People get B.O. People get halitosis. Dogs can get doggie breath, and they can get ear odors, especially if they are of poodle stock and swim a lot. There are simple remedies easily available from a veterinarian or even from off the store shelves. Vinegar and alcohol, hydrogen peroxide, vitamin C and mineral oil, and many other home remedies are to be easily found over the Internet. Digestive odors are another matter, and these can occur with changes in diet or in brands of dog food, and especially with the higher price brands that are grain free. I give Ellie the very best that is available. As a consequence she sometimes releases gas. I do not know why some people find this so offensive. Some of those people, if not all of them, release gas also, and sometimes when they do they think nobody but them knows about it. They assume no one else hears the release or smells it. Wrong! On both accounts.

Dogs, cats, and other animals go about their business with no sense of embarrassment. Humans developed a modesty that (thank God) places them in more solitary surroundings when relieving themselves. I regard these things as being just the way they should be. I have never been one to attempt to change the facts of life, much less some of the customs of life!

One day my longtime friend, Gay Ainsworth Houston and I were driving along Interstate 20. Of course Ellie May was with us because I take Ellie everywhere. The weather was very cool, and it was raining like the bottom had dropped out. All the windows were up and because of the downpour I could not roll them down. A very strong odor crept forth from the back of the vehicle into the front. Gay began fanning. "Did Ellie release a flatus?" I asked.

"I think so," said Gay, still fanning her nose.

"Well," I said, "It's all right because it is an Ellie flatus, and when you really love somebody a fart just doesn't matter."

Without so much as cracking the slightest of a smile Gay kept fanning and dryly said, "I don't know. I don't think I've ever loved anybody that much."

I have!

TIRED OF RIDING SHOTGUN.
SHE WANTS TO DRIVE

XII.
We Go to Arizona

We were on our way to Tubac, Arizona for the opening of the sculpture garden at the Karin Newby Gallery. Tubac is a ways off from New Art, like 833 miles way off. It is situated between Tucson, Arizona and Nogales, Mexico. This brought to mind a trip to Tubac about three years BE (Before Ellie). I had decided it might be easier to fly than to make the drive, so I made my second air trip since September 11, 2001.

Thus one February day in 2005 I left my Hill Country studio on the banks of the Llano River and drove to the San Antonio Airport. This airport is in the 7th largest city in the U.S.A., and it has been under construction and renovation since shortly after the days of Antonio

Lopez de Santa Anna and the flight at Kitty Hawk.

It is a two-hour drive from here to the airport if there is not a traffic problem or some kind of road construction work. I headed out. There was the parking and shuttle situation and there was the usual two-hour check in, so the time from my studio until I was in the air was crowding five hours. Because of special interest legislation, specifically Senator Wright's amendment, and the other bastards who approved it, I could not fly to Tucson on Southwest Airlines unless I caught a plane in Lubbock or Amarillo, or unless I flew from San Antonio to Las Vegas, and then to Tucson. Not on Southwest Airlines I couldn't, and that is because lobbyists for the other airline companies persuaded "The Honorable" Mr. Wright to discriminate against Southwest Airlines. That is the way lobbyists work when *lechergaters* go into seizure! The flight to Phoenix was two hours. Once there it took me an hour and fifteen minutes to obtain a rental car, even with a reservation. This was because the Phoenix Airport fathers decided that all rental car operations should be moved from the airport to downtown Phoenix. I needed a rental car once I arrived in Phoenix and here is how it went. Phoenix is the 6th largest city in the United States, so it took a while to negotiate all of this. After deplaning, as they say, I went to the curb and waited for a shuttle. When it finally arrived I rode to downtown Phoenix. The shuttle let me off near whatever car rental company I was using. There I waited another eternity to get to the clerk. After filling out the necessary papers I fought traffic back past the airport and on to Tucson, and from there I drove on down to Tubac. It took fifteen hours for me to arrive at Tubac from my New Art, Texas studio.

Three weeks later I had to return to the Tubac gallery for my annual one-man-show during Art Fest. I made the drive from my studio to the Karin Newby Gallery in twelve hours. I had a net gain of three hours and I did not have to undress in front of security guards or lose my temper because of an immoral, or at least an especially interested legislator. I also had my own vehicle and the choice of my own belongings, not to mention a much greater peace of mind. Additionally, I did not have to be seated beside some hairy-armed ape that would claim ownership of the armrest. Also I did not have to sit by someone that might have horribly bad halitosis. My luggage was not lost, either, as it had been on the previous airline trip.

Since that time I have always driven to Tubac, and to Sedona, and to Santa Fe, and even to Nashville and Kentucky. So once upon a time, after Osama bin Laden changed the world, Ellie May Lucille Worrell and I were on an Arizona odyssey. I was at the wheel and Ellie was in her crate. She loved her crate. It was her security cave, but these days she rides shotgun with me up front.

"Hey Worrell! Are we there yet?"

"Not quite, Baby Dog, but we're to Wilcox."

"Wilcox? Where is Wilcox? And how much farther is it?"

"Wilcox is in Arizona, and we have only a couple or three hundred more miles to go, Baby Dog."

"Two or three hundred miles!?!? Man, I'm sleeping my life away."

"I'm sorry, Baby Doggie. It won't be too much longer. Wanna get out and pee?"

"Oh no, just wake me up when we get there."

At Tubac I parked in front of the guest quarters Kim Roseman so graciously provided for us. I opened the back door of the Suburban and there was sweet, lovable, smiling Ellie May, standing in her crate.

"Are we here?" She wagged her nice, long, feathered tail.

"Yes, Baby Dog, we are here."

She sighed, "Thank God. You know, Worrell, I hope we go to Heaven. I'd sure hate to spend this long in Hell. Hey! What are those funny looking things over there?"

"Those are peccaries, Ellie. Collared peccaries. People around here call them javelinas."

"Have a whats? Oh boy! Can we chase them?"

Of course, the answer was no. We were in Tubac three nights and then returned to New Art, with a necessary overnight stop in some podunk motel crammed full of all night long noisy revelers. I learned a lot on that trip about the traveling needs of doggies.

IT IS MINE AND YOU
CAN'T HAVE IT!

XIII.
Toys

I *should own stock* in "Flippy-Flopper" or "Hyper Pet." These are companies that manufacture, or have someone manufacture for them flying disc toys for dogs. These toys resemble the famous Frisbees, only they are fabric and not plastic, which is much easier on canine's teeth. Google says that both are produced by Rose America Corp. out of Wichita, Kansas. It seems rather strange to me that a company named Rose America would have a toy manufactured in China, but that is the case these days, as it seems to be with nearly everything from coffee pots to computers. All sorts of products from China are shipped in huge, metal containers that are twenty feet and forty feet long, and eight feet wide and eight-and-a-half feet tall. Since we import much more than we export there is a vast

surplus of these overseas shipping containers and by the year 2050 there will be no more open space in America because it will be filled with empty shipping crates. It is more economically feasible for the Chinese to manufacture new containers than to have empty ones shipped back across the sea! Americans are using these empty containers to construct storage sheds, work spaces, and even apartment complexes.

Just try finding a product that is not manufactured in China. Instructions for items manufactured in China are humorous, although the humor is, once again, a bit grim when one really ponders it. For example, I recently purchased a backpack sprayer. It is the kind that pumps up and sprays fertilizers, herbicides, or pesticides, or simply water, for that matter. The printing of the instruction manual is in English, barely, and would be non-understandable if I had no mechanical ability. Instructions are probably written in English, translated into Chinese, and then again translated by Chinese people back into English. Item #6 in the operation manual is the troubleshooting portion and is printed as follows:

"Overhaul for breakdown." It then lists *"Breakdown, Cause, and Settlement."*

Read on. These are actual quotes.

Breakdown:	Leaking and Spraying Unwell
Cause:	Sealing Plate is Damaged or Not Wrenched Firm
Settlement:	Exchange the Sealing Plate or Wrench Firm
Breakdown:	When Shaking the Operation Arm Feeling Too Much Pressure
Cause:	Spray Head or Filter Block up
Settlement:	Clean the Filter and Spray Head. Add Vaseline to the Activating parts.
Breakdown:	Low Pressure
Cause:	Abrasion of the Bowl or the Sealing Ball
Settlement:	Change the Bowl or Sealing Ball
Breakdown:	When Shaking The Operation Arm Feeling No Pressure
Cause:	Sealing Ball is Mission (sic) or Removed
Settlement:	Fix the Sealing Ball Properly

All of the above are, as they state in journalistic lingo, "sic." They are also sick. These are verbatim quotations, including spelling, and the entire manual is written in this type of broken English, much as some present day American university doctoral graduate might pen. Anyway, it is a changing world. After two or three attempts to use the device I tossed it into the junkyard. My Japanese brand camera, a Nikon D 200, was outsourced by the Japanese to Thailand. Life in an oriental sweatshop is a horror to comprehend. After the Chinese merchant mongers kill off the laboring class I wonder to where and to whom they will outsource?

Some good things have resulted from foreign manufacturing. Automobiles are among them. It took the Japanese to show American vehicle manufacturers how to produce a reliable automobile. In times past American made cars would begin to break down after 50,000 miles. Toyota proved a car could be manufactured that would go 200,000 miles without breaking down, and likely with but one oil change.

Fine products have been made in America, at least they were in the good old days. Now it seems that about the only thing still made here is scandal and political corruption, not that other countries do not also create these. I think Victor mousetraps are still manufactured in Lititz, PA, U.S.A. by the Woodstream Corporation. This is a rare exception. The books my sister and I have published have been completely manufactured in America, even at far greater expense, and that is really a rare thing. Many books published today are printed in Hong Kong.

There are reasons for this vast amount of outsourcing. The American government and labor unions are the prime cause. This is due to workers' compensation, social security, health insurance, retirement benefits, minimum wages, legalized working hours, and whatever else foreign manufacturers do not have to comply with. I obtained a patent on a very simple device. It is a hatrack. I spent a lot of time creating prototypes, finally developing an incredibly simple item that attaches to any slick surface, holds a hat, will hold a soccer ball or basket ball, and in addition will hold bill caps, coat hangers, and belts. The perceived value of this unit will not exceed twenty U.S. dollars. The lowest cost per manufactured unit I have been able to contract in the United States

is $8.50 per unit. This does not include packaging or shipping, which brings the cost in excess of ten dollars. This means the retail price per unit must be around $30.00. I have not found a retailer who will pay the necessary wholesale amount because the perceived value far exceeds the necessary retail sales amount, which should be about $15.00. I have not yet whored out to fifty cents per unit in China. That is the plight of many an inventor and manufacturer in this country.

Anyway, I have gone through so many Frisbees and Flippy-Floppers you would not believe it. There is Chinese stuff, or remnants of this stuff scattered all over the yard, and I continue to engage in being a part of the sweat shops of the Far East because I continue to purchase these toys, along with coffee pots, electric blankets, lamps, toasters, vacuum cleaners, and computers. Absolutely no dog food or dog treats, though! Anyone who loves a pet should not purchase anything edible that is produced in China!

This morning Ellie May came up to me and said, "Hey Worrell, will you play with me? See, I've got my squeaky toy."

"O.K., Baby Dog, give it to me and I will toss it for you."

"Unh unh! I want it."

"Well, I can't throw it for you if you won't let me have it!"

"I knooooooooow! But I just can't help it. I just can't turn loose of it no matter how bad I want you to throw it for me."

"O.K., Ellie, give it to me, Baby."

"NO!"

So I playfully chase her around the yard. She holds onto the toy, smiling as she does, running in wide circles, and there is no way I can catch her. Eventually I manage to grab hold of it and she stops and backs up, growling a playful growl. She will not turn loose of the toy.

Ellie is *very* strong. I think she could pull a truck. I know she is training me and tying to teach me how to really play. I am beginning to learn.

ELLIE AND CASSIE
PLAYING STICK

XIV.
Weavers

a long strand of silk drifted above the yard, born by a gentle spring breeze. It must have had some measure of weight, yet it appeared to defy gravity. On one end of this strand there rode a passenger, a small eight-legged creature. How this long, thin craft and its passenger defied gravity is a mystery to me.

"Worrell, why are there so many spiders?" asked Ellie. "Everywhere I look there's some blasted spider! There are webs all over the place! I hate them! They get in my hair, they get in my mouth, and they get in my eyes. I can't stand them!"

"I don't know, Ellie," I replied, "but there sure are a lot of them. They bother me the same way. They are everywhere. They're in the house, the studio, and the barn. They are ubiquitous. They weave webs all over the place, in the piano, around the piano bench, all over the furniture, on the doors, on my paintings, all over my tools and brushes, and everywhere! And under their damned webs they leave those awful little

white fecal drippings that are so hard to remove. They're harder than dried glue." Then I sort of went into a rhythmic chant.

Eight-legged weavers
They are everywhere
Under the bed
Under the stairs

Under table legs
Under the chairs
Eight-legged weavers
They are everywhere

They're weaving their weavings
Like the mummy's old curse
Wrap my guitar
Wrap my houseguest's purse

Catching the wind
They float through the air
Catch my mouth and my eyes
Land in my hair

Slide open the drawer
View the weavings they wove
Open the door
They wove in my stove

Some are so tiny
They elude my eyesight
But they can weave a whole blanket
In less than a night

Some can puncture
The toughest of skin
And fester a sore
That seems never to mend

Not a crack too tight
The weavers creep in
Small specks of white

Reveal that they've been
Basements and attics
And cupboards their lairs
Clean for a week

You'll find them still there
Corners and ledges
Windows and sills
There's never a moment

The weavers are still
It is promised the meek
Will inherit the earth
The weavers will conquer

The whole universe

"Anyway, Baby Dog, I don't think we can do anything about spiders unless we move to the North Pole."

"Where is that?" Ellie asked.

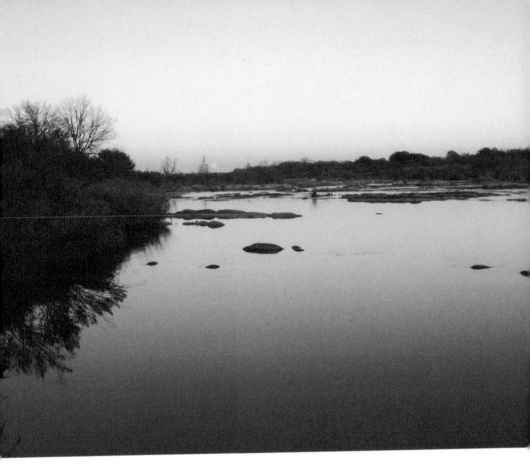

THE LLANO RIVER

XV.
Words and Stones

llie and I were lying in bed watching the news, as such broadcasts are misnomered. This is a very bad habit I have developed, and one that is a great thief of time. Ellie rolled her big eyes at me and asked me, "Worrell, why are people so mean?"

I was at an absolute loss for words. I pondered the question for days. A week or so later as we were in the studio and I was painting I looked at Ellie and said, "Greed!"

"Greed what?" Ellie queried. "What are you talking about?"

"The answer to your question: the one you asked the other morning. Greed is why people are so mean. That and fear."

"Worrell," she ruffed, "Sometimes you really confuse me. I didn't have the slightest idea what you were talking about. I asked you that

question a week ago."

"I'm sorry, Ellie, but I just now figured it out. Greed, fear, and egos. That's what it is. Paul told the followers of Jesus that the love of money is the root of all evil. Greed presents people with the perfect opportunity to be mean and selfish. Egos compel them to desire more than anyone else, whether it be cash, land, cattle, power, sex, or fame and recognition. Then enters the fear that they will not achieve this, along with the fear that there is not enough of anything to go around. Beyond this, Ellie, I think there is something in the genes of certain people that is just degenerate: something that makes them mean. I think it is somewhat like it is with some of your relatives, such as pit bulldogs. They kill just to kill. They bite just to bite. They are just born that way. It is our job to recognize mean people and to steer clear of them."

"Now Worrell, pit bulls can be nice, so can Jack Russells. It is people that make dogs mean."

"Yeah, Ellie, you are probably right, and that is what I am talking about: how mean people can be and how they teach their offspring and young people all sorts of vile, abusive, and unkind things.

"And physical meanness is not the only kind of meanness. There are many forms of meanness and terror. There is psychological meanness and verbal meanness. There is verbal, psychological, physical, and spiritual terrorism. There are words, words, words, bitter, harsh, cutting, and abrasive words that some people hurl about like stones from a sling. Some hit the mark, some miss the mark, and some that miss land upon the innocent, creating unintentional damage. It is nevertheless still damage. It takes a long time, sometimes, for the bruises and wounds to heal, that is, if they ever do heal.

"Often words and stones and bullets and missals and bombs are hurled out of fear. This may not always be the reason, Ellie, but it is usually the reason. The Rights fear the Lefts. The Lefts fear the Rights. Some of us fear them both. Islam fears the Christians, the Christians fear Islam. Some of us fear them both. Some of us fear all organized religions, and as we attempt to grab hold of and maintain our spirituality we cry, "God, please save us from those who have their identity confused with yours!"

"Fear drives people to do many crazy things. It drives them into a state the Hopis called *koyaanisqatsi*. This American Indian word means 'crazy life,' or 'life out of balance.'

"People fear God because they have been taught to do so, and have been threatened should they fail to do so. They have been taught the paradox that He is the epitome of Love, while at the same time He is angry, mean, intolerant, and vindictive. They have been taught that He is more undefeatable than Superman. He is immune to any assault his puny mortal creations would launch against him. He cannot be shot, hanged, lethally injected, or even nuked, therefore we best fear Him and not violate His mandates lest He zap us with all sorts of never-ending torment, misfortune, suffering, and pain and agony, both mentally and physically. This, of course, means that we cannot accept or even be tolerant of any religion other than what He personally ordains: what He Himself personally wrote in the Holy Bible, or the Koran, or any other organs of religion. But this is not true, Ellie. It is simply – or not so simply – not true! This is what people choose to believe out of fear and this fear drives them into behavior that is cruel, harsh, and mean. It is an imitation of the behavior of their god. It is kicking the dog."

"Man! The way you talk God sounds like a schizophrenic. I'm sure glad dogs don't have that kind of literature! It sounds pretty crazy to me, and I do not understand why anyone would want to kick me!"

"Well, Ellie, it is sometimes admitted that God did not write any of these books personally, but rather that He inspired and instructed his creatures to write them, those such as Moses, Mohammed, Paul, John, Mark, James, the various Buddhas, Zoroaster, Confucius, and whoever else. At least the followers of these 'faiths' tend to believe this, or at least they say that they do, and this is just another source of and catalyst for the generation of fear that is manifest in religious conflict and contention.

"Think about it. Just imagine a Christian making a friendship with a member of Islam. Can't you just imagine how much that would anger God? Or worse yet, just imagine a member of Islam accepting a Christian into his fellowship. This would anger Allah even more! And for a Jew to associate with someone who has not been circumcised is an abomination. I have wondered many times just how a Jew might know

whether some man has or has not been circumcised. I mean, what does a Jew do, make some kind of inspection? The circumcision issue is stated time and time again in the Bible. I have wondered many times why ancient Hebrew men were so obsessed with the human penis and the foreskin of the penis.

Ellie interrupted me. "Worrell, every human man I have ever known is obsessed with the penis!"

Boy, did that hit home! I instantly remembered seeing graffiti in a Lubbock, Texas restroom that stated, "Phy Psys have bigger dicks and we know how to use them!"

"I guess you got that right, Ellie. Among such myriad and audacious behaviors is that even so-called Christians war with each other. They fear the punishment of their God if they indulge what they consider to be a clandestine or straying denomination. That is why in Ireland the Catholics kill the Protestants and the Protestants kill the Catholics. That is the same kind of thinking that causes Islamic people to engage in terrorism and suicide bombings. That is why Christian evangelists engage in spiritual terrorism. That is why "Right to Lifers" blow up abortion clinics and kill innocent people while doing so. That is why, and is a part of the process of how people of all faiths justify their hate. It is practically always in the name of something they consider decent, good, sacred, and holy. "God's Will," or "Allah's will," they often call it. Let me submit that God's name or the name of Allah has never been so profaned and the prophets so dishonored! A decent, moral, kind, and considerate atheist or agnostic is to be much preferred above such misguided, self-appointed, and 'speaking-in-the-name-of-Deity' zealots.

"And here I am. Look at me, Ellie. I am judging these miserable souls! But keep in mind that there is a great difference in judging and evaluating. And should I judge, then forgive me Father, for I know not what I do, or forgive me even though I know very well what I am doing! I do not know what they might do, either, and that is what worries me. Jesus said, 'As you judge so will you also be judged.' Let it be, but let it also be considered that Jesus said, "By their fruits you shall know them." Then let it be proper for me to be a fruit inspector. As I inspect the fruits of practically all extremists I see chaos. I see hate. I see war. I see death and destruction. I see misery kindled and fanned. I see lies.

I see unkindness in unbelievable proportions. I see the loss of endless opportunities for directing astronomical resources into healing, and into bettering life upon this planet for all beings, and even all creatures.

"As I reflect upon the last decade of life in my own country I see a nation more divided now than it has been since the time of Abraham Lincoln and the American civil war. I see war and death. I see disgrace (yes, dis–grace) and loss of credibility brought upon my beautiful and wonderful country! I see a national debt never equaled in American history. I see fraud and embezzlement, the likes of which have not been known before. I see one political scandal after another. I see fear. I see the fear that generates hate, the hate that generates war, and the war that always generates death, destruction, and misery for innocent people. I see the megalomania that would sell the welfare of our nation in order to create personal wealth and ego stroking. The cycle goes on and on. It is essential when evaluating the performance of anyone to remember the words of Jesus: 'By their fruits you will know them.'"

So I got down upon my knees and prayed to God. I asked Him to please bestow upon us world peace and mutual co-existence. A voice came from Heaven and said: "Boy, are you out of your mind asking a thing like that? I can't even get them to have peace in Austin, Texas. I can't seem to get them to have peace in some of their congregations and some of their homes, and here you go asking me for people to have peace all over the world! You must be out of your mind."

Ellie laughed when I told her this. Then I wrote a new song and named it *Rotten Fruit.*

ROTTEN FRUIT

I'm not judging my brothers
Though it might seem like it to you
I'm just doing what the Bible
Told me I should do

I am not judging our leaders
I am just seeking the truth

Jesus told me I would know them
By looking at their fruits

Just look at their fruits
Don't it make you want to cry?
They embezzle they philander
When confronted they lie

They tell all kinds of falsehoods
Commit perjury too
Let me tell you in our country
There is a lot of rotten fruit

Rotten fruit
Nobody learns
We can't hide the truth
Cannot hide what we do

The Light will surely shine
It will always reveal
The many sordid deeds
We can never conceal

The press keeps digging
Digging up old bones
The people keep on casting
Casting their stones

And nearly everyone forgets
We have all done something wrong
In everybody's closet
There are some old dry bones

It seems nevertheless
Everybody gets confused
But one thing is for certain
There is a lot of rotten fruit

I sang the song. Ellie had gone to sleep.

TOTAL RELAXATION

XVI.
Faculty
Meetings

N *o one can know* the love that another feels, but each of us can relate to love in his or her own way, in each person's own capacity to love. And love is such an ambiguous word. It is used in such casual manners and ways. So when I say I love Ellie I know no one can understand or comprehend just how much or how deep my feelings are for her.

I was strolling around the property, talking with the birds, and trying to understand what those two cats, Milagra and Katrina were meowing about when something triggered my thoughts and took me back again to my college teaching days – or my college teaching daze – that era before I became a recovering teacher. This triggered all sorts of thoughts about how I came to be doing what I was doing. My days of student teaching flashed before me, along with the insanity of

what are labeled "education courses" at most colleges and universities. A participation in practically any of these courses would give a person great insight as to why the quality of public education in America is so poor, yet it would be so unfair to malign the many dedicated and wonderful teachers we have in this country. There are some fabulous teachers. Dedicated teachers. Effective and life-transforming teachers. The ratio of good teachers to bad teachers may be drastically low, and the problem is undisputedly compounded by lobbyists and special interest corporations that devise absurd, ineffective, and essentially worthless tests, and then glean public tax monies by selling them to our schools. Combine this with personnel who specialized in coaching football and basketball and were then promoted to offices of administration in the public schools and one can see that we have an epidemic of deteriorating education in America. And this is certainly not to say that all coaches are "dumb," either. There are some brilliant men and women who are coaches. Like in every other field there are some who are near morons. And I will be the first to admit that if technological development had been left up to me our society might still be a band of flint knappers!

Look around. There are marvels everywhere. We might even call them miracles, and do that without exaggerating. We live in a Golden Age, especially when we compare life today to daily living a century ago. We have medicines and vaccines. We have washing machines, toasters, vacuum cleaners, televisions, radios, movies, and wonderful devises that will allow us to play our choices of music with such fidelity the sound rivals, and in some cases is superior to sounds of live performances. We fly in planes and drive in cars. We have cellular telephones that allow us to communicate from almost everywhere. Our world is good.

For most of the population life is good and life is easy compared to the life of yesteryears. A very large part of this is the result of American education and some very wonderful, talented, and dedicated teachers.

I am a teacher, or I was a teacher. These days I tell people I am a recovering teacher, although I still teach from time to time at New Art (without remuneration) and on occasions return to Houston Baptist University to render assistance in the art department. In the past, one of

the finest experiences of my life was that of performing what is termed "student teaching." It was a marvelous thing for both the students and for me. One of the main things that made it thus was that the school's principal and my supervising teacher mostly left me alone and gave me *carte blanche* to follow my intuitions and reflexes about what to teach and how to teach it.

When I was in the process of receiving teacher certification in art education at the secondary level I had to take a series of "education" classes at a university. There was no way around it. I was required to take those courses. In those classes I had to design lesson plans that stated what I would be doing at precise times every school day for nine weeks. What an abysmally boring and unimaginative process that was! What a blessing it was when the principal and the supervising art teacher allowed me to ignore those lesson plans and teach spontaneously! Most public school teachers are not so fortunate. At the beginning of a school year they must create lesson plans for thirty-six weeks, or even longer.

After taking those unimaginative courses at the university and receiving teacher certification I became a community college instructor, where, as I began my professional teaching career, I was again required by the department chairman to engage in the same unimaginative and boring processes. I had to do this each year for twelve years. And speaking of nonproductive, meaningless, and trivial occupations of time and energy, there were faculty meetings, faculty meetings, and faculty meetings, *ad nauseam infinitum.* These were supposed to serve as pep rallies to inspire us to "teach better." What they really served to do was to erode the general morale of the teaching faculty and inspire all of us to create jokes and stories about how maladroit in cerebral processes some of the administrators were. Someday someone will find notes about these meetings in my files and some of that humor (grim humor) will be resurrected.

One day my late friend, Dr. D.J. Sibley and I were engaged in a discussion about American education. He stated, "Public Education was the first great socialistic experiment in America and it has been a miserable failure." Like many statements, this is partly truth and partly fiction. The truth is that much of early American education was wonderful. The fiction is that it is still as wonderful today. A part of

that truth is that evolution in education has produced elements that serve special interests, such as lobbyists, politicians, testing services, and administrators. In some cases it has produced power-hungry administrators that have almost insatiable needs, appetites, and desires to rule over their subjects, the "lowly teachers." It has produced a curriculum that places athletics in the forefront and scholastics as the "extra-curricular activities." I know brilliant and cognitive university presidents who defend athletic programs as the mainstay of the university's image and financial success. There is little doubt in my mind that $$$ is the loudest language in American society.

One of the things (and the main thing) American public education is about presently is money. There is a glaring absurdity in the avarice of administrators, their pay scale as compared to that of teachers, in the pay scale of athletic coaches compared to that of teachers, and in the "outsourcing" of teaching jobs, which is a major source of erosion in the teaching profession. When it comes to pay scales, it would not be so unequally bad that a coach gets five million a year if some really good English teacher, mathematics teacher, or art teacher would get at least one million. That would balance the scale a little bit. The problem is mathematics does not bring money into the system, and producing world class mathematicians does not bring the fame that a winning football or basketball team brings.

I went to a community college in south-central Texas, asked for an interview with the art department chairman, and had a visit with him. At the time I was professor of art at Houston Baptist University, which was 265 miles from my home and studio. San Antonio was much closer, so I desired a position there. I was informed that I could immediately find employment as a part time art teacher, that there were only six full time teachers and that there were some thirty-odd part time art teachers. It did not take an Einstein to comprehend why. Part time teachers had no benefits. That is to say they were not covered by health insurance or retirement programs. It boiled down to avarice. "Economics," the department chairman labeled it. This avarice (all right, it may not be avarice, but it is certainly excessive frugality or at least some fixation on money) prevails today in elementary schools, middle schools, and high schools. It prevails in junior or community colleges and also in universities: the same universities that compel students to

ELLIE HELPS WITH MANY PAINTINGS

"ANCIENT VOICES STILL SPEAK TODAY"
MIXED MEDIA ON CANVAS (55 X 37")

take "education" courses, elective courses, core courses, and major/minor courses in order to obtain teaching certificates and degrees. The lip service given this (for education majors) is that it is to train individuals for careers in the field of teaching. Then they are graduated, apply for teaching positions, and their would-be careers are outsourced to non-career teachers, such as the thirty some-odd part time art teachers at San Antonio College. These are substitute and part-time teachers who, as such, are not required to have teaching certificates, and in some cases not even college degrees. What a ripoff to our youth, to college and university students who are studying education, and to our citizenry! What a social injustice! What this does is to insure that our public school teachers will either be the most dedicated teachers there can be, they will be those who cannot do anything else, or they will be those who only want to teach casually. It makes a mockery of collegiate

teacher education courses and career teaching. We were so damned naive as students, or at least I was! We thought there was a *purpose* for those horrible education courses! We did not know it was all about money for the university and that professional teachers would be shut out by lesser trained or non-qualified personnel.

I live in Mason County, Texas, where athletics is king; where in the public school system there are 13 athletic coaches and one art teacher. A few years ago I wrote a letter to the Mason County News, stating that I had been an athlete, and acknowledging that athletics are important in teaching our youth physical fitness and teamwork. I wrote that our Mason County schools only had one art teacher and it seemed like a very big tail was wagging a very small dog. I went on to state that the likelihood of a student finding a career in a field related to the fine arts was much greater than a student finding a career in professional athletics. I concluded the letter by urging our school system to hire additional art teachers.

Within two days my telephone rang. The conversation went something like this:

"Mr. Worrell?"

"Yes?"

"This is coach McQueen."

"Yessir?"

"I read your letter!"

"Well good, thank you."

"Sounded like you were pickin' on us!"

"I certainly did not intend to be picking on anyone, I was just attempting to point out a weakness and a need."

"Well, it sounded like you were pickin' on us to me!"

"I am sorry you took it that way."

"You won't find nobody no more dedicated than us coaches!"

"I certainly believe that!" I stated it in mockery, but he did not get it.

"Anyway, there isn't thirteen of us! There's only twelve!"

I thought, *Lord God, save us all.*

The Mason County School system then hired another coach. Finally (I really hope it is not finally, but rather, at last) it hired another art teacher. This was several years later. You got it! It hired a part time teacher, a woman with a degree in art and who also holds teacher education certification. This school system still had twelve or thirteen or fourteen or however many it was coaches. This issue had come before the school board. A vote was taken regarding whether to hire another art teacher or another coach. The board hired another coach! Now there are one and one-half art teachers and thirteen or more athletic coaches – who also teach mathematics, history, and other "relatively unimportant studies."

I love knowledge. I love learning. I love discovering things. I love experimenting. I loved teaching, but I despised the arrogant attitudes of some administrators. I could write a dissertation about the inequity of their salaries as compared to the salaries of teachers. I could write pages about how our society pays some athlete millions of dollars a year because he can put a ball through a hoop or run offensive back like a wild pig, while we pay our teachers, firemen, and law enforcement officials a pittance. It is truly in line with that old Hopi word, *koyaanisqatsi.*

So I got me to thinking one day as I was creating art. I started thinking about the wonderful minds that came out of public education before the government, lobbyists, professional testing agencies, and bureaucrats became so entrenched in it, and I began thinking about Charles, Newton, Salk, Currie, Galileo, and some others, and especially Archimedes. A fantasy emerged in my mind, and I envisioned Archimedes teaching a physics class in a modern day high school.

It bored Archimedes considerably to have to fill out countless lesson plans, attend faculty meetings, and apply for career ladder. All he really wanted to do was to teach physics and to be totally emerged in what he loved so much, and to share it with the world and with the bright, young minds in his classes.

As he was driving to the school one morning a notion came to

his mind about displacement and buoyancy. He considered that objects sink in fluids until they displace their own weight in those fluids. When they sink beneath the surface they displace their volume, which is easily measured. The physical properties, and even the purity of elements and substances heaver than fluids could be measured by displacing them in fluids, by taking careful measurements of the amounts of displacement, and by using a system of logic, the known weights of elements, and mathematics to determine their elemental components. He could even "diagnose" the king's crown, determining whether or not the gold had been adulterated with another metal.

He was on fire! He was bursting with enthusiasm and thought that as soon as he got to class he would gather his physics students together, gather some vessels of water, counter balances, various objects, and conduct experiments to prove whether his nebulous notion was either correct or incorrect.

He entered the classroom almost shouting with ecstasy in apprehension of what would result. He gathered his students around him, told them what he had in mind, and they enthusiastically began assembling things to conduct the experiments.

Suddenly Archimedes caught a glimpse of something. He looked up. In the transom window of the classroom door he saw the principal glaring at him for not following the lesson plan he had written seven months earlier.

Hastily he ordered his students to their desks, had them open their textbooks, and began having them recite and memorize the periodic table of the elements. What a lamentable deprivation of discovery!

It is lamentable that this kind of thing happens so often in modern American "education." This is one of the reasons I am a recovering teacher. This is one of the reasons I teach classes for free. This is one of the reasons I wrote this parable and am sharing it with you and with Ellie May. This is one of the reasons I say to teachers, "Teach well. Inspire those minds to learn. Let them know there is a wonderful world out there and they are going to inherit it. Tell them there are such things as romance, adventure, discovery, and the joy of learning. Tell them there are still verbal languages and that there is much more to what they are

experiencing than digital apparatuses, football, basketball, track, and cheerleading, even as wonderful as these things might be. Help them discover what it is to be alive and to be conscious of being alive. And by all means, assist them to devise a way to cope with the inane, begodded attitudes of the inferiors who presume to be their superiors!

"Are you off again daydreaming, Worrell," asked Ellie May Lucille. "You are really weird, Worrell, you know that."

"Believe me, Ellie, you are not the only one who thinks that. I have been weird all my life. At least that is what most people think. But I tell you one thing, Ellie, I would not be so weird if everyone else was not so insanely normal!"

"You are a bit arrogant, too, Worrell, but I still love you anyway."

"I love you too, Ellie May, and there is nothing arrogant about that!"

And I was again off in my reverie. I thought about my bother and his high school experiences. He would have been valedictorian at Odessa High School had it not been for his poor grades in mathematics. He would get into arguements with his math teachers: the ones that were generally football coaches. John would make mathematic grades in the 80s on his report cards. All his other grades were 100s.

When he was graduated from high school at age sixteen he entered the University of Texas at Austin as a pre-med major, having chosen that field above becoming a concert violinist. Because he was "weak" in mathematics he took such courses as electives. That is when he met Dr. R.L. Moore, who recognized his brilliance. (It would serve any educator, and especially mathematics teachers to Google Dr. R.L. Moore.)

By age twenty-seven John Mays Worrell, Jr. had earned an MD from the University of Texas Medical School, John Sealy in Galveston. He had also earned a PhD in mathematics from UT in Austin. He was the resident physician for the UT Health Services, was licensed to practice medicine in three states, and spoke four languages. He was instrumental in the success of the first moon landing and the first Mars landing, having conducted topographical research for NASA. A recent Discovery Channel program testifies to this. Ah, but the high school

athletic coach math teachers scored him low!

Touché! I must admit that the University of Texas is an institution of public learning. Be that as it is, but such institutions as UT was is those days are rare and are far from what we consider as the public school systems. Yet even the fine universities have their share of mischief. Dr. Moore was fired. He turned out more world-class mathematicians than probably any professor in the history of American collegiate teaching. But he was fired because of his age and because of his nonconformity!

As I continued my reverie I remembered my days of graduate school at a well-known university. I had earned a BFA there in Sociology with an English minor and I later earned teacher certification in art education at the secondary level, as they say. After that I entered the graduate school and worked on an MFA in sculpture. I had forty-five hours on a sixty-hour program, and that with a 3.8 grade point average. I would have had a straight four-point average had it not been for my philosophical contesting of some of my art professors. My friend and sculptor teacher there, John Queen told me confidentially that "they did not like me and would never let me graduate."

He advised me to drop out and find another school. I did. I enrolled at another well-known university. I was able to transfer six of my forty-five hours. ($ talking again!)

At the university into which I transferred I earned a masters degree in painting and drawing with a sculpture minor. A few years later I took a leave of absence from Odessa College to accept a doctoral fellowship at that same university. At the same time I accepted a position with Houston Baptist University as a consultant.

All went very well until I took my written exams for my doctoral studies. The great day came where my committee met to evaluate my writings. The ceramics teacher was a "friend," or at least an acquaintance. I had not had one class under him but we drank beer, socialized together, and talked about acreage and bobwhite quail. He was on my doctoral committee because he was "graduate faculty." He was appointed at the exclusion of the sculpture teacher, Richard Davis, who was not "graduate faculty." More insanity.

He came out of the meeting room, walked up to me and said, "Well, I am the bad guy."

"What do you mean?" I asked.

"I failed you on your question."

I was shocked! "Why?" I asked, as I reflected upon the question he had submitted to me. I regarded it as a rather stupid question, though I did not tell him so. It was as follows: "Give a brief history of ceramics in America from colonial days to present." I wrote for three days on that question, and in the process raised some questions of my own, such as "North America, South America, Central America, or the part of America that lies north of the United States border?" I also asked about to which colonization he was referring, for there have been several colonizations in the Americas. I addressed them all and wrote about them all: those of Spain, France, England, Sweden, the Netherlands, and that of the first people who migrated across Beringia and eventually became the Anasazi, Pueblo, Hopi, Zuni, the Mimbres, and on and on. I researched their contributions to ceramics also, and I included such information in my answers to his question.

I was not tying to be a wiseass. I was simply attempting to be scholarly and thorough. I concluded by stating how indebted the modern United States of America's art world is to Paul Soldner for introducing the process of *raku* into this country.

The man said, "That is just not true." I argued with him, explaining that *raku yaki*, as it really should be called, originated when a Japanese ceramist witnessed a Korean tile maker pulling red-hot ware from a kiln in order to speed up the tile manufacturing process. An earthquake had destroyed much of his village and there was a drastic shortage of roofing tile. The visiting ceramist took the process to Japan and incorporated it into the studio pottery processes, where it became known as *raku yaki*, was associated with the Zen Tea Ceremony, and became the national art form of Japan.

Bernard Leech, a British graphic artist, had visited the studio of Hermado in Japan and had there experienced the *raku yaki* Zen Tea Ceremony. He was so impressed that when he returned to St. Ives, Cornwall England he gave up graphic art and became a ceramist: one of

the most famous in the world.

Paul Soldner later visited Leech's studio and was introduced to *raku*. He brought it to the United States of America, added a reduction process, and it has become a major part of the ceramic studio art form, especially popular in collegiate ceramic courses.

I confronted the man who had failed me on the answer to his question with these facts. His reply was, "Man, can I just level with you about something?"

"Okay, what?"

"My wife is in this doctoral program and she is having a real hard time. If I make it easy on you I am going to catch hell at home." I informed my committee chairman of this incidence. He then replied, "The doctoral program is a bunch of bullshit. It has always been a bunch of bullshit. It will always be a bunch of bullshit." Then, that was the end of it. He made no effort at all to defend me. The chairman of the art department told me, "The success of the doctoral student is directly related to the strength of the committee chairman, if you get my candor." I thought, *the doctoral program is a bunch of bullshit. It has always been a bunch of bullshit. It will always be a bunch of bullshit.* At least it was bullshit at the University of North Texas.

I packed up my things and went to Houston Baptist University, where I was professor of art for six years. I did not re-take written exams. I did not complete a dissertation. This led to a very wonderful, fulfilling, and rich life.

I recently told the new president of that university this story. She was mortified and shocked. She asked me to tell the dean of the College of Visual Arts and Design the story. He was aghast. "What can we do!" He exclaimed.

"Nothing," stated the president. Then I explained, or attempted to explain to them that as disgusting and painful as the experience was back then, that it is a small price to have paid for the story I now have, the story I am now sharing with readers.

I later became a member of the advisory board of the College of Visual Arts and Design at that university. I would probably have seen the man that failed me again had I not resigned the position. After all

those happenings it seemed ironic that I was appointed to that board.

Another kindred event occurred regarding Odessa College. I was surprised one day when I received a call from Grace King, president of the Odessa Heritage Foundation, an organization founded by the late William D. Noel. She told me I was to be honored as one of that city's former outstanding citizens. I was a bit shocked, especially after all the trials and tribulations I experienced while teaching at Odessa College.

The main problem for me with Odessa College had three sources. They were: one of the universities where I did graduate work, the chairman of the art department at Odessa College, and faculty meetings. The latter, in my opinion, was over the notion of regressive evolution. It was the O.C. art department chairman who did not want me to be graduated at Texas Tech University, or from any other university, for that matter, because if I were not graduated I would lose my job at O.C. and he could hire a friend to replace me. Thus he stirred up all sorts of trouble on my behalf every place he could, and at every opportunity. He stirred great amounts of trouble for me at Texas Tech University and that is why I had so much difficulty with my graduate committee. In the long run, though, he lost his war.

Faculty meetings were quite controversial, and quite like carnivals. The faculty was usually asleep and the administrators were usually hyper from overactive adrenal glands. They always got so pumped up when they got to administrate! They loved to administrate! My sister/manager told me I should not mention the real names of the officials, but unless I do a lot of meaning will be lost. There are names such as Bernard T. W. Sedate III, the chief dean under the president. Dean Sedate should have been sedated. There was Phillip Speegle. President Speegle was always flaunting his catalogue of insane proposals. And there was Dr. Joe Buice. (We called him Joe *Bias* and sometimes Joe *Bi-Ass.*) Dr. Buice made constant displays of his arrogant intellectual superiority. The pronunciation of his surname fit his personality, just as with the names of the others. Mr. Phillips, the art department chairman constantly confused his identity with that of Almighty God. And there, now the reader has a portrait of the Odessa College administration.

On one particular hot and boring August day, the first day of our return from a summer off, there was a motivational faculty meeting.

(Now, keep in mind the notion of regressive evolution.) Dr. Speegle had paid many thousands of dollars to an educational specialty company out of Chicago to come motivate the Odessa College faculty. A part of the motivation was to have the faculty engaged in making paper airplanes. Alas! The staff of the education specialty company that the Odessa College administrators had hired to motivate us lowly teachers had forgotten to bring the paper to make the airplanes. In fact, it had forgotten to bring almost all of its motivational material. The materials were back in Chicago. Well, so much for teaching and inspiring the faculty. Can't teach and inspire if you can't make paper airplanes; and forget teamwork, because without the paper the assembly line could not operate. So there we were, in our limbonic fluid, gestating into incompetence. At that point we were instructed to *pretend* that we were making paper airplanes. Now, just attempt for a moment to *imagine* that you are precisely folding paper into flying objects and that you are in a contest with other groups of faculty members to determine which group could produce the greatest number of these imaginary objects; then you will catch a glimpse of our predicament. It seemed easier to visualize a black hole.

So there I was, trapped within a crowded and stuffy room on a hot, August, Odessa day tying to pretend that I was on an assembly line manufacturing paper airplanes without any paper. After about two minutes of this I stood up and exclaimed, "We are finished! We have manufactured 17,000,003!" The faculty laughed. The administrators glared at me and told me to sit down and shut up. There was not much I could do except drift into reverie for escape. Thus I began to remember my kindergarten days when the only thing Mrs. Coffee would let me play was the triangle. I played one note, over and over, either loud or soft, depending upon how hard I struck the triangle. At least it wasn't as boring as faculty meetings, and there was a certain girl to look at, although in later life I was most grateful that she did not take a shine to me. She just never seemed to quit growing. Toenails don't either, but at least you can trim them off. I know some people don't but that's their problem, unless, of course, it is a girl sleeping in my bed without an invitation. Then it becomes my problem because I do not like having my legs all scratched up because someone has not become *disungulated*. There are enough grass burrs and cactus to take care of that, and if there

were not, some pervert would probably go around seeding them, kinda like Johnny Appleseed or Kokopelli did by going around planting apples on the landscape or babies in wombs. Who knows? The Shadow will lie every time and tell you he does, but he doesn't even know Jack what's-his-name. For that matter I have only known one individual who does know Jack, and that is because he had it on a bumper sticker in Santa Fe. "I Know Jack Shit," it proudly proclaimed.

I know; he could have been lying too. Santa Fe can be kind of weird, like Austin wants to be, and let me tell you that after being at the zoo they call Maria's Taco Express for the Gospel Brunch I can give you the fact that there is no way in Hell that Austin, Texas will ever not be weird.

The thing that makes people weird is that everybody else is so almostmighty normal! I know I would hate to be that way, even if hate turns your heart black, which means, I guess, that no blueblood person can really ever hate, at least like you are supposed to hate if you are of certain religions. Some of them hate themselves so much they blow themselves up, and they have a big shock in the afterlife.

It never made much sense to me but neither did faculty meetings and that is where most of the problems began, at least at Odessa College, with regressive evolution and all. And if you don't believe that just go sit in on one at any university or especially any community college, especially Odessa College as it was when Phil Speegle was president, Bernhard T.W. Sedate III was dean and Joe Buice was divisional chairman. They called him divisional chairman for a reason you know, and if our citizens are stupid enough to elect a certain nominee president things will get a whole lot worse, just like with faculty meetings, and especially if we forget what one of the former presidents did with cigars. Did you ever wonder what he was doing having cigars anyway, when the media used to show him running and exercising, and then he had to undergo open heart surgery? Well, let me tell you, one young girl dang sure knew.

Well, that's about it for tonight's bedtime faculty meeting story. I had to put this all down on paper because the TV writers are all on strike and somebody's gotta do something even if they really don't have to, or at least don't think they don't have to until at a faculty meeting

some college or university administrator says they do. When that happens I cast my vote for mutiny, even if it does sink the ship we are all on, the Ship of State. Worse things could happen, you know, like having to go to another faculty meeting, and sometimes they won't even let you drink coffee and they still say a blessing! One of these days the ACLU is going to show up right in the middle of that blessing and all hell will break lose.

I did that once, offered the prayer at a Black Southern Baptist revival meeting because I was asked to, and believe me, I couldn't even hear myself think, much less understand what I was asking God for. This was because half the congregation kept hollering "amen!" Had I understood just what I was asking for I might not have been asking for it. Keep in mind that since I did not understand what I was asking for I really don't know whether it was granted or not, but it really does not matter because right now I am driving down the highway towards Houston. I am going to Houston Baptist University to use the art department's clay mixer. I am joyful that I do not have to attend a faculty meeting or make certain my sideburns are not below my ear lobes. That should certainly render an idea about whether my blessing was heard or not.

And, dear reader, if you think the last few paragraphs do not make much sense and appear as the work of some quasi-literate, demented, irrational person, you really got it! That is what most faculty meetings were like back in the daze when I was teaching!

Ellie gave one of her famous groaning sounds, looked up at me, yawned real big, licked her lips, sighed, placed her beautiful, silky head flat upon the sofa cushion and said, "Good grief, Worrell! This really makes me glad not to be a human: and especially a human college teacher! A faculty meeting would probably give me rabies or distemper!"

ELLIE EXPRESSING MY SENTIMENTS
ABOUT FACULTY MEETINGS

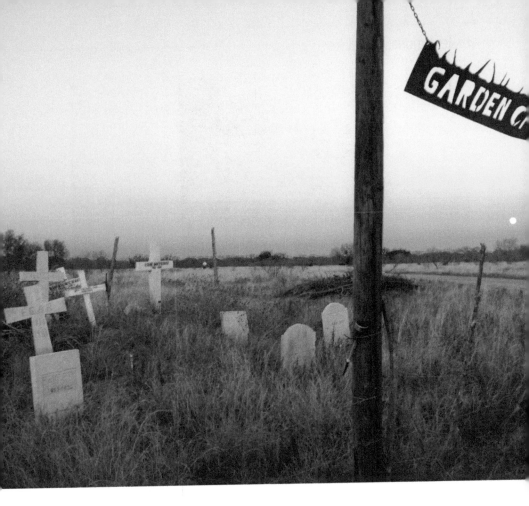

HATE, ENVY, POVERTY, BLAME,
SHAME, AND OTHER GARBAGE
IS BURIED HERE.

XVII.
Confusion
About Prayer

"*Worrell, you seem to be in a trance,*" said Ellie. "What's going on?"

"Aw, Ellie, I was thinking about that question you asked me a while back about deism. That got me to thinking about other things and I got to thinking about prayer."

"What is prayer, Worrell?"

"That is what I am trying to figure out, Ellie, Baby. What *is* prayer? What is prayer, or what *should* prayer be?"

Then I reminded Ellie that the philosophy of deism purports that God created His creation(s) then left the scene, so to speak, that the deistic concept is that there is a God but He no longer has involvement with His earth product. This would render prayer useful only as a sort of

self-hypnosis, or as a means to bond humans together by some common spiritual thread, some hysterical association. Hysterical, that is, should they be praying in a group and outside their closets and in public, as Jesus instructed followers not to do. I mean after all, Ellie, people violate the commandment about prayer as much as they violate the one about idolatry. They seem to have all sorts of gods before themselves, sometimes, and they have portraits of Jesus hanging in their church buildings.

"Now, keep in mind, Ellie, that the things I tell you are my opinions. They may be correct and they may not be correct. They may be no more than ideas or wonderings. The God of Judo-Christianity is all knowing, all-powerful, all loving, and through Jesus, his "Only Begotten Son," He is all-forgiving. At least this is the claim made by Christians. What a paradox this presents regarding prayer. In a certain sense it could even make prayer insulting to God. Here is an example of the paradox and my confusion. As I write this you and I are driving west to Santa Fe on Highway 285. Four hundred miles to the east I have a friend in Austin with cancer. It is in her lungs and it is in her brain. Along with her family and her other friends I pray for her healing. If God is omnipotent and all loving, then why did He allow her to be infected? So we could all pray for her? So that she would then be healed and her healing would make our faith stronger? Surely God's love exceeds my capacity to love and I would heal her instantly if I could. I would have prevented the disease in the first place if I could have. Why is she not healed? If God is all knowing it seems it would not be necessary for me to bring this to His attention by praying for her healing, and if God is all-loving it seems He would not have allowed the disease to enter her body in the first place, or it seems that He would eradicate it from her without my having to ask Him to do so. See why I am so confused?

"Prayer is more than a bit confusing to me, at least it is in the way it has always been presented to me. Jesus said, 'You will hear of wars and rumors of wars. Let not your hearts be troubled, for such things must needs be.' Yet I find myself praying for world peace and mutual co-existence. Do you know what I was doing about 9:00 a.m. on September 11, 2001, Ellie, before you were born?"

"No, Worrell, what were you doing?"

"I was praying at that very moment for world peace and mutual co-existence among all people and nations. The phone rang while I was praying and it interrupted my prayers. The ringing phone was so distracting that I stopped what I was doing and answered it. It was Michelle, my assistant, telling me the World Trade Center had just been sabotaged. I mean it happened even while I was praying for worldwide peace among all people! And I was not praying in public, either. I was alone in the peace and serenity of New Art.

"Jesus said when we pray we should go into our closets and pray to the Father in secret, yet I have prayed in public, and such is a common practice in almost every Protestant church and in every Roman Catholic Church.

"Jesus said not to use vain repetitions when praying, yet I find myself making some of the same requests of God over and over, as if His memory were shorter than mine. Vain repetitions may be the cause of much grief, for all I know. Consider this bit of poetry I recently penned.

A PRAYERFUL ADMONITION

People pray for rain -
There comes a flood
They pray for the flood to end
There comes a drought

Someone lonely prays for company
There comes a crowd
The crowd will not leave
So the lonely one prays for solitude

Sometimes it is best
Just to be satisfied
To be satisfied with the status quo
Best to stroll through life

Best to stroll through life
Travel in a gentle lope
Take leisure in the walk
Than to sprint to the finish line

"What is it that drives us to our knees? Is it love, is it fear, is it ritual, is it confusion, or is it something we cannot understand?" I am convinced about one thing, and that is that sometimes people think they are praying when in reality they are giving God instructions. One day an old friend from high school just suddenly appeared at my door. I had not seen him for years. I asked about his daughter and her husband, and he proceeded to tell me how they were suing him. The suit was over money and possessions, as many lawsuits are. During his relating of the details to me he wanted to go down by the River, and there, suddenly he said, "Let's pray," and he grabbed both my hands, bowed his head and for about twenty minutes he gave God a full account of what I am convinced God already knew. Then he tacked on a few instructions for God to follow. Little wonder so many think there are so many unanswered "prayers." That experience prompted me to write another song.

I'LL DO THE TALKING (WHILE YOU DO THE LISTENING)

I was weary I was burdened as I traveled along
Headed down life's confusing highway
My heart was heavy my mind was troubled
So I bowed my head and I prayed

I said, "Lord, God please help me, I know You can
There are so many things I need from You
There are so many things I don't know where to begin
And Lord, I don't know what to do"

I paused for a moment to catch my labored breath
When a voice came down from the sky
It said, "Let me tell you, Worrell, you sure do talk a lot
I can't get one word in edge-wise

Now I know you try to live a decent life
I know you often walk the extra mile
But have you ever thought about just being quiet
And simply listening for a while?"

(Then that Voice said, "Worrell –)
You do the listening – I'll do the talking
That is the way it should be when you pray
People are so busy telling me what to do
They seldom hear a thing I have to say

Let not your heart be troubled by these worldly things
Just walk this road by faith every day
Don't worry 'bout the things that really do not matter
All your worries won't change them anyway."

I stopped doing so much talking started doing lots of listening
Then a brand new world opened up to me
I started hearing clear directions – LIGHT was all around me
And I saw things that I had never ever seen

So I laid my burdens down my troubled mind was eased
As I traveled life's beautiful highway
There was no more confusion, no more heavy heart
When at last I was taught how to pray

(He said,)
"You do the listening – I'll do the talking
That is the way it should be when you pray
People are so busy telling me what to do
They seldom hear a thing I have to say

Let not your heart be troubled by these worldly things
Just walk this road by faith each day
Don't worry 'bout the things that really do not matter
All your worries won't change them anyway."

"You still haven't answered my question, Worrell!" Then Ellie gave a long groan and stretched her beautiful, black body. She said, "You know, Worrell, you need to relax. You get so upset. Can't you just be content with the notion that God loves you and is not going to harm you?" Then she went to sleep. I drove on to Santa Fe.

~

As I was standing at my computer editing this story I kept hearing a strange noise. It sounded like it was in my studio. I looked around and could see nothing, but I heard a noise. I cupped my hands around my ears and attempted to listen more closely. I heard a scratching sound but I could not locate it. I went back to the computer and to the task of editing and typing.

I heard the sound again. It sounded like a large insect flying behind me. Suddenly it dawned upon me what it was. It was a hummingbird! I recognized the sound, looked up and saw it executing a rather wobbly flight before it landed upon the stucco wall on the other side of the room and a bit out of reach. It must have been in here making attempts to exit all day. I was pondering how I could catch it and release it outside when it flew a bit more and again landed on the wall, scratching the plaster and pecking at it a bit. As I was about to attempt to grasp it, it flew again, landed on the wall and slid to the floor, exhausted. I picked it up and it made a mild but feeble protest. I grabbed a spoon and dipped it into a sugar bowl, then stirred in some water. I held the offering to its tiny beak. Nothing happened. My nose was itching. I had no free hand to scratch it, so I just let it itch away. Then I noticed a tiny tongue come out of the beak and lap the sugar water in the spoon. Faster and faster it lapped. I could actually see the abdomen of the creature begin to expand. I was afraid the little bird might overdose on sugar, so I allowed it one final, concentrated lick and placed it in a tray-like feeder outside, above the reach of Milagra and Katrina, the two resident cats.

During all of this I completely forgot about a pot boiling on the kitchen stove inside the house and I burned a BIG cooker full of beans. I did not care, the bird was worth more than a dozen pots of beans; but

after I placed it in the feeder I ran to the stove and turned the flame off, then went back out to check on the hummingbird. It was just sitting there, and did for a long, long time. I noticed a big blob of sugar on its beak and then realized it had hardened and the bird might not be able to open its mouth. I tried to wipe it off and the bird did not protest, but the sugar had hardened. I got a spoonful of clean water and soaked its beak in that. Suddenly it stuck out a very long, rather white-looking tongue and hopped upon the rim of the feeder. Then it flew and lit in a nearby mesquite tree. It flew again and went to a higher tree. Then it flew to the highest clump of branches and leaves and after that into the beautiful Texas Hill Country landscape. It was free!

Ah! Freedom. Freedom. Just like most of us have. That creature was free to leave my studio at any time of its choosing, because the doors were wide open. But in its panic to be free it had confined itself by hovering near the rafters, three feet and two feet and fifteen feet above the open doors.

"Did you see all that, Ellie?" We do a similar thing all the time. We are so free, and we do not realize it. We enslave ourselves. We go into voluntary captivity!"

"Hey Worrell," Ellie said, "Since we are free do you want to go play some Frisbee?"

We did!

NEXT PAGE: ELLIE PLAYING
AIR DOG, FRONT YARD, TEXAS

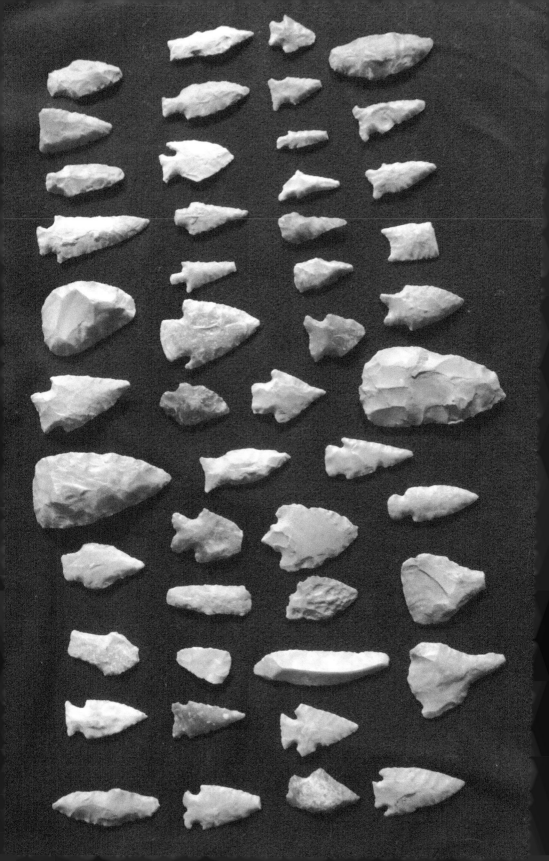

TOP: ARTIFACTS PICKED UP
OVER 60 YEARS AGO

LEFT: 1,200-9,000 YEARS OF
ANTIQUITY...DARTPOINTS,
ARROWHEADS AND SCRAPERS.
4TH DOWN ON RIGHT IS A
BROKEN OBLIQUE YUMA OR
ALLEN POINT

XVII.
Meeting
God

after a long session of swimming, minnow chasing, stick retrieving, and a bunch of tosses of the Frisbee Ellie asked me this:
"Worrell, how did you meet God anyway? Did your parents introduce you? Did you meet God in Sunday school? Did some preacher tell you about Him? Some school teacher? Did He reveal Himself to you in a burning bush like you told me He did with Moses, or just how? Did you meet Him when you were real young or later in life? And, hey Worrell, How did you know when you met God, anyway? Is He invisible? I heard some old guy on the TV say if anyone ever looked at God he would die: 'surely die,' that guy said."

"Well Ellie, maybe all of those things have happened to me. It seems they have, but I think the latter part of your question is the ultimate answer, and for sure it was the most profound of all my

experiences."

"You mean invisible?"

"No, I mean later in life. When God revealed himself to Moses
He commanded him not to make any graven images of His Being,
yet His portrait is on the Sistine Chapel ceiling. It is there by order
of a previous Pope. That was a man named Pope Julias II. In 1941
Warner Sallman painted a portrait he named 'Head of Christ.' This
portrait is almost ubiquitous in Christian churches, having sold more
than 500,000,000 printed copies! Imagine that. If he (or his heirs)
only received a nickel a print they would be wealthy. That would be 25
million dollars, and no telling what the original is worth. But remember,
it is nevertheless a graven image, and thus a violation of the second
commandment – if Jesus is a part of the Holy Trinity and therefore is
God. For that matter just consider the entire Ten Commandments and
consider how many of them are violated by the churches and by many of
the (so-called) believers. Here those commandments are:

1. Thou shalt have no other gods before me.

2. Thou shalt not make unto thee any graven image, or any
 likeness of any thing that is in heaven above, or that is in
 the earth beneath, or that is in the water under the earth.
 Thou shalt not bow down thyself to them, nor serve them:
 for I the Lord thy God am a jealous God, visiting the
 iniquity of the fathers upon the children unto the third
 and fourth generation of them that hate me; And shewing
 mercy unto thousands of them that love me, and keep my
 commandments.

3. Thou shalt not take the name of the Lord thy God in vain;
 for the Lord will not hold him guiltless that taketh his name
 in vain.

4. Remember the sabbath day, to keep it holy. Six days shalt
 thou labour, and do all thy work: But the seventh day is the
 sabbath of the Lord thy God: in it thou shalt not do any
 work, thou, nor thy son, nor thy daughter, thy manservant,
 nor thy maidservant, nor thy cattle, nor thy stranger that

is within thy gates: For in six days the Lord made heaven and earth, the sea, and all that in them is, and rested the seventh day: wherefore the Lord blessed the sabbath day, and hallowed it.

5. Honour thy father and thy mother: that thy days may be long upon the land which the Lord thy God giveth thee.

6. Thou shalt not kill.

7. Thou shalt not commit adultery.

8. Thou shalt not steal.

9. Thou shalt not bear false witness against thy neighbour.

10. Thou shalt not covet thy neighbour's house, thou shalt not covet thy neighbour's wife, nor his manservant, nor his maidservant, nor his ox, nor his ass, nor any thing that is thy neighbour's.

We could write a book about how many of these are broken daily, even by the clergy! No wonder it is so hard to persuade people to believe in God! When St. Paul appeared before the Roman King, Herod Agrippa and testified about his experience with Jesus, the king said, 'Almost thou persuadest me to be a Christian.' The world looks, and has looked with contempt at the violations of proclaimed believers and their oftentimes lackadaisical disregard for the teachings of the scriptures they claim to believe and live by. Then, in agony this world moans and cries, 'Almost thou persuadest us to be atheists.'

"There is a word of common slang or vulgarity that refers to the incredibility of almost anything. The word refers to the fecal material of male bovines. There is an overwhelming and endless abundance of that material infused with almost all organized religion, but a lot of people will not admit this. Some will be offended at my telling you this. This is due to fear, Ellie. It is due to fear. Fear seems to lock people into this organized, or disorganized, if you will, element and prevents them from experiencing pure and true spirituality. They are afraid they are going to make God angry and that He is going to severely punish them for so doing, or that He is going to punish them by casting them into eternal Hell. The truth is that God does not punish people nearly like people

punish people! God has not burned people at the stake, but the Puritans have. God has not beheaded people, but officials of the church have. God has not engaged in such conspiracies as has the Roman Catholic Church and the King of France, the one in particular who created what is called 'Black Friday.' Organized religion has, throughout the centuries, tortured, maimed, and killed people for blasphemy, witchery, heresy, and opposition to the establishment: opposition to what the self-appointed prophets, priests, preachers, and gurus self proclaim. I do not think God has done this, but the priests and prophets have done it, and claimed that God instructed them to do so. They even did it to Jesus. It should be noted that God has the power to do such acts without having to command Samuel, Solomon, the Pope, Osama bin Laden, George W. Bush, or Barack Hussein Obama to do so. The paradox implied by this makes a good case for deism.

"Much mischief has been done in the name of religion, and much mischief is still being done in the name of religion. A friend wrote me a note the other day and said, 'Religion is for people who are afraid of going to Hell. Spirituality is for people who have already been there.'

"When I met God that day in Houston I forgave Him, and I forgave Jesus, too. I forgave them for all the wrongdoings of man, since man is God's creation. This sounds absurd, if not blasphemous, but it was true for me, and God is not angry with me for it. I had simply been holding God responsible for all of men's evils. After all, God made man. It suddenly became very clear that all of the evils of human beings have not been God's fault, any more than my own children's misconduct have been my fault. For so stating that I forgave God I would have been burned at the stake, lashed with whips, or decapitated, or placed in blocks in former times. It is true; I did forgive God, in the spirit of how we are taught that we should forgive one another. I might better phrase it by saying that I came to a point of understanding where I held God blameless for the actions of mankind. I am totally at peace with how I think God feels about my attitude, too.

"I met a God quite different from the one described by the ranting, raving, maniacal, screaming, and fanatical, self-proclaimed prophet-guru-preachers that I have seen in person, or have viewed over television. I met the most peaceful, wonderful, loving Spirit I have ever

known. I met a God who looks like a tree. I met a God who looks like a flower, who looks like the sky in endless splendor. I met a God who looks like a child, who looks like a beautiful woman. I met a God who looks like the mountains, the seas, the rivers, the plains, the oceans, and all of the wonders manifested about me. I met a God who sometimes looks like me. The latter statement sounds vain and pretentious, doesn't it? It is not. Why else would I be? Why else would you be? So I am a blasphemer, I admit it. I do not believe what Ezekiel said when he (allegedly) stated that the best works of man are but filthy rags in the sight of God. I have seen far too many beautiful and wonderful acts of human kindness to believe this! Yes, I know, Ezekiel was only trying to describe the absolutely incomparable goodness of God. That is the problem with taking a written sentence and transforming it into dogma! And what I have said is not pantheism, either, yet I would not be so brazen as to tell God that I think He did a really good job with nature.

"When I met God I met the true Creator who has always been. This was not the god men have so often created in their own image. It was The One who has not been defamed and bastardized by human liars.

"When I 'surrendered to the ministry' it was under the auspices of a different god. This was the god of wrath, vengeance, jealousy, and cruel, unending punishment. That god caused me a lot of consternation, and it was exacerbated by my friends and associates in the church and over at the Baptist Student Center. Because of them I knew I had to go get the soul of my dear friend, Doc Lane saved. Those of us who were redeemed by the blood of Christ had to witness to everyone in the entire world and convince them to be saved by accepting Jesus Christ as their personal Lord and Savior. If we did not do this we were sinning. It was that old sin of omission, and in this sinning process we ourselves, along with our peers heaped and heaped guilt upon our own poor, miserable, wretched souls. Not only that, the people we loved who did not accept Jesus and confess with their mouths this acceptance and believe it in their hearts were going to burn forever in the flames of Hell, and we might be accountable for this! Those of us who did repent and accept Christ were going to be in Glory Land forever and forever, watching their eternal torment! What a nauseating and horrible torment that would be! What a torment to view loved ones in eternal agony, burning in the fires of Hell while we enjoy eternal bliss! And what a paradox

that their blood was going to be upon our hands! We were saved by the blood of the Lamb. Our sins were forgiven. We were redeemed, yet we were going to be held accountable for the disbelief of others. This is what we were taught by the 'Christian' authorities and leaders: those who, again, so very often confused their own identities with that of God. Just imagine, Ellie May, how in any way could someone be happy in Heaven while viewing friends and loved ones burn in eternal torment? How?"

Ellie whimpered, then she said, "Good grief, Worrell! This stuff is depressing! Can't we talk about chasing deer and minnows instead of all this messed up religion stuff?"

"Yes, we can, Ellie, Baby Doggie, and we'll go to the River and go minnow chasing in a little while. But first let me tell you about how I tried to get my friend, Doc Lane saved."

Ellie rolled her eyes, yawned real big, rolled herself around in a couple of curls, and then, resigned to my diatribe, lay down on the cool floor of the studio. "I really have no choice, do I, Worrell?"

"Doc was one of my best friends. He was a chiropractor. A sign

RESIGNED TO HEAR ABOUT DOC LANE

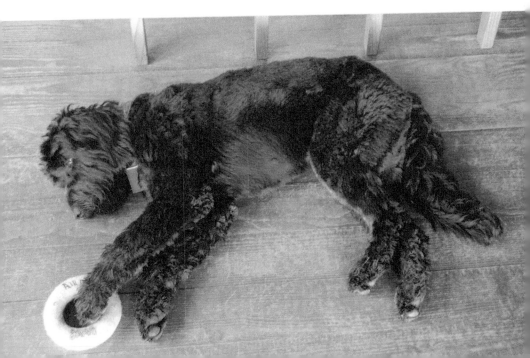

hung over the door leading to his modest, upstairs office on Main Street in Colorado City, Texas. It read, 'DR. CHARLES HENRY LANE, D.C.' We hunted arrowheads together, Doc Lane and I. I introduced him to David (Clabber) Merritt and the three of us hunted arrowheads almost every Sunday. David and I would arise at 4:00 a.m. and pick Doc up at his Chiropractic Clinic, then head to Silver or Robert Lee, where there were all-night oilfield cafés. That is where I learned to not only drink, but to also love the taste of black coffee. We would have coffee and a doughnut, and then travel on to some ancient Indian campsite, walking its haunting and sacred grounds before the sun rose. We would walk through those ancient sites that were littered with astronomical pieces of chipped flint and long abandoned tools, some of which had probably not been touched by human hands for three thousand years. We later learned that some of those flint artifacts were six to nine thousand years old. It was magic! David and I would cut off the legs from an old pair of jeans, tie knots in them to transform them into sacks, and literally fill them with flint artifacts.

David and I were Tom Sawyer and Huckleberry Finn. Doc was our friend: my friend, and likely Samuel Longhorne Clemens reincarnated. He was in his eighties and I knew he did not have unlimited time on this earth. I had to witness to him and get him saved. If I did not do this he would die and burn and suffer forever in the eternal fires of Hell and his blood would be on my hands!

"I was filled with dread about this task, about witnessing to Doc Lane. I fired up my old 1949 Mercury and drove from Lubbock to Colorado City to tell this eighty-however-many-year-old chiropractor about Jesus. At the time I was a Texas Tech student, twenty years of age. I told him he was lost, he was going to go to Hell, and he needed to repent and be saved. When I finished my plea he looked at me and said, 'I appreciate your concern. Jesus was a brilliant and wonderful teacher, and if the world lived by his teachings it would be a much finer place. The problem is that after Jesus was crucified his disciples got hold of his teachings and they have been fucked up ever since.'

"I am not intending to be offensive by using the f-word, Ellie May. There are those that state it should never be used in any literature, just as the word 'aint' is not to be used. That is some more of that male

bovine fecal material, and what I just stated is as verbatim a quote
as I can remember after more than fifty-five years. I left Doc's office
feeling like a failure for not succeeding in getting my friend saved. In
the five decades that have followed I realize the truth and the wisdom
in Doc's admonition. After all these years I have come to realize that
Jesus was a brilliant and wonderful teacher, and if the world lived by his
teachings it would be a much finer place. The problem is that after Jesus
was crucified his disciples got hold of his teachings and they have been
fucked up ever since. It is in that spirit of knowledge and understanding
that I state that I met the beautiful, pure God, One whose concept has
not been corrupted by human mischief.

 "Were someone to ask me about believing, Ellie, I would reply
with this:

> You ask me to help you believe
> To lead you to the truth
> The task is not that easy
> For someone else to do
>
> My friend the truth is something
> Every mortal soul must seek
> It is not just a little task
> Helping someone else believe
>
> I cannot believe for you
> Just as you cannot for me
> But when you find the truth
> You'll find a peace beyond belief
>
> In your uncertain sadness
> You ask me to show you truth
> My friend it's not that easy
> Here's the best that I can do
>
> I can only hope to tell you
> What the truth is to me
> It is something that I find
> In every flower and every seed

I can only hope to tell you
What believing is to me
It is something that I know
From every tree and every leaf

I can only hope to tell you
What the truth is to me
It is something that I find
In the stars and in the sea

I can only hope to tell you
What believing is to me
It is something that I know
When children laugh and children sing

Life sure has its circumstances
That produce some doubts and griefs
Drives some souls to miss the mark
Drives some souls to disbelief

But I can only hope to tell you
What believing is to me
It is something deep inside
That keeps my spirit free

I can only hope to tell you
What the truth is to me
It is something that I find
In acts of kindness that I see

I can only hope to tell you
What believing is to me
It's a light that I find
In every child that I see

I can only hope to tell you
What the truth is to me

It is something that I find
In every flower and every seed

I can only hope to tell you
What believing is to me
It is something that I know
From the beauties that I see

I can only hope to tell you

"I would submit that if someone does not believe in God he could just as easily also not believe in matter, or even in existence, for that matter. It occurs to me that if I can conceive that matter has always existed I can conceive that God has always existed.

"If I do not believe that matter has always existed then I am acknowledging creation, since, and obviously, I am. And obviously there are things around me. I cannot comprehend that disbelieving makes more sense than believing. I cannot comprehend that believing makes more sense than disbelieving – except that – I am. *Cogito ergo sum.* Just having an ability to possess the concept that all might be some illusion serves to prove to me that it is not.

"It is my choice, Ellie, and that, Doggie Baby, is why I believe!"

ANCIENT ICON

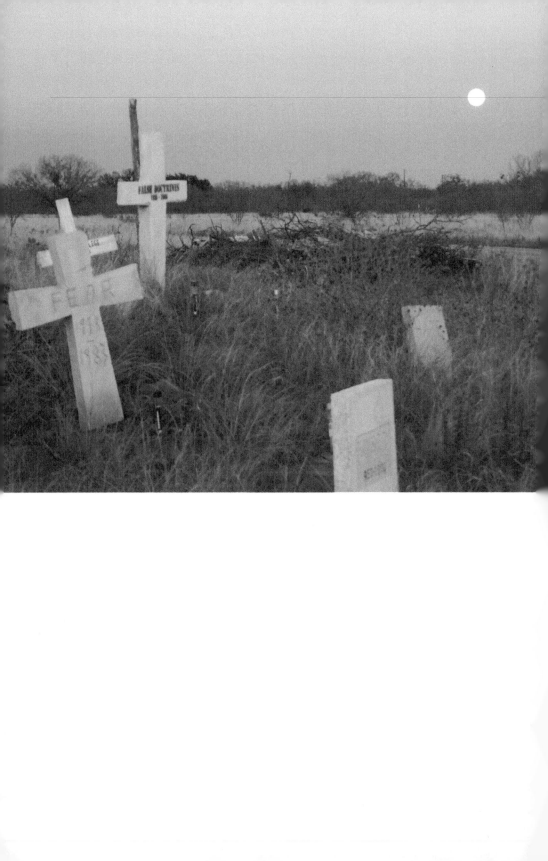

XIX.
Ellie Asks About Jesus

"*You never give short answers*, do you, Worrell? And Worrell, you sure have done a lot of different things in your days."

"I have, Ellie. I have done a lot of things. I have been a carpenter, a house painter, an oilfield refinery worker, a car parker, a preacher, a professional Boy Scout, and a teacher. I am an artist, a writer, and a musician. I am proud of some of the things I have done. I had just as soon forget some of the things I have done, too. For those I assume full responsibility. For the good things, or decent things I have done I can only give credit to Great Spirit for the inspirations.

"I wrote a song about this, Ellie. Do you want to hear the lyrics?"

"Shoot, Worrell, you're going to sing them to me whether I want to hear them or not, so go ahead. But *please*, Worrell, sing on key."

And I did.

Don't you tell no lies
When you lay me down
Speak only the truth
As you plant me in the ground

Don't bestow on me
Virtues no one ever found
Don't you tell no lies
When you lay me down

Don't create a lot of fables
Then carve them on my stone
Don't make me out to be someone
Nobody's ever known

Don't embarrass me forever
As those viewers come around
Don't you tell no lies
When you lay me down

Don't say I was a cowboy
Don't say I was top hand
But you can say I loved nothing more
Than prowling 'round this land

Don't say I was a hero
Or some famous man
Don't you tell no lies
When you lay me down

Don't you tell no lies It is.
When you lay me down
Don't say I was a saint
But don't say I am Hell bound
I am on my way to Heaven

From the faith I have found
Don't you tell no lies
When you lay me down

Whatever good I have done
You are interring with my bones
And I have done some things
I'd just as soon were left unknown

When my time has come
And people gather 'round
Don't you tell no lies
When you lay me down

Don't say that I was nothing
Other than what I have been
Ain't no need in making gods
Out of ordinary men

Don't bestow on me
Virtues no one ever found
Don't you tell no lies
When you lay me down

Don't you tell no lies
When you lay me down

"Good grief, Worrell, what brought that on?" Ellie queried.

"I don't know, Ellie. I think the older one gets the more realistic the inevitable becomes, so I have been doing a lot of thinking about my estate, my possessions, and even my remains."

"What do you mean by *remains?*"

"My deceased body, Ellie: you know, what is left of me after my soul flies away."

"I thought you'all went to Heaven after you die," she said. "I thought you got erections and went to Heaven."

"Ellie! Ellie, Baby, the word is *resurrected*, not erections. No one gets erections after he is dead, unless he overdoses on Viagra or Cialis, or whatever it is."

Did that statement by Ellie ever get me to thinking! Once again, I was absorbed in reverie, thinking about a recent communication from an acquaintance. She had emailed me and asked me a simple question: "What are your resources for the teachings of Jesus beyond the Bible?"

I think it is a poignant question. It is certainly one that presented an occasion for me to contemplate. The New Testament portion of the book that is given title to as the Holy Bible is full of references to Jesus. Outside this there are countless papers, theses, volumes, and books about Jesus: about His life, about His teachings, and about who He was, and they are all exponents of Matthew, Mark, Luke, and John, the (alleged) writers of the Gospels, and of course, Paul, a later disciple and the probable founder of Christianity. Maybe Peter, too. Notice the upper case of the pronoun, "He." That comes from conditioning: from the teachings that Jesus was and is the Son of God, the Messiah, the Anointed One, the Savior, the King of Kings, the King of the Jews, and in fact, God, or a part of the Holy Trinity, which is the Father, the Son, and the Holy Spirit. (The later is often referred to as the Holy Ghost.) That always seemed a bit funny to me, Ellie Baby Doggie. Calling God a ghost. Somehow it seems a bit sacrilegious. As long as I thought it was sacrilegious I wrote a song about it. It went like this: *(Please* do not tell anyone about this, Ellie! *Please!)*

THE HOLY GHOST
(scared the hell out of me)

In my wild and younger days
Long before I changed my ways
I had no comprehension
Of the price that I would pay

I was cruel I was mean
Full of pride as I could be
Until the Holy Ghost
Scared the hell out of me

I love to live in sin
I live to just raise hell
The shape that I was in
Was my heart was hard as nails

My life was as worthless
As a life could ever be
Until the Holy Ghost
Scared the hell out of me

Oh the Holy Ghost
Scared the hell out of me
Showed me a vision
That brought me to my knees

The love of Jesus Christ
And the Father did I see
When the Holy Ghost
Scared the hell out of me

Now I live my life
With a different attitude
My evil ways subsided
And the Devil was subdued

I live my life in peace
My heart and soul are free
Ever since the Holy Ghost
Scared the hell out of me

My heart my soul are free
And I live my life in peace
Ever since the Holy Ghost
Scared the hell out of me

There are followers of Jesus, those who believe Jesus is literally
divine, that He was born of a Jewish virgin named Mary, that He lived

a completely perfect life, that at age thirty-three He was murdered by crucifixion, and three days later* arose unto life again, ascended into Heaven and that He now reigns at the right hand of God, the Father Almighty. I think many of those who say they believe this to be true live in a constant fear of betrayal. Not all of them, but many of them. I would term it a "Judas complex."

Judas Iscariot was a friend and follower of Jesus, and although he was Jesus' friend, he betrayed his friend by revealing his identity to Roman guards. It is alleged that he did so in exchange for thirty pieces of silver. I do not believe this. I think he betrayed Christ because he was attempting to save Judaism, his traditional religious heritage. The so-called thirty pieces of silver have been a means through the ages of maligning Judas, of making him a whore. After the arrest of Jesus, and as His trials and horrible tribulations began, Judas hanged himself out of remorse for what he had done. Pontius Pilate, in attempts to satisfy Roman law and to appease the Hebrew section of Roman population resigned himself to a neutral position, declaring that he washed his hands of the matter. The trials were completed and Jesus was executed.

This is another example of religious zealots plotting and conspiring to engage in illegal activities and deceiving themselves into thinking that the end justifies the means. The Jews, that is from among them the elders, the priests, and the Sanhedrin, had no legal method of stopping the young heretic, Jesus: not by Jewish law. Neither did they have any legal method of putting him to death, something that would surely quite his blasphemies. Thus they successfully schemed with the Roman officials to carry out the punishment and the execution, devising a rhetoric by which he could be condemned under Roman law. By Roman law there was a legal way to kill Jesus: just accuse him of insurrection. That is what they did, and they convinced Judas to reveal His identity.

Judas is one of the truly pathetic personalities of all religious literature, one caught between betraying his religious heritage and betraying his friend. It is logical to assume that as his doubts soured about his friend his allegiance to centuries of religious tradition persuaded him that this man was a heretic and might destroy Judaism. He feared that his friend's teachings might destroy at least two

thousand years of religious foundation and tradition. That heritage, he feared, might vanish. In the mind of Judas his betrayal was an act of Hebrew patriotism. In a certain sense Judas is a martyr. In another sense he is one of the most vile and despicable personalities who has lived. He is and has been despised and maligned since the time he identified his Master and friend to the Roman officers in the Garden of Gethsemane, at the Mount of Olives, where Jesus was praying.

Two thousand years later all of this, what I am writing, is hearsay. So is the account of Moses, of Abraham, Jacob, and Isaac. In the year 2014 and far beyond, the deeds and acts of Napoleon Bonaparte are hearsay, as they will be from now on. It might be stated that the deeds of practically any personality of the past is now merely hearsay. This would include Hitler, Roosevelt, Kennedy, Johnson, too many others to name, and all others that could be named. They could well all be fables except that for some there are yet remaining living witnesses.

One might be convinced that photography is a witness, but this is not necessarily so. Photography only bears witness that there is a human figure or face that was photographed. It bears testimony that there is an image and does not or cannot testify that the image is that of any certain person. Even with the hundreds of photographs of starving Jews, of lampshades made from the skins of Jewish children, of mass graves heaped with the bodies of dead Jews, and other horrors perpetrated by Nazi Germany; even with all this evidence there are still those that deny that such events ever happened. Those horrors were committed within the last seventy years. How is one going to prove what happened four thousand years in the past, or two thousand years in the past – or even yesterday? Additionally, modern digital technology has made truth and falsehood even more difficult to define or to prove.

One of the most famous images in the world is a painting that has been named the "Mona Lisa." No one knows who the female subject of the painting was. Some presume she was Lisa Gherardini. Others insist she was Lisa del Giocando. Who was she? She was certainly someone, but no one knows for certain who she was. Am I supposed to know? Are art history scholars supposed to know?

Certainly by now you know the question that arises. How can anyone know who Jesus was? In 1941 Warner Sallman painted that

portrait; the one he named "Head of Christ." As previously mentioned, this famous painting has been reproduced as prints over 500,000,000 times! Despite the obvious implications of idolatry, this portrait has given millions and millions the concept that they know who Jesus was, or at least it has given them the concept that they think they know what Jesus looked like – not quite Jewish, not quite Anglo, not quite any particular race or genetic strain, but rendered in such a manner that He mostly passes for a long-haired, Anglo Saxon. (We might add "protestant," too, if the reader can stand a bit of humor.)

In reality there is no known portrait of Jesus that was painted at the time of His mortal life: no photographs, no drawings. In fact (if not fact, then lore), the chronicles pertaining to the life and activities of Jesus were not recorded until some years after His death. Biblical and religious scholars argue about how many years lapsed between His life and the various biographies of His life. To get a perspective on this just think back to the time of the assassination of John F. Kennedy. That was in 1963. It was fifty years ago. Had no person recorded any biographical material about President Kennedy in the past, and no biographical material is to be recorded until the year 2033, think about just how accurate or inaccurate Kennedy's biography might be when it is, or would finally be recorded. It is probable that no truly mature historian, observer, or writer that was alive and mature in 1963 will be alive to write about JFK in 2033. That is possible, but it is unlikely. What is likely is that if the above were the case we could expect a drastically different biography of John Kennedy than the one we now have.

So how am I, or how is anyone else living today supposed to know who Jesus was, what he looked like, and what He taught? The answer is always the same: "From the Bible." Ah! Here we go again with the Judas complex! If we do not believe the Bible we are betraying something! We are betraying something, be it traditional religious heritage or be it betraying Jesus. It might even be self-betrayal! And thus we are called upon, if we are Christians, to bear witness to hearsay. With all this, it seems to me that there has arisen a type of mass hysteria, or a complex similar to the Judas Complex. As Judas might have thought he would be the foundation for the collapse of Judaism if he did not betray Jesus, there are some today who believe they might be the foundation for the collapse of Christianity if they speak the truth

about what they really believe.

There are other accounts written about Jesus that are not found in the Bible. They are not in the Bible because Church leaders, or some alleged council of "protestant" bishops decided that they were not divinely inspired and voted them out of the Bible. Accounts of Jesus by Thomas and Mary were eliminated and were considered to be not "divinely inspired" and possibly even heretical.

Archaic religious literature is an amazing thing. It is amazing that it was written at all, especially given the writing materials available at the time. It is amazing that it endured. It is amazing that some of it was discovered at all. It is amazing that ignorant people used some of it as kindling to build fires (to wit, some of the *Dead Sea Scrolls.)* It is amazing that some consider it holy and sacred. It is amazing that it has been used as a cause for so many wars and that it has been used to put so many people to death. It is amazing that it has created such a Judas complex. I think we would be even more amazed if we knew about all of it that has not yet been discovered – and might not ever be discovered, like the coins and gold and artifacts so close to our touch, just beneath our feet, and yet we pass right over them like we pass over unmarked graves. One can only wonder about how much ancient religious writing has been destroyed by the forces of nature without having been discovered.

One amazing religious literary work is the *Koran,* attributed to Mohammed. This prophet is presumed by some to have been illiterate If he was illiterate how could he have written the *Koran,* or the *Quran,* or how could he have even proof read it? The answer is, of course, he could not have done so. Yet look at the millions and millions of people that believe it as "the absolute truth." The lore about Mohammad can be confusing. It seems ironic, if such be truth, that Mohammad was a rather impoverished sheepherder until he married a wealthy woman. This afforded him the luxury of living most of his life in a cave: dwelling therein while seeking divine inspiration. Thus was founded Islam. How strange it is to me that in that society, that culture of Islam, no woman has been allowed to be a property owner since! Men own everything, including women. If he actually spent most of his life in a cave meditating he would have had little time to be a very effective war lord.

Other than the Bible, what sources are there for the teachings of Jesus? I know of none. At least I know of none that is not an exponent of the Bible, or any that are no less than the ideas of preachers, prophets, and gurus. Of course, there are those who claim to have experienced epiphanies, but there is no way to verify or negate their experiences. And even within the New Testament scriptures Paul cites at least one statement he attributes to Jesus that is not found in any of the four gospel accounts. He (allegedly) wrote something generally attributed to one of the Gospel authors as a statement of Jesus: "Remember the Lord Jesus himself said: it is more blessed to give than to receive." Now, I am not saying that Jesus did not say this. I am saying that I have not found a reference to this statement other than this reference in the Book of Acts. It is presumed by some that Luke wrote the Acts of the Apostles. Others think Paul was the author. Still others think Peter wrote the book of Acts, which mostly deals with acts of Peter and Paul, or again, that is what is presumed. This is really hearsay. It seems very likely that this statement is hearsay: the one stating, "Remember the Lord Jesus himself said: it is more blessed to give than to receive."

My own personal convictions are that it is my responsibility to distill relevancies from Biblical writings. Within Biblical writings are things difficult for me to believe, such as making the sun stand still, such as the confusion about Jesus' resurrection being the only resurrection and yet Jesus raised Lazarus from the dead. Also, Jesus (according to what is read in Matthew 11:5) told his disciples to "Tell them what you see. The blind receive their sight, and the lame walk, the lepers are cleansed, and the deaf hear, the dead are raised up, and the poor have the gospel preached unto them." It is hard for me to grasp something such as Noah being able to get two of every kind of animals on the earth loaded onto an ark, for Jonah to spend three days in the belly of a fish, and on and on. Jesus turning wine into water and God parting the Red Sea are to me quite believable.

By far the most believable of all teachings attributed to Jesus are His admonishing words: "Love God with your total capacity and treat others as you would have them treat you. Upon these two things hang all the laws of all the prophets." This is my own interpretation or translation and as such is worded differently than it is in the King James Version of the Bible. I believe it, and I believe that if the world lived by

this we would end all war. We would channel our energies into healing, into love, into the betterment of life for all people, and into more discovery of Light. This is my distillate from the Bible.

Once again I had slipped far into reverie, as Ellie reminded me. As I drifted back into reality I saw that she was looking quite confused. "Where have you been, Worrell?" she asked me.

"Far, far away Ellie Baby Dog, far, far away." I was wonderfully relieved to be back in the present, to see the sky, the trees, the golden grass blowing and bending in the autumn winds, to see the sparkling waters of the Llano River flowing over the colorful slabs of granite, and to smell the wonderful freshness of the October morning.

"Don't forget something, Ellie."

"What, Worrell?"

"Faith, Ellie, faith. Faith combined with reason."

"Worrell," she asked, "What *are* you talking about?"

"Come on, Ellie, let's go down to the River and play stick."

~

* *Some say Jesus was resurrected after three days. To me this is not correct. He was crucified on a Friday and was resurrected on a Sunday. From Friday afternoon until Sunday morning is about half of three days, and it is* upon *the third day and not* after *three days.*

WORRELL ON THE ROCKS. ELLIE IS NAPPING IN
THE EXPEDITION. PHOTOGRAPH BY JIM EPPLER

XX.
A Relevancy

I was multitasking, that is, I was sipping steaming, hot, wonderful, Anderson's coffee, checking email, working on a painting, and enjoying the beautiful Hill Country morning. It was another day in paradise, as the old cliché goes. The rapids were singing and the wind was humming soft melodies through the live oak trees. Two bright, red male cardinals were in a macho contest to see which would win the feathered lady's affection. A gathering of axis deer down in the campground was peering toward the studio, most likely with whetted appetites, anticipating the savory qualities of my many botanical wonders spread in colorful array around the studio patio. They are referred to as "exotics," because they are not indigenous to this country. Sometimes this makes me wonder why we do not simply call illegal immigrants exotics, too. Beautiful creatures, the axis deer are, spotted, as are whitetail fawns at birth. Their spots do not fade with age, and the males grow incredibly long antlers. They were brought to game ranches

from India for the sport of hunters. They compete with native whitetails and have voracious appetites. They can wipe out a garden. They can kill young and tender trees by rubbing them to remove the velvet from their antlers. Once a beautiful novelty, they are now becoming unwanted pests. I indulge them, but I do fence the garden and place wire cages around the young trees. Two or three or more times a day they love to parade across the campground, silhouetted against the dazzling clear waters of the Llano River.

I was marveling at them when Ellie nudged me from behind with her Air Dog toy and said, "Come on, Worrell, let's go play!" I practically always oblige her and honor her requests. It is part of that unconditional love she taught me. I realized that playing Air Dog with her was probably a lot more important than pondering axis deer or than any message that might be on the Internet, so I followed her outside and we played for a while. After she slowed down a bit she came up to me panting, and asked me, "Hey Worrell, who is Ruff Bimball?"

"Who?" I asked her.

"Ruff Bimball. The guy spouting off on the TV."

"Oh, Ellie, that is so funny. And it is so descriptive, too. His name is Rush Limbaugh, Ellie, and I don't really know who he is, but I think I know who he thinks he is."

"Who?"

"I think that he thinks that he is the great decipherer of truth and integrity: the separator of truth and lies, and the greatest of broadcasting orators. I do not agree with his opinion of himself. I think he is an overweight druggy and a personality just about diametrically opposed to being a peacemaker. He is a bad habit for a lot of people. He may think he is God, too, for all I know."

"He is?"

"No, Ellie, I think he seems to think he is. In reality he is just another opinionated and angry person that managed to get a deal with media networks, and he has to keep things hyped up to keep his deal going. No controversy, no deal. No bad and degrading stuff, no deal. But I will tell you, Ellie, if people had integrity he would be out of business in a nanosecond. So would most of the lawyers. And if politicians

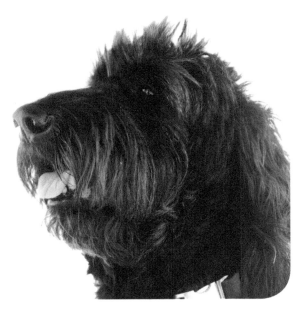

would quit lying, cheating, and stealing he would not have much to talk about. Sometimes his opinions are incorrect and sometimes they are accurate. When he speaks the truth people get riled up at him. When he lies people get riled up at him. But the way I have it figured is that if the truth makes someone angry, then my advice to them is not to do things that will make them fear the truth. There is seldom a deed that can be kept concealed, and there is never a bad word that the truth will not reveal – eventually.

"This man has placed himself in a position of being some paragon of truth and perhaps even virtue, yet he has been involved with illegal drugs, or so state the reports. But understand, Ellie, and this is very important, that the bad behavior of someone does not negate words of truth that that person might utter. Truth is truth. It is written, *All have sinned and come short of the glory of God.* We should always remember what Jesus said, too, when He said, 'Let him that is without guilt cast the first stone.'"

"Worrell," Ellie asked, a bit sarcastically, "Do you always have to keep quoting the Bible?"

"No, not always. But sometimes it fits. And I'm not throwing any rocks, either."

SEEKING A LULLABY

XXI.

The Wonderful Lizard of Odd

was busy. I am always busy when I am awake. Sometimes I
am busy when I am asleep, too, busy dreaming about finding
arrowheads, or treasures, or finding romance, or flying, even
though I am without wings. I was busy in vain attempts to multi-task,
as it is called, and it made me consider the lyrics to the song, *Why Did
I Come In This Room?* This is a humorous song about forgetfulness. I
was going through stacks of e-mails. I was tending to a theft claim
at my house in Santa Fe. I was working out. I was downloading
170-something songs from a hard drive to archival CDs. I was
unpacking some newly arrived bronzes from Hutch's Casting Company
in Albuquerque. In addition I was taking care of some tomato plants
just placed in the earth and I was watering trees and flowers just planted.
This does not include the various telephone calls with which I was

dealing.

I took a break and played Air Dog with Ellie May for a few minutes, sipping some gourmet coffee from Ohori's in Santa Fe as I did so. Air Dog is one of Ellie May's most favorite games. I am sure the Air Dog toy is made in China, but it is either that or no Air Dog game. This toy resembles an extra large bagel, or an oversized doughnut. It is made of some dense flexible material that is covered with yellow fabric, much like a tennis ball, and it squeaks when it is mashed. I throw it. She chases it and brings it back. I throw it again and she chases it and brings it back again. She is a black streak of lightening. This goes on until she decides to bring it halfway back. Then she lies down in the cool, green grass and chews it, relishing the squeaks it makes.

We played this game for a while and then I returned to the multi tasks and began working on that new song I named *Rotten Fruit:* working up a melody for it.

There I was, strumming one of my guitars and singing when Milagra walks in with a really big lizard. It was a Texas spiny lizard. She had a hold on its neck and the poor reptile was hanging from her mouth in a limp state. I immediately chased her out. I knew she would go to a favorite lair and start a feast, then abandon it. I also knew that in a few days the atmosphere around my studio would be altered. The main thing I knew was that there would be one less Texas spiny lizard and therefore more pesky insects.

I went back to my song – for a few seconds. But only for a few seconds, because I knew I had to rescue that lizard. I tracked Milagra down, took it from her and released it. This did not fill the cat with great joy. However, she rolled over as she does when she desires some stroking and I stroked her, picked her up, and carried her over to her cat food.

"Why can't I have that lizard?" she asked.

"Because I like lizards, and I do not want you to kill that one. I am not fussing at you. I know it is just your nature and you can't help it, but I do not want you to eat it."

"I bet you'd change your mind if you ever tried one," she meowed.

Then Ellie came up and asked, "What's going on?"

I explained, and then she told Milagra, "Shoot, Milagra, why don't you try a really dead snake, or an old bone or a rotten deer carcass? They're a lot better than lizards! Especially if you bury them for a while so they can rot a little. And if you bury them it keeps the maggots out of them. Man, they're good! There is nothing quite as fine as the smell of an old, rotten bone, so I bet lizards would be good that way, too!"

She had found one of her old bones last night when I let her out to pee and drink. She brought it to bed, too! I discovered it as I reached over to pet her. It was kinda moist and sandy, but it was Ellie's bone and I rolled over and went back to sleep, wondering why humans cannot be satisfied with such simple things. And I wondered why those things make humans sick and do not make dogs and cats sick.

NO MICE PLAYING HERE

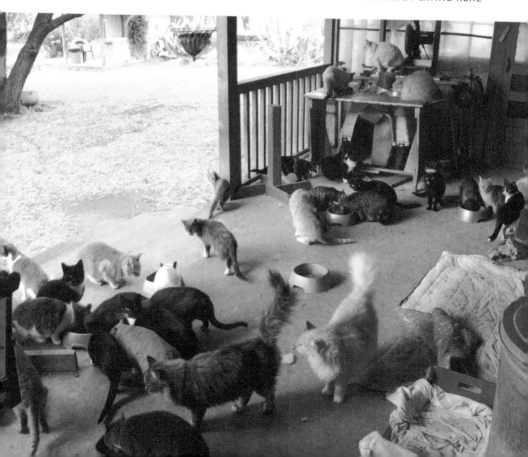

XXII.
Goats

*O*ne *summer day* my sister called and asked if I would be willing
to host some visitors. A rescue dog trainer named Jan Stalder
and her husband, Kelly, wanted to bring some guests to New
Art. They would be bringing firemen from Dallas and from Ground
Zero in New York City. My sister need not have even asked. I would do
anything I could do for those way underpaid and incredibly dedicated
people. They place their lives at risk at a moment's notice, as do police
personnel, and in these days, so do teachers. Although they do so, we
consider professional athletes with far more amenity. Society treats them
like gods or kings or nobility, even when they sell illegal substances and
violate laws. Yeah, let us pay someone who can slam dunk a thump ball
a few million bucks a year; then let's pay the firemen, policemen, and
teachers about thirty grand. Try to figure out which will put his life at
risk to come to your aid when the times get rough. There are lots of
crosses on lots of graves of police and firemen that have died in attempts

to save citizens.

I cooked barbecue, and I constructed a gourmet meal, served beside a campfire by the Llano River. I persuaded Jay Boy Adams and Sam Baker to join me and we played a concert for them. I gave each of them a SYMBOL, which is a sterling silver spiral that incorporates a cross into its design. After dinner and the music the group went on to Ingram, Texas to engage in rescue training and I went about my work.

Several of them attended my annual Christmas Party the following December. One was a New York City fireman named David Raynor. He was wearing the spiral cross and he waited for an opportune time to get me alone.

"I made something for you," he stated. He was very shy about endowing me with his work, and a bit reluctantly he handed it to me. It was a thick steel cross mounted upon a fragment of heavy plate glass. He had fashioned the metal cross with a cutting torch, and stamped on the front was this: "09/11/01."

"This steel and glass was once a part of the World Trade Center," he said.

I cried. I am crying now as I write these words: crying so much that I can hardly see to type. Later that evening the music began in my studio. There were some 300 people in attendance listening to Jay Boy Adams, Sam Baker, Walt and Tina Wilkins, Stephanie Urbina Jones, Dennis Robbins, Rob Roy Parnell, Mark Nessler, and other Nashville artists. I told the story and passed the cross around for each person to touch and hold. There was not one dry eye.

A few days passed and I e-mailed David, telling him that I had many connections with galleries and if he wanted to make some of these crosses to sell and raise money for the NYCFD I would be glad to promote them and make certain 100 percent of the revenue from sales went to the firemen. His response was, "No matter how noble a cause this would be I could never make one cent profit from the deaths of my fallen buddies. Not even for the New York City Fire Department!" In my days I have seen demonstrations of integrity. Never have I witnessed integrity that surpasses that of David Raynor's.

So, that is how I met Jan Stalder. Readers probably wonder what in the world this has to do with goats. It has a lot to do with goats.

Worrell

Jan sent me a couple of stories about her rescue dogs, Eclipse and Pearl, and some of the amazing feats they performed. Eclipse was one of the first called to Ground Zero on September 12, 2001. Jan's stories were captivating. I could not put them down. While reading them Ellie began some of the most serious barking I had yet heard her vocalize. It was so intense I could not concentrate on the writings, so I walked down to the River to check out what was bothering her. It was a bunch of goats. Spanish goats, they were. They were Billy Bode's Spanish goats. They were across the River, frolicking upon the rocks.

"Ellie! What are you barking at?"

"Don't you smell all those goats? Don't you see them? Can't you hear them? They need a good dose of barking and by gosh that is what I am giving them! They need a good chasing, too, but I can't get over that dadgum Invisible Fence you put down!

"Look at them! They're almost as stupid as cows! I bark my rear end off and all they can say is *Maahh! Maahh! Maahh!* They can't even talk. The only thing they are good for is eating weeds and making browse lines. They're probably good for barbecuing too, but I don't know how to do that. I would just have to eat one raw."

"O.K., Baby, you've done a great job of barking at them but come on, let's go back up to the studio."

"You go ahead," she told me. "They still need a bit more barking at."

A while later she came in, wagging her tail, and nuzzling my leg. Seems Ellie May Lucille is always letting me know why I love her so much.

I made a special platform for David Raynor's steel cross. It rests upon that platform now, in my studio, less than two feet from where I am standing and typing. It is my most favorite of all pieces of art that I own.

LEFT TO RIGHT:

ELLIE, *SHAMAN OF THE RIO GRANDE*
(94" ABOVE STONE), *THE MAKER
OF PEACE* (17' 3" ABOVE STONE),
AND *SHAMAN OF THE BENEDICTION*
(92" ABOVE STONE).

FOR YOUR PHILOSPHICAL
ENTERTAINMENT, GOOGLE 'SEMINOLE
CANYON SHAMAN DEDICATION' AND
LOOK CLOSELY AT THE SHAMAN'S
WATER VESSEL. THEN GOOGLE
"RED SOLO CUP BY TOBY KEITH"...

XXIII.
A Past
Love

hat a wonderful and brisk morning it was. The sky was endless cerulean, unmarked by one cloud. The Llano River was totally flat. It was like a sheet of glass except for the rapids, and the water was crystal clear, revealing various sorts of fish and aquatic life swimming around the submerged, massive granite boulders. It was the kind of morning that makes one more than doubly glad to be alive, and as Ellie and I walked around the grounds I gave the Good Lord my thanks – my prevailing attitude.

She was as frisky as could be, and made it quite evident that she wanted to play stick and get in some swimming, minnow chasing, and much-needed running. She had a stick in her mouth already and began nudging me, rapidly wagging her long, black, beautifully feathered tail.

"O.K., Baby Dog, let me have it," and I grabbed hold. She began

vigorously shaking her head. She was smiling, clasping the stick, and her teeth were gleaming white pearls against her black muzzle. She looked at me, and through her teeth said, "No!"

"Come on, Baby, let go."

"No!"

It was part of her usual game again, and it was evident she was enjoying teasing me. I considered that it was probably retribution of some sort, remembering how we played this game up in Santa Fe one morning. She loves it up there when the mornings are chilly and the mountain air falls from the peaks and tumbles down through the valley. I would throw the stick, she would run fetch it, and then dart past me, running way up the driveway, turning, running past me again, and then darting down almost clear to the Santa Fe River, way in back of the house. Then she would repeat the maneuvers a few times before finally bringing me her favorite toy of the moment. She ran like the wind! Like a vapor. Like liquid. She is unbelievably beautiful in motion!

Then she eagerly said, "Throw the stick, Worrell! Throw the stick!"

I cocked my arm back and threw – only I did not let it go. She took off like a sprinter out of the blocks, and then turned, looking confused. She reared up on her long, lean, back legs, looking all around. She was pure, black grace. Then she saw I still had the stick in my hands and she quickly overcame her perplexity when I actually threw it for her. She was off again, after it like a black streak.

I do not become bored watching such beauty and grace, but I get a bit antsy to get on with work that I need to do, thus we ended this session. Back in the studio I began painting as she lay on the couch, looking at me. She had a little different look than usual, one hard to describe. It was a look like women sometimes display, and then she asked me, "Worrell?"

"Yes, Ellie, what is it?"

"Worrell, has there ever been anyone else?"

"What do you mean, Ellie?"

"I mean anyone else besides me?"

I flushed. Talking about *exes* has always been a subject I try to avoid. I have never been fond of hearing someone with whom I was romantically involved tell me about her past relationships: her boyfriends, her husbands, her birthing experiences, her lactation, and other such intimate and private matters. I prefer to simply be in the now of a relationship. But there we were. She asked the question and I somehow felt obliged to give her an answer. Instantly my thoughts flashed back through the years. I thought about Lucky and I thought about Amuhrilluh.

But I explained to Ellie, or I attempted to explain to her that those were not romances. I told her they were acts of human kindness. I told her that I had been involved with some human girls from time to time, but that no human girl can share the love that a human and a doggie like the two of us can share. All of my girlfriends were a little bit crazy anyway, and that is why I am a single man today. And I realize that I am crazy too, but they just were not my kind of crazy. Humans seem to place conditions upon love and doggies do not. It seemed like Ellie wanted to accept this, but I started stuttering and clearing my throat as I told her about Cadmium Red, the wonderful Irish setter.

I went into immediate reverie thinking about Cadmium Red. She was bright, clever, and a bit cunning. I could put her on "stay" and she would stay for hours. She would allow people to pet her but she would not break her stay, not even when people tried all sorts of things to lure her away. She would move a little bit, but that was only to follow the shade that a tree or building created when parrying the sun. I would take her to the campus, put her on stay, and teach a three-hour sculpture class. She would be right where I told her to stay when class was over.

Cadmium loved to go with me everywhere. Unfortunately some members of Homo sapiens do not care for canines, so there were places I could not take her. One time I had to go to the grocery store in Eagle Nest, New Mexico. My kids were with me, as was my sister and her family. We were staying at the extant and historic Eagle Nest Lodge. I left Cadmium Red with the family and went into the village. My sister told me how she sulked as I dove away, lying in the driveway, looking all sad and dejected.

As soon as I was out of sight she bounced up and frolicked,

playing and frisking with the kids. An hour or so later, when she heard me returning down that long driveway she immediately went back to the spot where she had sulked and assumed her forsaken airs. Cadmium was no dummy!

That dog was as gentle as a lamb. There were only two things she could not tolerate: utility personnel and some stranger who might happen to bump into my VW van. We were returning from Eagle Nest one hot summer day, en route to Sweeny, Texas, about a thousand miles distant. Summer was over for Sawndra and Billy and I had to return them to their mother and to the public school.

Sawndra and Billy loved Cadmium as much as a dog can be loved. They were always doing fun things with her, such as putting a baseball cap on her and a pair of sunglasses, holding these in place with rubber bands. That is what they had done when we stopped in Brady, Texas at the Dairy Queen for lunch. As usual I put the dog on stay and left the side door of the van open so she could have plenty of fresh air. We were inside having a burger when I heard an incredibly loud, roaring, growling, and barking. Some poor, innocent pedestrian man had accidentally bumped into the van and Cadmium looked like she would eat him alive. He jumped quickly aside. The man was completely bewildered to see an Irish setter wearing a baseball cap and sunglasses growling and barking with fangs barred and hackle raised, feigning that she was about to chew him up.

Well, I was a tad embarrassed as I told Ellie May Lucille about Cadmium Red. This is a breed not known for intellectual prowess. But, she was an exception! She and I often had long conversations after our morning runs, during which I would run three miles and she would probably run fifteen. Until Ellie came into my life I thought I would never love anybody like I did Cadmium, and I told Ellie this. She sulked a bit, so I asked her, "Aw, Ellie Baby, are you jealous?"

"No, I just wondered."

"I think you are jealous."

"I am not! I told you I just wondered! Dogs are not jealous. We have no reason to be."

"Okay, Baby Dog, just know that I love you more than any doggie in the universe has ever been loved. You're the best doggie in the United States of America and to the Republic for Which it Stands."

She seemed to be accepting of this. Then, about that time Cassie, a rescued dog that lives down the road with the Bosses, my neighbors and friends, appeared.

"Hi, Cassie, Baby! Whatcha doin," I asked her, reaching down and petting her on the head as I did so. Ellie went boncos, and immediately nuzzled her way into the scene, panting, licking, finding my hand, and then rubbing the top of her head on my palm, demanding my undivided attention. "Naa," I thought. *Dogs aren't jealous.*

MILAGRA AND KATRINA LOVE NAPS ON MY PAINTS

Miss Priss

E llie and Milagra were romping about, playing their usual cat and dog game. Katrina was attempting to sneak past them so she could jump up on the table under the shed and get a bite to eat. Ellie spotted her and bounded off in playful pursuit. Katrina hauled you-know-what out of there and bounded up a tree, making it quite obvious she wanted absolutely nothing to do with Ellie May Lucille Worrell. I know this hurt Ellie's feelings. She looked at me with a rejected countenance and asked me, "Hey Worrell, what's the deal with cats?"

"What do you mean, Ellie?"

"Why do they think they are such hot stuff?"

"Do they?"

"Good grief, Worrell, just look at them. They're a bunch of

snobs. They priss around like they own the planet. They're mean to birds. In the middle of the day they have midnight in their eyes. They scratch around on almost everything, and they spend most of the day either sleeping or primping. They are obnoxious, except for Milagra. She's different. But I'll have to say, there's some of it in her too. And Katrina really thinks she is hot stuff."

"I never cared much for cats either, Ellie, until I got Miss Priss."

"Who, may I ask, is Miss Priss?"

"Miss Priss was a cat the Bosses gave me. You know the Bosses. They're our neighbors, over where Cassie and all those bunches of cats live."

"I really like Cassie!"

"Cassie likes you too, and I love watching you two play together. She's a nice doggie, even if she does have extra sharp claws."

"Finish telling me about Miss Priss."

"Well, Miss Priss was born in Odessa, when the Bosses still lived there. I was visiting them and they gave her to me. About the first thing she did was run off when I stopped in Sweetwater to see your Aunt B.J. I finally had to leave because I had a teaching job at Houston and I had to get back home. Aunt Debra and Aunt B.J. found her wandering around their neighborhood and brought her here to me at New Art, where she lived with me for several years. One November I had company in from Santa Fe. I think they accidentally put something out that caused her death. I was very sad. I took her in to Dr. Rosberg about 6:00 a. m. but he just could not save her. She went into convulsions and died. I have also wondered if somehow she got into some antifreeze. That stuff is lethal, and you know how cats are, they will drink almost anything. Some could have leaked out of one of the automobiles parked around the compound. I buried Miss Priss across the road, near the gate, over toward the Green House.

"That is sad," said Ellie.

"I know, Baby Dog. It is sad. I think the best way to describe Miss Priss is like this: It is a poem I wrote about her."

THE QUEEN OF NEW ART

I'd be lying to say I ever owned a cat.
A few have owned me – that's the facts.
No cat's ever been owned and never will be.
They're in a class all alone – independently.

But a cat lived with me – for a while she did.
She came to my home by the way of a gift.
Didn't take her too long to have her own way.
Soon as we got home she started to stray.

Miss Priss wasn't bashful, I can tell you that.
She thought she was Queen even though just a cat.
She thought the world should kneel and bow
At her every purr, at her every meow.

She was born in Odessa at the Bosse home
Of a mother named B. W. and a father unknown.
Born out of wedlock – you know what I mean,
Cutest little bastard you ever have seen!

I ain't what you'd call a real cat man,
But I took her in and we became friends.
As much of a friend as I knew how to be,
And most of the friendship was left up to me.

Cats seem so gentle when they groom and they preen,
Belying the fact they're just killing machines.
Always late to bed and early to rise,
In the brightest of day midnight glows in their eyes.

I'll wager I could feed her
Every day ten times or more,
And she'd still be looking hungry
Every time I walked out the door.

There's a myth that's all wrong,
Cats living nine lives long.
One out here's lived forty times –
Forty shots and he's still going strong.

Cats beg and they plead in the direst of need,
So I think I must give them a treat.
With their tails straight up and their heads held high
They're a tangled mess around my own feet.

The gifts of men and the gifts of cats,
How different these two things be,
Flowers for my mommy, a ring for my bonnie,
And my cats bring dead mice to me!

Now Miss Priss was an amazing creature.
God gave her an extraordinary feature.
She purred like a motor tuned so fine,
She could inhale and exhale at the very same time.

She could crouch and run like a long, thin line,
And arch her back like she had no spine.
She had needles for claws and a rasp for a tongue,
And a soft, gray coat like a silk worm spun.

I made her a bowl for her royal drink –
Her preference, of course, the commode or the sink.
Her elegant business she did with finesse
Neat as a pin, never a mess.

With a soft, furry, meowful bliss
She would rub on my leg – her little cat kiss.
I've known cat after cat, quite a long list,
But I've never known a cat like Miss Priss.

She'd schmoozy the catnip, smashing its leaves,
Licking all over her royal catanality.

MILAGRA PLAYING GUITAR

Just like a dog she'd go with me on hikes,
Even follow along when I rode my bike.

To know Miss Priss was to understand
Some of the more stupid ways of man.
So I got it down, by golly I got it down pat,
Freud found no ego – he just found a cat.

She checked out one day at the local vet's,
I was all sad and completely perplexed.
One thing's for certain, a sure fire bet,
She was the Queen of New Art – and I was her pet.

FULL MOON OVER THE LLANO.
THE MOON IS ALWAYS "FULL,"
BUT NO EYE HAS EVER SEEN A
"FULL MOON" (SEE DIAGRAM
ON PAGE 189)

XXV.
Coyotes

S *ometimes I have difficulty sleeping.* I go to bed and my mind starts racing, even though my body is tired. One way to stop the race, I have learned, is to turn on the TV. Television is the old standby, my reliable barbiturate. TV usually puts me to sleep within five minutes. There is seldom anything new presented, just the same old same old in a different format. This is a bit unfair to state because now and then there is something new, such as the death of Michael Jackson, the scandal of Tiger Woods, the Christmas Terrorist, or whatever. When something new is exposed then it so very quickly becomes the same old, same old, because the viewers get to watch it for the following four weeks – or much longer – until there is a new eruption of some sorts. Few things in our culture are as boring and unimaginative to me as television, and especially television's situation comedies. I think that few things are as malignant to a society as television. Fifty years ago it inspired Ray Bradbury to pen *Fahrenheit 451*. It is a bit staggering to comprehend

how much trash and filth we pipe into our lairs and sanctuaries via the tube. Americans feed their children vast quantities of garbage! They feed them incredible amounts of it, and then wonder why they behave in such trashy manners.

TV is often the school of the rude. It is often the school of the crude. It is often the means whereby crooks market their goods. Con artists market real estate, youth tonics, skin rejuvenating miracles, reverse mortgages, the purchasing of gold, and the selling of religion and salvation by lying televangelists. Some of this can be observed on almost any talk show, where crude things are discussed and where the hosts constantly interrupt the guests while the guests are constantly interrupting each other and their host. What a confused, garbled, and non-understandable bunch of prattle those things are! What ever happened to good manners in this country?

One evening the same old same old late night TV had me almost anesthetized when I heard Ellie May Lucille going "Bark! Bark! Bark!" She seemed to keep it up all night long, *"Bark! Bark! Bark!"*

Good grief, I thought, will she ever stop? It went on and on and on. I suppose I was a little restless too, so I thought I should cut her some slack. Maybe it was the moon. It was "full." All sorts of creatures seem affected by a full moon. We call it "full," but that is actually a myth. I mean, the moon is always full from somewhere in space, but no eye of any creature has ever seen a full moon. Not from this earth, and not from a space ship. Not from any place. It is impossible.

It was likely June 4, 1993, during a total lunar eclipse and also during a full moon, that my brother and I were talking about the "full moon." My brother is a mathematician of world renown. (He was involved with mathematical research for NASA for both the first moon landing and the first Mars landing.) I asked him for how long is the moon full. He pondered the question for a while and then said, "For zero seconds."

I have pondered this now for several years, and two days ago I concluded that no one has ever been able to see a full moon. I diagramed my notions about this.

"FULL MOON" OVER THE LLANO RIVER

186

DIAGRAM AT RIGHT,
FROM TOP DOWN:

Sun, earth, moon all aligned through center axes produces total lunar eclipse.

Sun, moon, earth all aligned through center axes produces total solar eclipse.

Sun and earth are always aligned through center axes. When earth crosses that line segment there is a partial eclipse and sometimes a total eclipse of the moon.

Sun and moon are always aligned through center axes. When the earth is in a position where its edge is tangent to the line segment from the sun's center axis and the moon's center axis there then occurs what is referred to as a "full moon." However, it is not completely "full." It appears as an ellipse, one perhaps so slight that the human eye does not readily perceive it as such, but perceives it as a full circle.

The moon is perpetually "full" in what is termed outer space, except when the earth is between the sun and the moon in such positions that the axes of all three are in line or the tangents of earth cross that line segment. However, if a viewer were in outer space he could not perceive a "full moon" because he would be askew of the line segment from the center axes of the sun through the center of the moon, thereby perceiving an ellipse. If the viewer were to be on the line segment from the center of the sun's axis and the center of the moon's axis the viewer would cast a shadow upon the surface of the moon, thus the moon would not be "full," even if his shadow were so slight that he could not perceive it.

However, people here on earth just assume that sometimes the moon is full because when contrasted with a half moon, a quarter moon, or what is referred to as a new moon, sometimes it certainly does appear to be full, like in the photograph on page 187, taken beside the Llano River. But what is actually seen is an ellipse and not a full circle.

Anyway, Ellie was barking. Maybe it was her worthless, thieving, murdering, distant-cousin relatives, those damned coyotes, that triggered it. They were over at Billy Bode's ranch, across the River, howling and screaming like the world was coming to an end: like the world was coming to an end and that they were the appointed and anointed prophetical ones to announce it to all of the kingdom and all creation, much like raving, ranting, screaming, howling, panting televangelists.

MYTH OF SEEING A "FULL MOON"

I called Ellie back inside, where she always sleeps at night. I patted the covers with the palm of my hand, my signal for her to jump into bed with me. Ellie is a big girl. Stretched out she is about five feet in length, which is one of the reasons she has such a long name. She also weighs just a bit over seventy pounds. She has a way of jumping into bed that is a bit comical, going high into the air and landing with all fours simultaneously. Often she lands with two feet in my stomach and two feet on my gonads, but it is okay because she is the best doggie in the whole planetary system and I love her. And when you really love somebody things like that just don't matter!

"What's up with those guys?" she asked. "Haven't they learned to bark? Are they tying to become country music singers using all that falsetto?"

"I don't think so, Ellie. That's just their nature. They are really just a bunch of thugs. They are really sort of like a gang, the kind you read about and see on TV. They are sly and tricky. They lie and they steal. You really have to watch out for them. They come on a bit like they are doggies, but they are not. They are hoodlums in doggie disguise. I do not want you to ever attempt to associate with any of them. Some lone coyote might start talking to you and trying to make friends with you and get you off your guard. Then he might tell you to follow him and he will show you some real good fun. Then he will lure you away and there will be a gang of twenty or thirty of them and they will attack you and try to rip you into pieces. They would eat you too, after killing you. They will eat almost anything, even their own scat. They are worse than cannibals because cannibals only eat their own kind and not their own fecal material.

"The truth is, Ellie, Coyotes are a lot like politicians and bureaucrats. They are sly and cunning. They make a lot of noise. They exploit and feed off anything

they can seduce. They move into an area and take it over, multiplying at an alarming rate. They steal anything they can get their paws on. They oftentimes kill just for the thrill of killing, when there is no need to do so. Another thing is that they are amoral. They have no scruples and they have no conscience.

"You do not have to feel ashamed, though, just because you are distantly related. We all have relatives that are deviates and derelicts. On almost every family tree there is some bad fruit, and some of the fruit is absolutely rotten."

Ellie nuzzled my arm. "I'm sure glad I am not a coyote," she said.

"Me too, Ellie, Baby." And while the politicians across the River kept up their plaintiff wailings we both drifted off to sleep.

COYOTE CROSSING THE DRIVEWAY AT NEW ART. IT IS A BRONZE COYOTE SCULPTED BY ARTIST JIM EPPLER.

LEFT: EPPLER WITH BRONZE COYOTE

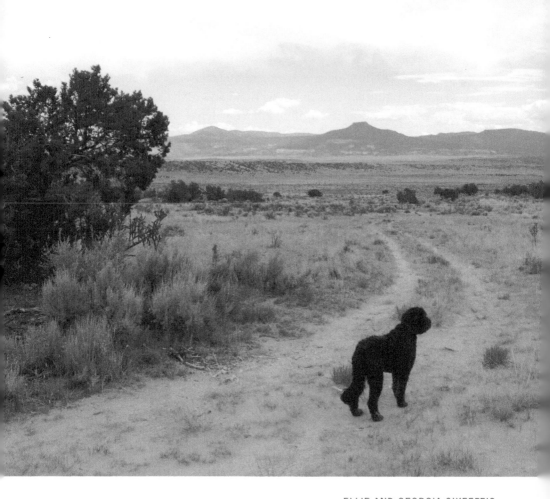

ELLIE AND GEORGIA O'KEEFE'S
"PEDERNAL" MOUNTAIN

XXVI.
Where Ellie Came From

O *ne day Ellie asked me,*
"Hey, Worrell, where did I come from?"

I found myself at a loss for words, and also a bit embarrassed.

How was I to tell her about her Black Poodle father having sex with her Golden Retriever mother? How was I to tell her about estrus, erection, ejaculation, and about them getting tied up and all that sort of thing?

"Well, Ellie, you came from Canton, Texas. That is where you were born, about a hundred miles or so east of Dallas. Your Aunt Sawndra brought you to live with me in November of 2006."

"Well, Worrell, what did you do before I was born, and before I came to live with you?"

"I tell you what, Ellie, I think about that often and I myself wonder just what I did do before you came into my life. My world was much darker and far less joyful before you came to live with me." Then I tried to tell her how much I love her and began to choke up. That's the way it is sometimes with people we really care about. We seem able to tell mere acquaintances how much they mean to us and seem able to express to them our affection for them, but when it comes to someone really close to us we get all embarrassed and shy about expressing our love.

But it sure is not that way with dogs. They have no modesty or embarrassment at all about such matters. Ellie snuggles up to me and licks me and wags her tail for me without the slightest flinch, and she does this with my friends too. Then I thought about that question she asked that I never completely answered: the one about whether God is a dog or a human or what. I knew then that when the time is right, when we engage in our next theological discussion, I would have the answer for her. I will simply tell her that if God is not a doggie then He or She certainly should be.

YOU CAN SEE WHY I LOVE HER

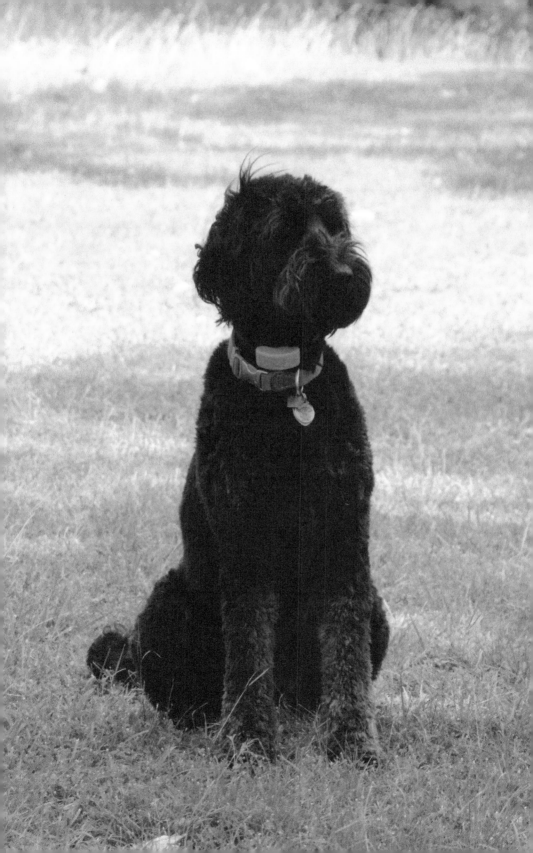

ELLIE HAD THIS ENTIRE HARE IN
HER MOUTH, PLAYING WITH IT

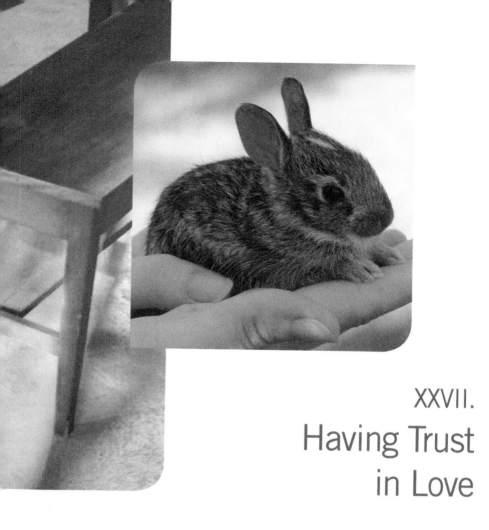

XXVII.
Having Trust in Love

*P**rejudice is a strange emotion,* or a strange thought process. It is something that seems to afflict every human on the planet, even those that think they are immune to it. It is much like the thing Jesus described when He stated that there are people who see the splinter in someone else's eye but cannot detect the log that is in their own eye. There are those who believe themselves to be so above being prejudice that they become prejudiced against those who display prejudice. It is an absurdity.

Ellie is the most unprejudiced doggie in the world. She will associate with cats and with dogs of any race or color, at least whatever cats will associate with her. She even tries to associate with rabbits. A few days ago she caught a baby jackrabbit. (These are really not rabbits.

They are hares, and as such, unlike rabbits, are born with their eyes open and are capable of hopping around at birth.) She had its head in her mouth. Its body was hanging out, limp as it could be. My guests and I walked over to Ellie and she took a big gulp. The rabbit disappeared. It looked as if she had swallowed the creature whole, but she had not. She was just trying to be playful and had the entire hare in her big jaws. We opened her mouth, removed the creature, placed it upon the ground, and it began hopping around. We thought we spotted its mother a ways off, so we picked it up and released it over where we thought she was. Ellie is so gentle, and she is very sociable. In my heart I know she loves me and she loves other creatures, even if she does bark at them.

Franny Jackson, a friend residing in Sedona Arizona, came to visit and make pottery. She brought Cassidy and Sundance with her. Cassidy is a Shih Tzu and Sundance is a Lhasa Apso. Both are small, and both are white, although their skins are black beneath their hair. Both are polite and friendly. I cannot tell you how many times during their visit that Ellie almost acted as if I did not exist. She played and played with those two, just ignoring me most of the time. It really kind of hurt my feelings, but I tried to be mature and to act like an adult about it.

I came out of my studio for a while to greet the warm, spring sunshine, feed the birds, and enjoy the morning dew. Ellie walked past the big granite stone upon which I was seated. It is beneath a large mesquite tree, and I was again sipping some more of that hot, gourmet coffee from Ohori's in Santa Fe. "Hi Ellie Baby Dog. You're the best doggie in the whole planetary system, yes you are, and I love you Baby Dog. Come here, Baby Doggie, yes, yes."

"Not right now, Worrell, I'm just not in the mood. I have a couple of friends over there I need to play with."

And she did. She strolled over to Cassidy and Sundance, romping around with them as if I did not even exist. It kinda reminded me of ol' What's Her Name back in high school, the girl who daily vowed she would never stop loving me – and then did, by the way! Sometimes we are so easily wounded. Sometimes our egos do not serve us too well. Sometimes it is necessary to have faith: to believe someone loves you no matter what the circumstances and the outward

appearances seem to indicate. Many are the times appearances are deceiving. And I know it is always me that I must deal with, not someone else. I penned some lyrics about it.

He's stalking me, my old foe
He follows me where ere I go
I fight so hard, still lose you know
I'll never beat this damned ego

Here he comes, my old foe
No place to hide, no place to go
Can't get away from this old foe
There's no escape from my ego

Don't seem like me, who's in control
More like someone I do not know
I'll never win against this foe
I'll never beat my damned ego

I never win against this foe
He tracks me down where ere I go
Takes me to lands of forebode
Worst enemy, my damned ego

Seems he stalks me from the darkness
From some dim place far below
Appears when I least expect
That old Devil, my ego

In my heart I surely know
Were I should and should not go
But pushing me to realms of woe
He leads me on, my damned ego

He's stalking me, this man of woe
Spawned by the Devil, so big he grows
I'll never win, though I fight so
Lose every time to my ego

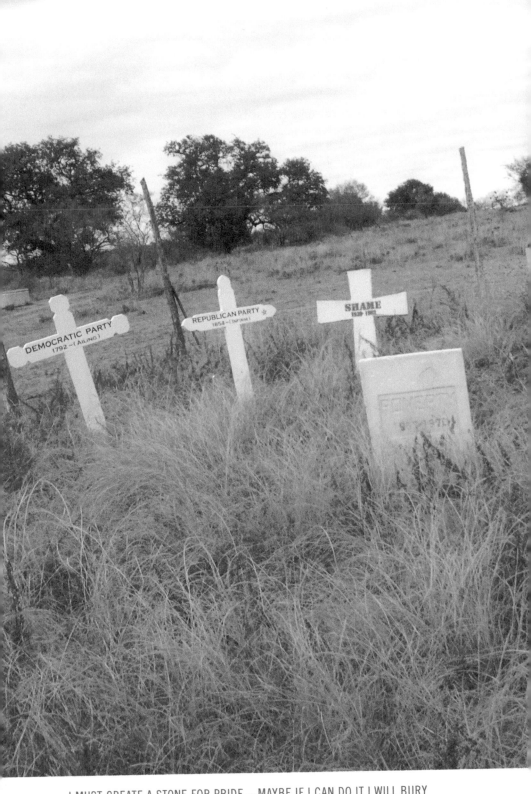

I MUST CREATE A STONE FOR PRIDE — MAYBE IF I CAN DO IT I WILL BURY
JUDGEMENT. I'LL DO THAT WHEN EVERYONE STOPS DOING BAD THINGS

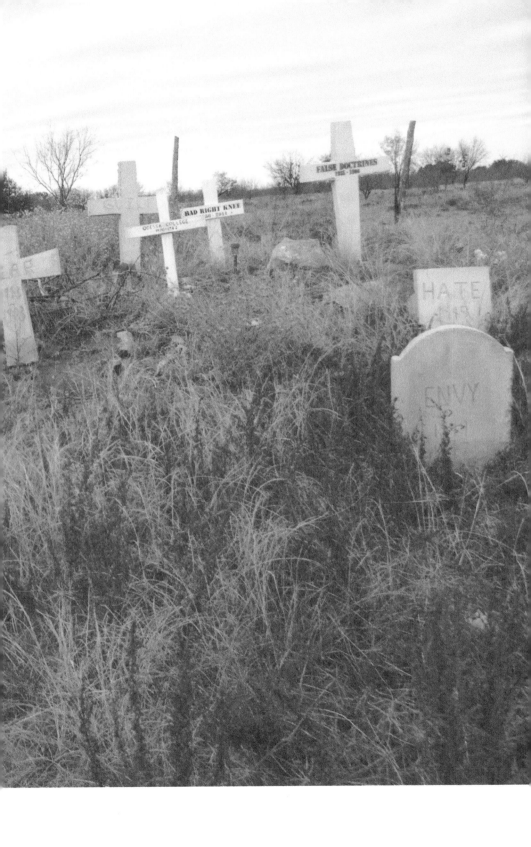

Here he comes, he's stalking me
From some dark, dim world below
Where the light so seldom shows
He pleads with me to trade my soul

There he is, my worst old foe
Run like hell, I should, I know
But I have never run so slow
Can't outrun my damned ego

Lying here in my grave
I clearly see from down below
Shoveling sod upon my face
My worst foe, my damned ego

Relentless pride brought me so low
Shoveling sod he fills the hole
My ego, the ruin of me
Creates illusions of what I'll never be

There is a counterpart to this ego and pride thing. In my deistic journals I have an entire book about the subject. I named the unprinted book *A Bag of Salt*. Like unto Lot's wife we often turn around and look back when it does not serve us to do so. This happens with jobs, with all sorts of schemes, and with romances. In today's world I can both laugh and thank God that Ol' What's Her Name sent me that Dear John letter. I can (and do) also thank God that I did not get a couple of jobs I applied for. Had these things happened like I thought they should have happened my life would have turned out to be something completely different from the rich and fulfilled one it now is. That might be true for you, too, dear reader. Think about it.

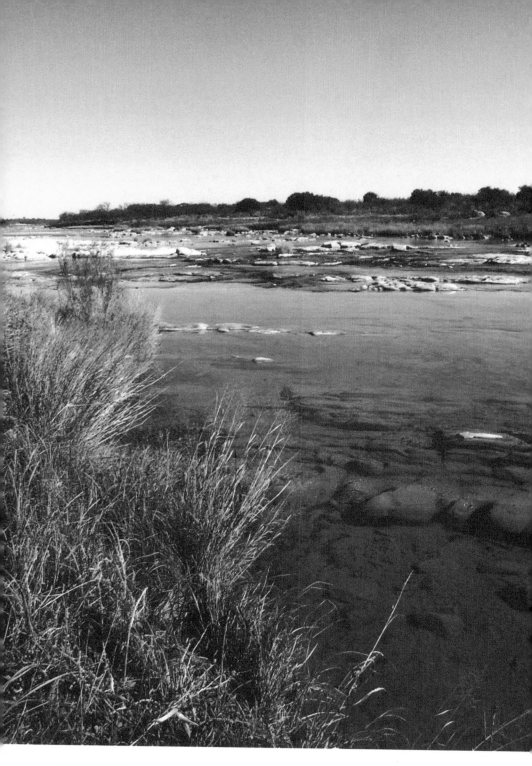

PRISTINE WATERS –
LLANO RIVER

"God give me the serenity - To remember who I am."

Joe South

XXVIII.
Adverse
Possession

n Texas there are some insane laws and regulations. At least they seem insane to those who are victimized by them, even though they might seem quite reasonable to the special interest lobbyists and legislators who have enacted them. The "Blue Laws," now mostly eradicated from the books (I think and I hope, although the vestiges of these are yet abundant), were among the most insidious, unfair, and unjust of them all. The likes of the "mom & pop" stores and the Retail Merchants Association helped keep them legal for decades. Now mom and pop and a lot of hometown retailers are paying the wages for their sins, just as the Bible says. "The wages of sin is (sic) death," says the Bible, and death it has been to many small businesses. They are paying these wages to Wal-Mart, Walgreen's, Target, KMart, Sam's Club, Costco, and various large discount chains. These large corporations

"learned them a lesson," as it is stated in the vernacular. For crying out loud! Thirty years ago one could not buy a blank cassette tape on a Sunday in Texas. Selling certain items on Sunday in Texas was illegal. It was illegal because of the Texas Blue Laws. A person could purchase a pair of jeans or socks but not a blank cassette tape. One could purchase a recorded tape: one produced by any number of recording labels or record companies, but not a blank one. That would be sinful on a Sunday!

There have been occasions in times past where in the state of Texas storeowners have been arrested or fined for something as trivial as selling a pouch of roll-your-own Bull Durham Tobacco on Sunday. Sunday became Sundae in the confection world. This was a maneuver to make it legal for drug stores to sell ice cream and other confections on the first day of the week, the day that is so often mistaken for the Sabbath. I have found myself frustrated because Gibson's Discount Store would not sell me certain merchandise on a Sunday: in particular one Sunday when I was miles away from my home base, creating a historical document. It was an interview with one of the old time windmill repairmen and installers. Melvin Beam was his name. We were out of recording media and could not purchase more because of the damned Blue Laws. What we were able to do was to purchase some cheap cassette tape by some unknown mariachi recording artist and then we taped the holes and recorded over it. That way the merchant obeyed the law and we completed the interview. The irony later on was that my then wife needed a tape one day, and rather than go to the trouble of purchasing one she also taped the holes and simply recorded over my tape of Melvin Beam, the one-legged windmill man from San Angelo, Texas. (Melvin was a smoker, and he laughed about his leg catching on fire one time when he dropped a cigarette into it.) I suppose some things just are just not meant to be: things like having that historical and hysterical recording, and things like my maintaining some order of filing here at New Art, and bringing to order my system of keeping certain things in places where I know where they are and where I know they will be.

Another crazy law in Texas is the law or statute of "Adverse Possession." Basically it states that if someone uses your property for seven or ten or whatever it is years, and you do not protest, and you do not fence the intruder out, then the intruder can go to court and claim

the property as his or her own. What insanity! What if you are also using it? Should you not be able to use adverse possession to gain or regain possession?

So I found things changing here at New Art. Upon a recommendation I hired a woman to clean house for me. She removed all cooking utensils from some cabinets on one side of the kitchen, those beside the cooking range, and moved them to some cabinets on the other side of the room. I found my Nikon Camera in the deep freeze. She won the universal toilet bowl brush hiding championship. After buying several others I finally found the one she had used. It was out in the pasture. My most recent guest moved almost everything in the house around, from pressure cooker weights to ornaments on fixtures and cabinets. I walked into the house and it was completely rearranged. I found a totally new rearrangement in my casita in Santa Fe, too. Some guest had assumed the responsibility of moving beds, benches, chairs, and tables in that house to different spaces.

This happens in my studio too. People move my tools, my paints, my brushes, telephone directories, books, photographs, CDs, and all sorts of things. Then they become adversely possessed by their new quarters until some other person moves them around again. Then people wonder why I am crazy! A recent guest at my house in Santa Fe took the liberty of placing his and his entire family's handprints upon a wall in my dining room, and he was not invited to do this, either. That did not make me insane. It made me mad. It is the sloppiest presentation of handprints I have collected, and soon they will be sanded away and I will do the best I can to matching the wall paint over the scar.

"Why do people do this?" I asked Ellie. She could see that I was tense and distraught.

"Get over it, Worrell. It is not the end of the world. You will learn where everything is and then it will all be okay. You can paint over the handprints and it will be okay. The problem is you get upset over little things. You are too tied down to materialism. You place too much emphasis on things. Get over it. Just get over it!"

"You are probably right, Ellie. I'll work on it. But what about when Cassie comes over and takes your Air Dog toy, or your Flippy Flopper, or your Squeaky Toy?"

Ellie sat up in her Sphinx position, raised her ears up high and said, "*That* is an entirely different matter!"

HANDPRINTS AT THE SANTA FE CASITA

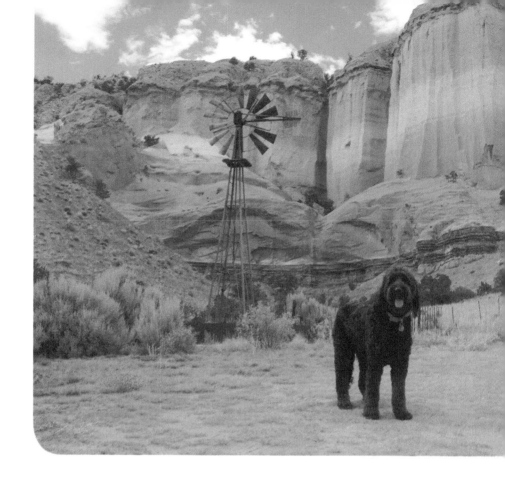

BACK IN THE 1980S, I REPAIRED
THIS WINDMILL FOR A WORK CREW
OF FOREST RANGERS WHO WERE
VERY THIRSTY. THE SUCKER ROD
HAD BECOME UNATTACHED. I
SPLICED IT TOGETHER, CLIMBED
THE TOWER AND BEGAN TURNING
THE BLADES, INSTRUCTING THE
CREW TO PUSH UP AND DOWN
ON THE SUCKER ROD. SOON
BEAUTIFUL, CRYSTAL WATER BEGAN
FLOWING AND WE ALL DRANK
HEARTILY WITH GRATITUDE.

RIGHT: MIDNIGHT AND
THAT OTHER BLACK CAT

XXVIII.
Ellie and I
in Santa Fe

I could smell the mountain air. It was rich with piñon. The aspens were flaming gold, and the profusely scattered bouquets of chamisa were rich, vibrant yellows. It was just right for a crackling fire in the traditional Navajo fireplace. Her Royal Blackness was on the couch with me.

"Hey, Ellie Baby Doggie. Do you like being up here in Santa Fe?"

"Not really, Worrell. There is nothing to do here, except I like going to the gallery and seeing Aunt Vera, Aunt Jody, Aunt Mary, and meeting some of the people that come in. Other than that it is pretty boring. You won't let me run out in the yard and you put me on a tether. I can't chase anything! How would *you* like that?"

"Well, Ellie, I wouldn't like it. But you wouldn't have to do that

to me because I have enough sense not to run off."

"Yeah, sure! What you really mean is you don't have enough sense to chase a rabbit. Don't you realize they need chasing?"

"Well, maybe so, but not on Upper Canyon Road."

"Why?"

"Cause people drive like crazy on this road and they might run over you. They drive 50 miles an hour in a 25-mile an hour zone, there are hills and curves and they aren't watching out for dogs. They're not even watching for humans. The speed limit should really be 15 mph."

"But what about the rabbits?"

"What about them?"

"They run on that road. That's why I went after them."

"Yea, and didn't you see some of them smashed flatter than a pancake?"

"No."

"Well, they are. They are there, mashed flat, and I don't want that happening to you."

"But they need chasing!"

I could see that this discussion was going nowhere. I gave Ellie a treat, told her she is the best doggie in the United States of America and to the Republic for Which it Stands. Then I called Invisible Fence.

Ellie looked at me and said, "Yeah, Worrell. Remember, bad neighbors make for good fences."

A REAL GOOD FENCE, SANTA FE

XXX.
Endangered Species

*W*e are killing things off, we are, those of us that claim title to being human beings. We try desperately to kill some things off, with either no success, or limited success: things like influenza, aids, cancer, diabetes, heart disease, birth defects, and other maladies.

Some things we unintentionally make extinct, and not often enough with proper regret, like the passenger pigeon, the ivory-billed woodpecker, the lobo, and other now and forever gone creatures.

Now we have a list of endangered species. On that list are horned lizards, California condors, the black rhinoceros, the Texas gambozia, and other creatures. There are mammals, reptiles, fish, crustaceans, amphibians, insects, plants and a long list of various life

forms that are endangered.

But that is not all! There are some other things that are endangered. We are losing elements of culture and heritage. Some of these endangered things are social things: mores, so to speak. So here they are, the twelve most endangered species of social elements.

1. Integrity
2. Honor
3. Honesty
4. Ambition (work ethic)
5. Morality
6. Reverence
7. Sanctity
8. Justice
9. Loyalty
10. Courtesy
11. Trustworthiness
12. Dependability

I read this list to Ellie May and she said, "Worrell, it is a lot longer list than that! You humans are so full of guile and subterfuge! You pretend to be so nice and so sweet and so kind, then you lash out at your fellow humans with incredible fury. Too many of you just don't walk your talk.

"I am not pointing this at you, Worrell. You have never abused me and I have never seen you abuse anyone else, but I have heard you go into orbit when you start discussing and cussing political issues. You do this with such unbridled passion, too, as if it were going to make some sort of difference. In reality all it does is rile you up and alienate the people that do not agree with you."

"And dogs don't do mean things to other dogs?" I asked her.

"Sure we do," she replied, "But we don't lie about how we feel. We bite and growl and chew. We do not engage in subterfuge about it and we do not lie about it. We don't try to court some other canine to gain an advantage. Dogs are a lot different from humans. We behave differently. You are not likely to see a ninety pound Doberman come

wagging its tail up to a stranger or an intruder, then lick the person's hands, roll over on its back, and then, once it gains the other's trust, be it dog or be it human, suddenly stand up, charge, and tear the flesh of that poor, unsuspecting person or dog with its molars and fangs. Dogs are just different from humans. I bet you cannot show me one mean thing a dog ever did that was not taught to it by some human: like your noble professional athlete that taught pit bulls how to kill each other for perverted human entertainment. He did that while you humans paid him millions and millions of dollars just because he could play football. That is a fine thing to teach your young people! And the other 'upstanding' athletes that take drugs and deal drugs and cheat by taking steroids almost make me have canine seizures of some sort. You humans seem to be all hung up on keeping score, if you will pardon the expression."

"Pardon what expression?" I asked.

"Hung up," she explained. "If you humans had been made to do that you would have much longer and more pleasurable experiences, in my opinion. You would also be able to understand how cruel it is to have someone pour a bucket of water on you or spray you with a water hose at such a sensitive moment. And one more thing; it would reduce the incidences of infidelity for the human race."

"How could it do that?" I asked.

"Because you would know you would be unable to scramble rapidly to a get-away place, for one thing; and another thing is that more of you would be shot; therefore there would be fewer of you to cheat. It would start cleaning up the gene pool a bit.

Ellie continued. "And as for keeping score, that is mostly what humans do. They keep score on how many possessions they have, the luxuries they have, the money they have, and the games they win. Dogs just play around for the sport of it. You have never heard of dogs having a super bowl where a pack of us wins some grand title for chasing sticks. But admittedly, sometimes humans make us do some crazy things that we would not do on our own.

"There's something else about you humans that seems quite peculiar to us doggies, and that is all the big deal you make about your

opposable thumb."

"What do you mean, Ellie, Baby Dog?"

"Oh, Worrell! You know good and well what I am talking about. Your books on anthropology and archaeology are crammed full of stuff about your precious thumbs: about how your mighty thumb let you go to the moon, and how you all might still be living in the trees and the caves if it were not for your opposable thumb.

"And I'll tell you something else, Worrell, I can do things with my nose that you can't even start to do with your thumb! A nose is kind of like eyes that can see in the dark. You hear something outside in the dark and you have to go get a flashlight. All I have to do is use my nose. There is a big world of fragrance out there that you are missing, Worrell: rotten rabbits, dead snakes, cow paddies, and a lot more things. Really, it takes intellect to appreciate the nose, and to comprehend the nose as a basic tool. Humans so often underestimate the nose, when it is one of the greatest tools on earth. I'd be absolutely lost without my nose.

Ellie sniffed and went on. "And I am reluctant to tell you this, but honestly, I think you would look a whole lot better, Worrell, if you had a nose more like mine. How do you get anything done with such a little snout? All you get when somebody pets you is a head rub. You just don't know what it is to get a really good nose rub.

"The nose is the best entrance there is to a lot of things: doors, gopher holes, pillows and bedcovers, and especially conversations. In front of every good dog there is a really good nose. You human beings would be a lot better off if you would trade in your precious cephalic index for more nasal capacity – in my opinion, that is.

"You humans are one of the funniest, most comical species I have ever seen. If you had a longer nose you might have a better set of teeth. I don't see how you get much chewing done, anyway, and try digging up a gopher hole with that little weenie thing of yours.

"If I had it to do all over again I would try for an even bigger nose. I'll tell you something else about my nose compared to yours. Mine is right in line with what I am looking at. When you look at something your nose is pointed almost ninety degrees down from it, then when you look down to see what you were smelling all you get is

ELLIE NOSE A LOT

the odor from your own body, which can be really bad if you don't mind my saying so. I can smell what I am looking at and you can't! And how many times have you known humans to be called in to sniff down some escaped convict, or use their noses to track down some child lost in the woods?"

I went to the mirror and looked into it. I bared my fangs. They seemed so inadequate. I looked at my poor excuse for a nose, and I thought how much warmer my cheeks would be in the cold winter months if my ears were as nice and long as Ellie's are. I became a little bit depressed and thought about these conversations I have had with Ellie. I gave her a treat and told her, "You know, Ellie May, you are right on target."

219

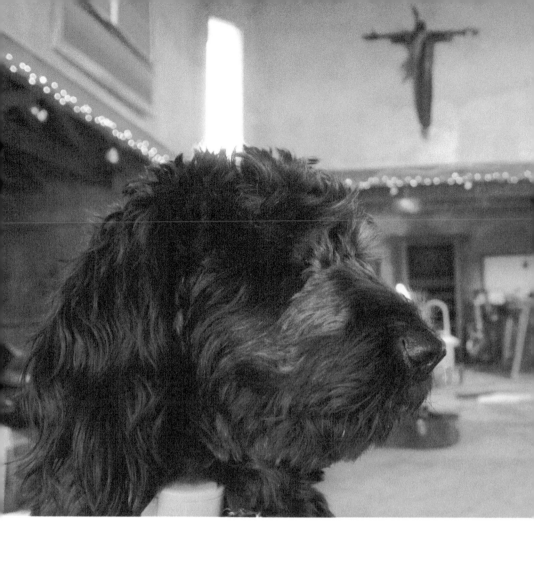

XXXI.
Black Dog

hen I am seated Ellie May Lucille loves to walk under my legs and rub her back on them. She has a way of smiling when she does this that is so very cute and so beautiful. She turns her head about 180 degrees and looks up at me with big, bright eyes, issuing a soft growl that is almost like a purr. One morning she was doing that while I was sitting on the big rock under the mesquite tree in our front yard. She asked me a question.

"Hey, Worrell, do you remember that day in November when Sawndra brought me to live with you?"

"I sure do, Ellie May Baby Dog. She arrived so late I was already in bed asleep, and when I awakened the next morning I looked out the door and saw her walking you on a leash right out here in the yard. I thought to myself, *'she has brought me a nutria!'*"

"A what?!"

"A nutria. You know, they are kinda like beavers, except they have long round tails instead of flat ones. They really resemble big, overgrown rats."

Ellie frowned. "That sort of hurts my feelings, Worrell."

"Aw, Baby Dog, I didn't mean for it to. You are the cutest and most beautiful doggie I have ever seen. You are Miss Canine America. You are Miss Black Canine America!"

"Okay, but what I want to know is this: when I came to live with you it was so wonderful and cool, with short days and long sleeping nights. What in the world is going on now that makes the days so long, the nights so short, and that makes it so blasted hot? And remember, I can't sweat like you humans and the horses do."

"Well, Ellie May, it has to do with the seasons. It is summer now. It was winter then, or almost winter. Some say it is global warming, but if you want to know the truth it is simply summer. The Planet Earth rotates on its axis, making it appear that the sun is sinking lower in the south in the fall, and then seems to begin rising in the winter. Actually the sun does not move the way it seems to. The earth is just wobbling a bit, back and forth, as it has done for countless ages.

"On the first day of winter the days start getting longer. Spring arrives and then, on the first day of summer the sun appears to start sinking in the south again. It appears to sink lower and lower throughout the fall, then appears to begin rising in the winter. This is what accounts for long hours of darkness in fall and winter and longer hours of light in spring and summer, even though the sun seemingly begins sinking again on the first day of summer. This has been going on for thousands, even millions and millions of years. There has been fall, winter, spring, and then summer. But these days it seems that people just have to have someone to blame for their dislikes and their discomforts, and also for their ignorance and fear. Somehow they think this is something new, but it is not. Shoot, Ellie, when I was back in high school we thought the world was coming to an end because it was so hot and dry. It scarcely rained for seven years. That is what made the arrowhead hunting so wonderful. All those ancient Indian camps on the

Colorado River and its tributaries were laid bare by the drought. The sheep, goats, and cattle that survived the screwworms ate every blade of anything trying to grow. The landscape was desiccated, and because of that, flint artifacts were uncovered. We would find them baking in the hot sun, lying naked on the parched earth. We picked them up almost by the sacks full.

"People have short memories, and of course there are a lot of people living now who were not born in those days, so they cannot know the hardships that such climate and weather imposed. If they had been living ten million years ago they would have truly experienced global warming. They would have experienced ice ages too. Those ice ages froze the water of the ocean around Beringia, and ancient nomads crossed over the frozen straits from Europe and Asia into what is now called the North American Continent.

"In some of those ancient days the area that is now Lubbock, Texas was beneath a sea. That is how the Caprock was formed. And El Capitan, the eighth highest peak in Texas is an ancient limestone reef. It is now 8085 feet above sea level and was formed because the oceans were once, or more than once, covering the place where this mountain is. Global warming is nothing new. There were just no humans in those times to witness it, complain about it, and broadcast reports blaming it on the governments and the big corporations.

"Neither is global freezing something not previously experienced, and it will with certainty occur again. There were ice ages in ancient times as well as warm periods. The latter melted the polar ice and caused inundations by seas and oceans. There was an incredible vastness of life and life forms that are now extinct. That is how crude oil was formed and is now one of the reasons why humans are causing so much war and strife in the world: all because of ancient weather and climate patterns."

"You sure do talk a lot, Worrell. I asked you a plain and simple question, and here you go, giving me courses in geology and meteorology. Sawndra told me that you used to drive her and Billy crazy this way. Can't you just answer my simple question? Why is it so blasted hot?"

"Because it is summer, Ellie, that's why."

223

You should have seen the look
she gave me!

Weary black dog
Hot summer day
Wishes for winter
Winter forever away

Black August dog
Panting for breath
Dripping long tongue
Soaks the sod wet

Summer will pass
Winter will come
Black dog will smile
She will soak in the sun

ELLIE IN EAGLE CAVE, A VERY
INTERESTING HUMAN HABITATION.

MEXICO IS THE BACKGROUND.
FOR A VERY INTERESTING STORY,
GOOGLE 'JUDGE ROY BEAN'S
PRIZEFIGHT,' HELD ON A SANDBAR
OF THE RIO GRANDE IN 1896. THE
WINDMILL ON THE LEFT PUMPED
WATER FROM A SPRING IN THE
CANYON BELOW VIA A PUMP JACK
CABLE RELAY TO A HOUSE ABOVE
THE CLIFFS ON THE RIGHT. A WATER
PUMPLINE WAS SUSPENDED FROM
A CABLE STRETCHED ACROSS
EAGLE CANYON. THIS IS QUITE AN
ENGINEERING FEAT.

LLANO RIVER SUNRISE

Ellie Asks About Evolution

That duck was going off big time. It was a mallard duck, and it went on and on and on, quacking and quacking, then I felt a nudging at the back of my legs. I was standing at the antique stove pecking away on my laptop. This is the place I mostly do computer work. It is an old Magic Chef stove, and it is filled with paper, envelopes, stamps, and such. Ellie had the mallard in her mouth, bumping into me and hollering – between quacks, of course, – "Hey, Worrell, come on! We need to play with this duck!"

The duck is made of stuffed fabric. We named it Quack. Marti, Shelby, and Clark Perkins gave it to Ellie. It is the second duck they

have given her. They brought the first one to Santa Fe and gifted it to her there. She was frantic, jumping, bounding, prancing and pacing around with Quack in her mouth. We could not get it away from her. Suddenly it was gone. We looked everywhere for that duck and could not find it. We looked under every piece of furniture in the house. We searched the yard. We searched the casita in back. There was no Quack.

The day after the Perkins left I was doing something in the house when I heard the noise: *Quack! Quack! Quack!* I went out back and there was Ellie May Lucille, frisking around with Quack in her mouth, just daring me to try to take it from her. It is a bit feather worn now, one might say. I am still baffled by her abilities to hide things where no human can find them. We left Quack to stay in Santa Fe.

They brought another one to New Art and Ellie was just as excited. We named this one Quack II, so as not to be confused about who was Quack and who was not Quack. We knew Ellie would not be confused, but we might be.

A few days later Ellie was busy quacking Quack II when she stopped and asked me, "Hey, Worrell, do you like ducks?"

"Why sure, Ellie, I like ducks. Why do you ask?"

"Because I never see you chew on one, that's why. They are so FUN! And especially the way they make that honking noise. Man, would I like to get hold of a real one instead of this piece of fabric made in China. That kind of bothered me from the start, Worrell, something made in China. Do you'all make anything here in America any more?"

"Well, Ellie, not too much. I think Victor mousetraps are still made here in America. A few books are printed and bound here, but not too many. Some pretzels are still made here but now they have even outsourced bagel chips to Bulgaria, of all places! Of course they still label them 'New York Style Bagel Chips.' There is certainly a lot of dishonesty and corruption made here! But you know, Ellie, most of the time it is either buy it from China or do without it. That is what killed your daddy, Prince, by the way. It was dog food that came in from China that did him in. That event caught the public unaware and lots of your relatives died from it, sort of like humans do from the swine flu. That is why I stopped feeding you anything except the very safest and the

very best dog food I can buy. That's why I pay more than $50 a bag for Blue Buffalo and Taste of the Wild and other fine foods instead of $25 for the stuff that even some veterinarians mistakenly think is safe. That is why I trashed three big fifteen-dollar bags of chicken breast treats when I read the label and found that they were processed in China. You really gotta be careful these days, Ellie. There are more crooks and schemes and charlatans than you can count on all four of your doggie paws. It is part of the evolutionary process, I think. We are all dealing with scoundrels in industry, manufacturing, foods, produce, products, education, religion, and politics: from strawberries grown in China to dog food and coffee pots made there, and to the by-products of the lobbyists who bribe and seduce educators and legislators."

Ellie looked inquisitive. "Now, Worrell, you mentioned evolution earlier when you were talking about people and monkeys and stuff. Now you're using it to refer to commerce, trade, religion, education, politics, and all kinds of stuff. What's up with this? What is evolution, anyway? Is it everywhere?"

So there I was, stumped about how to explain this to Ellie. I told her that there are two main types of evolution. There is positive evolution and there is what we might label as regressive evolution. I told her, "An example of positive evolution is the human opposable thumb: the one you chided me about earlier. An example of regressive evolution is something such as the now extinct mastodon and mammoth, animals that began to grow enormous tusks. The tusks grew so long, so large, and so heavy that they interfered with grazing and browsing, the two main methods of herbivore feeding. Those massive tusks also interfered with basic pedestrian activities, making it hard for those animals to easily move around. Eventually those animals became extinct. Another example of regressive evolution is found in American politics, where the weight and size of political offices and agencies is so large, clumsy, and cumbersome that it is difficult for any legislator to get anything done. A good example of this is what is now occurring with the so-called health care reforms. It is also manifest in religious organizations, especially the Roman Catholic Church. The Church, as it is called, has the Vatican, which is a space given status as an independent country or nation. There is a lot of mischief that comes from the Vatican, and there is a lot of evolution there also!"

"Good grief, Worrell, health care is all I hear on the news while we are driving down the highway. And you have it on half the night long on TV. I'm sick of health care!"

"That's pretty funny Ellie, since it is health issues we are conversing about. And believe me, you are not the only one tired of hearing about it."

Ellie barked a little doggie laugh and said, "Tell me some more about the human evolution: about the monkey stuff."

"Well, Ellie, I tell you what; I began writing and illustrating a book several years ago about this. I had some amazing drawings for it, too. I had illustrations of human beings with huge mouths and vestigial ears. They were the evolutionary descendants of educational administrators that would not listen to anything. All they did was espouse, ad infinitum.

"I had a drawing of a human shown in profile, looking as normal as could be. But the face-on view showed a cranium so thin that both eyes were so close together it looked like a cyclops and the ears nearly touched each other. This human was descended from narrow-minded religious bigots.

"Still another drawing showed a group of human beings with hands nearly as large as those mastodon and mammoth tusks I was telling you about. This group was descended from politicians: the ones that never give anything. All they know to do is take money from the public via taxes, duns, donations, and such. I had a similar drawing for the descendants of preachers, except they were all real, real fat from overeating, and one hand was taking money while the other was stuffing it in a pocket.

"You can just imagine what I did regarding the McDonald's frenzy-feeding people, with the doctors that converted the 'Oath of Hippocrates' into the 'hypocritical oath,' the personalities of the news media, with their oversized mouths, and the people who spent most of their time listening to them, having thus developed craniums the size of golf balls and ears the size of elephants' ears."

"Worrell," Ellie said, "if you will pardon me for saying so again, you're weird. You're just plain weird! So what's gonna happen to you in

all this evolutionary thing, Worrell?"

"That I would like to know, Ellie, and I have spent much time pondering that issue, and the question of what will happen to the sculptures I have made, the paintings I have painted, the volumes of things I have written, and even to the songs I have penned. Let me simply answer that by quoting to you some lyrics by Walt Wilkins and Billy Montana. Ready?"

"Sure, Worrell, go ahead."

Then I sang these lines to Sweet Ellie May Lucille, the love of my life.

> At the end of this life
> That I've been given
> After the prayers and the bells are rung
> I ain't afraid of where I'm going
> But what'll become of these songs I've sung?
> What'll become of these songs I've sung?

Lyrics by Walt Wilkins and Billy Montana, Songs I've Sung, *from the album VIGIL.*

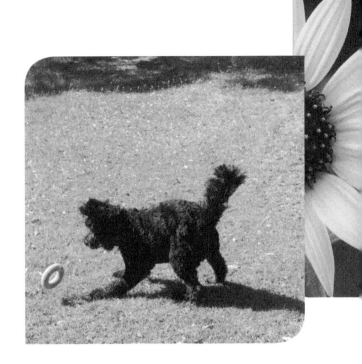

Epilogue

a friend was telling me about a conversation she had. A rather opinionated behaviorist was pontificating to her about how superior humans are to other animals and how ridiculous it is for humans to believe that animals can communicate with human beings linguistically. He elaborated on and on about the superiority of humans over other animals. She simply asked him: "If you are so damn smart why don't you learn their language so you can understand them instead of your expecting them to understand you?"

I love it! As they say in French, *"touché!"*

So right now, go get your doggies a treat and tell them how much you love them. Then give them a nice, long petting session.

People who don't like dogs don't have souls.

Remember, "Dog is man's best friend." This is the truth, and dogs are the most loyal of all friends, too. Just think about how many dogs have done you wrong and then think about how many humans have done you wrong. Can you have any doubt? Any doubt at all?

Think about it.

 And also remember that if you want a really good relationship never look upon a doggie as a possession; look upon a doggie as a friend. Humans should be a dog's best and his most loyal friend too!

THE END

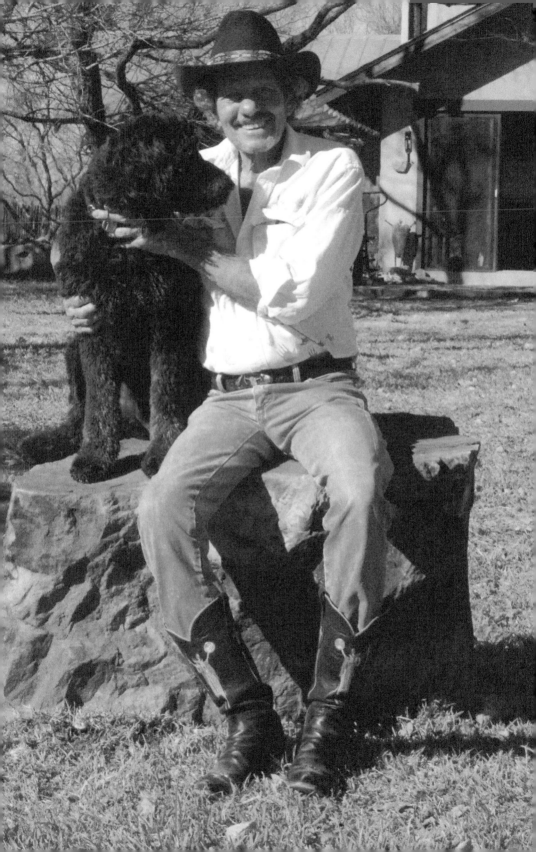

About
Bill Worrell

ill Worrell's art career spans more than forty years. He holds a Bachelor of Arts degree in sociology with a minor in English and teaching certification in art education from Texas Tech University. He was awarded a Master of Fine Arts degree in painting and drawing with a minor in sculpture from the University of North Texas, where he also held a doctoral fellowship. He was Associate Professor of Art at Odessa College, and was Professor of Art at Houston Baptist University. He has served on the advisory board of UNT School of Art and Visual design.

Worrell left the classroom in 1989 to devote full time to his artistic pursuits and to become a "recovering teacher." (He acknowledges that he is recovering more from legislation than from teaching.) His sculptures, paintings, and jewelry are in fine art galleries across the country, and his works are in collections around the world.

Worrell is a person of wide and varied interests. He has appeared on the NBC Today Show, The Nashville Network, and in music videos with Brooks and Dunn and other Nashville personalities. In 1996 the Odessa Heritage Foundation named Worrell as one of the city's outstanding former citizens. The University of North Texas named him as an outstanding graduate in 2009. In 2009 Colorado High School honored Worrell by naming him an outstanding graduate of that school. He has been featured in Southwest Art Magazine and other publications, and he has also been featured on the Texas Country Reporter and the Sounds of Texas. Gold medal awards have been earned for wine labels he designed.

Bill Worrell is an outdoors man, inventor, philosopher, songwriter, music-maker, and lover of life. His four published books are *Places of Mystery, Power, & Energy, Voices from the Cave – the Shamans Speak, Colorado City, Texas* and *Journeys Through The Winds of Time.* He currently has five other books in progress. Highway 29 Records published his CD, *Carpe **EVERY** Diem* in 2006. Other musical works have been published by Boosey & Hawks and performed at Carnegie Hall, Spivey Hall, and at the National Association of Chorale Directors Meeting in Vancouver.

The oldest pictorial art in North America is in Texas, on the Lower Pecos River and the Middle Rio Grande. For the past three decades Worrell's paintings and sculptures have helped make this area known around the world. His monumental sculpture, *The Maker of Peace,* graces the entrance to the Texas Seminole Canyon Historical State Park. This park is located on a tributary of the Rio Grande a few miles east of Lantry, Texas, home of the infamous Judge Roy Bean. Seminole Canyon derives its name not from the Ancient Texans who created the pictographs, but for the Seminole Indians who were scouts for the U.S. Calvary in the 1800s.

Bill Worrell and Ellie May Lucille, a wonderful Golden-doodle, reside beside the Llano River in Mason County, near Art, Texas. They also reside part time in Santa Fe, New Mexico, and in a Ford Expedition on the beautiful highways of the Southwest.

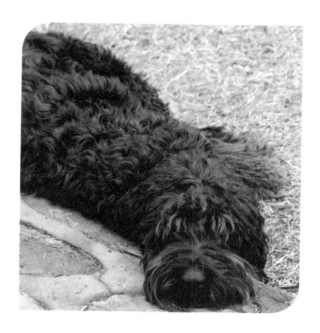

You can write to Ellie May Lucille Worrell at any of Worrell's gallery affiliates or through Debra Worrell Hernandez at the website below.

Visit billworrell.com

CPSIA information can be obtained at www.ICGtesting.com
Printed in the USA
BVOW10*1658101114

374071BV00002B/2/P